LOUISE NEVELSON

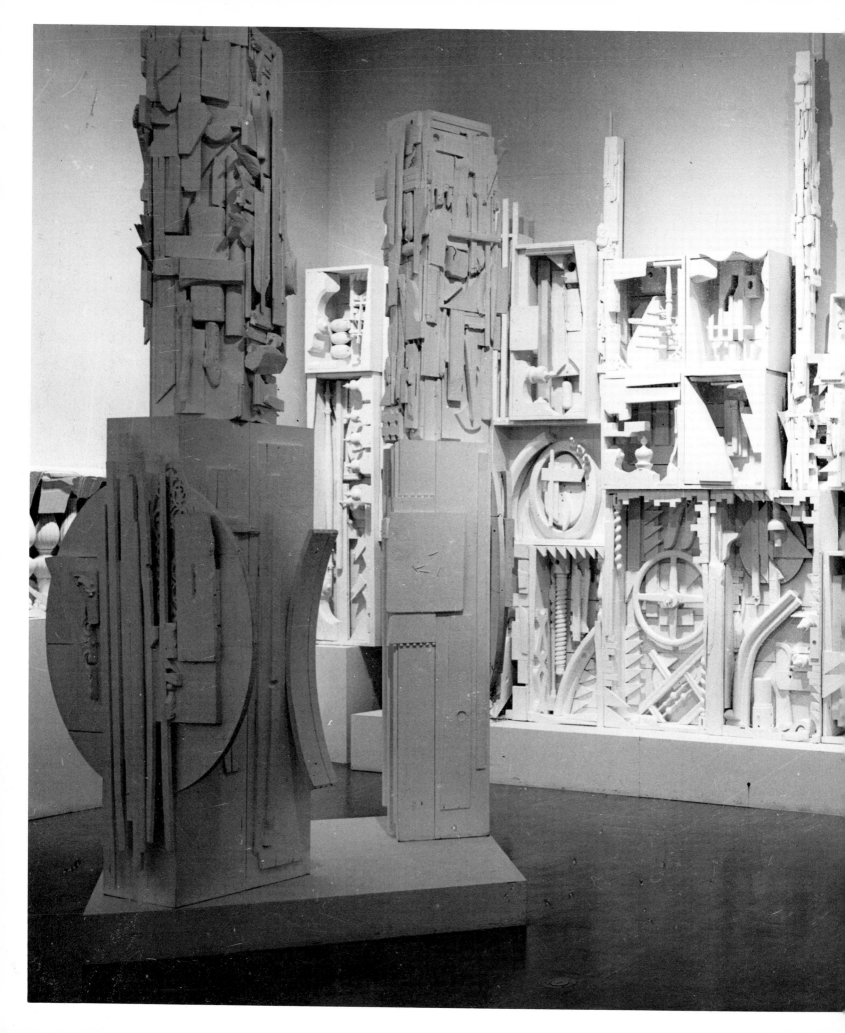

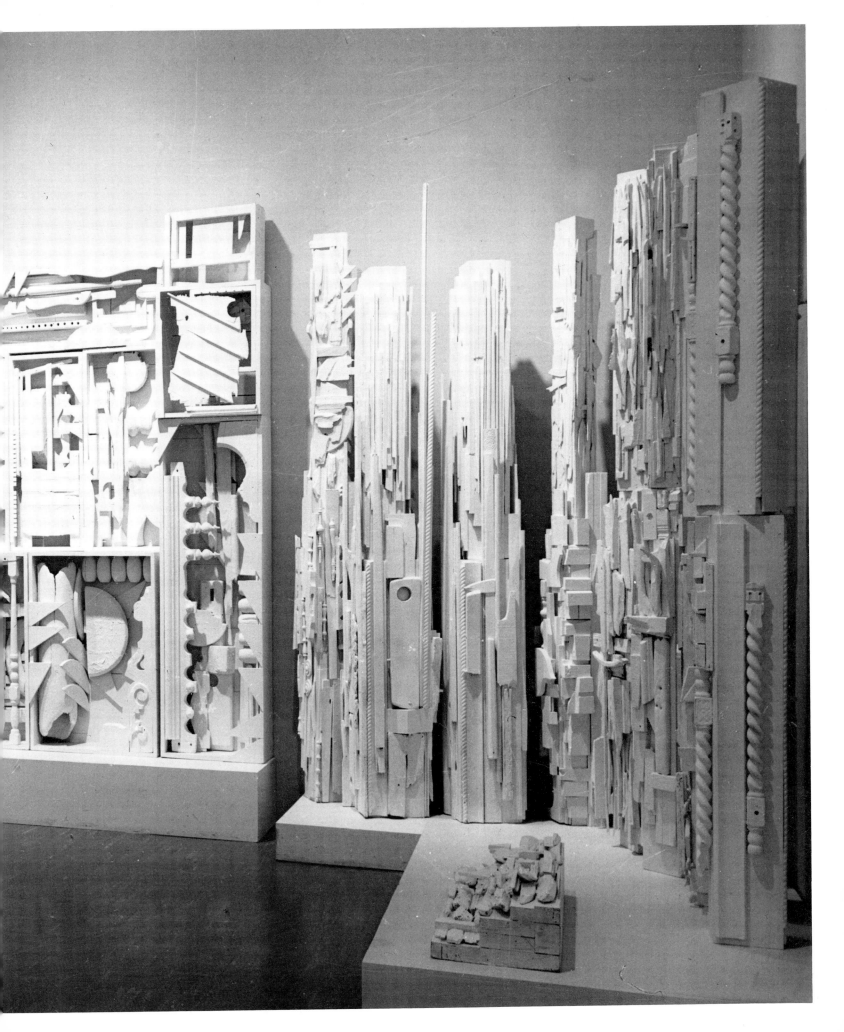

LOUISE NEVELSON

ARNOLD B. GLIMCHER

SECKER & WARBURG · LONDON

ACKNOWLEDGMENTS

For the past ten years, Louise Nevelson has helped me to fulfill my career as an art dealer and to extend my perception. Until I began to work on this book, I assumed that I had a total knowledge of the artist's motivations, personal history, and chronology of the works. However, in preparing this work, I came to realize the complexity of the artist as a total individual and that my previous knowledge was only superficial.

I am indebted to Mrs. Nevelson for the many hours of taped interviews and access to her personal files. I am also indebted to the authors and publishers of the interviews and articles for permission to produce segments from these works; to Mrs. Nevelson's assistant, Diana McKown; to Garnett McCoy and Butler Coleman at the Archives of American Art; to E. J. Krinsly of the Martha Jackson Gallery; to the late Colette Roberts; and to Dorothy Miller and the entire staff of The Pace Gallery, who also provided invaluable assistance. I am especially grateful to my editor, John Hochmann, without whose patient assistance I could not have completed the book. Most of all, I am indebted to my wife, Milly, for her tireless collaboration on this project.

Arnold B. Glimcher
August, 1972

PHOTO CREDITS

Archives of American Art, Smithsonian Institution, Louise Nevelson Papers, Ferdinand Boesch, Rudolph Burckhardt, Barney Burnstein, Geoffry Clements, Roxanne Everett, Giacomelli, Howard Harrison, Helga Photo Studio, Joseph Klima, Jr., Diana McKowan, Allen Mewbourn, O. E. Nelson, Ugo Mulas, Jeremiah W. Russell, John D. Schiff, William Suttle, Taylor and Dull.

First published in Great Britain 1972 by Martin Secker and Warburg Limited, 14 Carlisle Street, Soho Square, London WIV 6NN

Copyright © 1972 Praeger Publishers, Inc.

SBN: 436 18140 1

Printed in the United States of America

FOR PAUL AND MARC

CONTENTS

BIOGRAPHICAL SUMMARY

1899 Born in Kiev, Russia. Parents were Isaac Berliawsky and Minna Ziesel Smolerank. There were four children: Nathan, Louise, Anita, and Lillian.

1905 The family moved to the United States and settled in Rockland, Maine, where she attended public schools. Here the father was a builder and ran a lumber yard.

1918 Graduated from Rockland High School.

1920 Married Charles Nevelson. Moved to New York.
Studied painting and drawing with Theresa Bernstein and William Meyerwitz. Studied voice professionally with Metropolitan coach Estelle Liebling. Also studied dramatics. From this point on she educated herself in all of the arts.

1922 Son Myron (Mike) born.

1929–30 Studied at the Art Students League with Kenneth Hayes Miller and Kimon Nicolaides.

1931 Studied for a short time with Hans Hofmann in Munich. Worked as an extra in films in Berlin and Vienna.

1932 Was an assistant to Diego Rivera. Studied modern dance with Ellen Kearns.

1933–34 Exhibited in group shows at various New York galleries.

1935 Exhibited in group show, *Young Sculptors*, arranged by the Secession Gallery at the Brooklyn Museum.

1937 As part of the Works Progress Administration, taught art at the Educational Alliance School of Art.

1941 First one-woman show at Nierendorf Gallery.

1948 Traveled to Europe (England, France, Italy).

1949–50	Worked at the Sculpture Center in terra cotta, aluminum, bronze. Observed Atelier 17 with Stanley William Hayter for a short time. Made two trips to Mexico.
1953–55	Worked at Atelier 17, New York. Produced a series of Black Wood Landscape sculptures.
1956	Whitney Museum of American Art acquired *Black Majesty*.
1957	Brooklyn Museum acquired *First Personage*.
1957–59	President of New York chapter of Artists' Equity.
1958	Museum of Modern Art acquired *Sky Cathedral*.
1962	Included in United States Pavilion, XXXI Biennale Internazionale d'Arte, Venice. Whitney Museum purchased the wall *Young Shadows*.
1962–64	President of National Artists' Equity. In this capacity, participated in Conference of World Affairs, which included international leaders in the fields of science, government, arts, etc. First Vice-President of Federation of Modern Painters and Sculptors. Member, National Association of Women Artists. Member, Sculptors' Guild.
1963	Fellowship to Tamarind Workshop, Los Angeles, completed twenty-six editions of lithographs. President, Artists' Equity.
1965	Participated in National Council on Arts and Government in Washington. Israel Museum, Jerusalem, acquired *Homage, 6,000,000*.
1966	Honorary degree, Doctor of Fine Arts, from Western College for Women, Oxford, Ohio.
1967	Major retrospective show at the Whitney Museum of American Art, New York (March–April). Fellowship at Tamarind Workshop, Los Angeles.
1969	Commissioned by Princeton University to do first monumental cor-ten steel work (fall). MacDowell Colony Medalist winner (September). Juilliard School of Music acquires wall *Nightsphere Light* (December). Major retrospective exhibition at the Museum of Fine Arts, Houston, Texas, and at the University of Texas, College of Fine Arts, at Austin. One-woman exhibitions at Rijksmuseum Kroller-Muller (Otterlo) and Museo Civico di Torino.
1970	55-foot wall commissioned by Temple Beth-El, Great Neck, N.Y.
1971	Brandeis University Creative Arts Award in Sculpture. Skowhegan Medal for Sculpture.
1972	Honorary degree, Doctor of Fine Arts, Rutgers University, New Brunswick, New Jersey.

MAJOR EXHIBITIONS AND COLLECTIONS

ONE-WOMAN EXHIBITIONS

1941 Nierendorf Gallery, New York.

1942 Nierendorf Gallery, New York.

1943 Norlyst Gallery, New York: *The Circus, The Clown Is the Center of His World.*
Nierendorf Gallery, New York: *A Sculptor's Portraits in Paint.*

1944 Nierendorf Gallery, New York: *Sculpture Montages.*

1946 Nierendorf Gallery, New York.

1950 Lotte Jacobi Gallery, New York: *Moonscapes.*

1954 Lotte Jacobi Gallery, New York. Marcia Clapp Gallery, New York.

1955 Grand Central Moderns Gallery, New York: *Ancient Games and Ancient Places.*

1956 Grand Central Moderns Gallery, New York: *The Forest.*

1958 Grand Central Moderns Gallery, New York: *Moon Garden Plus One.* Esther Stutt-
man Gallery, New York.

1959 Martha Jackson Gallery, New York: *Sky Columns Presence.*

1960 David Herbert Gallery, New York. Devorah Sherman Gallery, Chicago. Galerie
Daniel Cordier, Paris.

1961 Martha Jackson Gallery, New York: *Royal Tides.* Tanager Gallery, New York: *The
Private Myth.* Galerie Daniel Cordier, Paris. Staatliche Kunsthalle, Baden-Baden.
Pace Gallery, Boston.

1963 Sidney Janis Gallery, New York. Hanover Gallery, London. Balin-Traube Gallery, New York. Martha Jackson Gallery, New York.

1964 Pace Gallery, New York and Boston. Gimpel-Hanover Gallery, Zurich. Kunsthalle, Bern. Galeria d'Arte Contemporanea, Torino.

1965 Pace Gallery, New York. David Mirvish Gallery, Toronto. Galerie Schmela, Düsseldorf.

1966 Pace Gallery, New York. Ferus-Pace Gallery, Los Angeles.

1967 Whitney Museum of American Art, New York. Rose Art Museum, Waltham, Massachusetts.

1968 Arts Club of Chicago, Illinois.

1969 Harcus/Krakow Gallery, Boston. Museo Civico di Torino, Torino. Pace Gallery, New York. Galerie Jeanne Bucher, Paris. Pace Columbus Gallery, Ohio. Akron Art Institute, Ohio. Rijksmuseum Kroller-Muller, Otterlo, Netherlands. Museum of Fine Arts, Houston, Texas.

1970 University Art Museum, University of Texas at Austin. Martha Jackson Gallery, New York. Whitney Museum of American Art, New York.

1971 Makler Gallery, Philadelphia. Pace Gallery, New York: *Seventh Decade Garden*.

1972 Dunkelman Gallery, Toronto, Canada. Parker 470, Boston, Mass.

SELECTED GROUP EXHIBITIONS

1934 Secession Gallery, New York.

1935 *Young Sculptors*, Brooklyn Museum, New York.
Also exhibited about this time at Contemporary Arts, Jacobsen Gallery, The Society of Independent Artists, The New York Municipal Art Exhibition, A.C.A. Gallery, Federal Art Gallery, all in New York.

1941 *Art in Therapy*, Museum of Modern Art, New York, prize.

1944 139th Annual Exhibition, Pennsylvania Academy of the Fine Arts, Philadelphia.

1948–49 Sculpture Center and the Artists Gallery, New York.

1953 Group show of sculptors (selected by Hugo Robus and Milton Hebald), Grand Central Moderns Gallery, New York.

1955 Stable Gallery Annual (also in 1956), Roko Gallery, New York.

1958 *Nature in Abstraction*, Whitney Museum of American Art, New York.

1959 *Work in Three Dimensions*, Leo Castelli Gallery, New York. *Sixteen Americans*, Museum of Modern Art, New York. *Art, U.S.A.*, New York Coliseum, Grand Prize.

1960 *63rd-American Exhibition*, Art Institute of Chicago, Logan Award.

1961 *The Art of Assemblage*, Museum of Modern Art, New York.

1962 XXXI Biennale Internazionale d'Arte, Venice (United States Pavilion). *Art Since 1950*, World's Fair, Seattle.

1964 *Documenta III*, Kassel, W. Germany. *Painting and Sculpture of a Decade, 54–64*, Tate Gallery, London. *The Artist Reality*, New School Art Center, New York. *Between the Fairs*, Whitney Museum of American Art, New York. *Boston Collects Modern Art*, Boston.

1965 *American Sculpture of the 20th Century*, Musée Rodin, Paris. *Sculpture of the 20th Century*, Dallas Museum of Fine Arts. *Highlights of the '64–'65 Season*, Larry Aldrich Museum, Ridgefield, Conn. *Kane Memorial Exhibition*, Providence, Rhode Island. *Contemporary Art Acquisitions 1962–65*, Albright-Knox Gallery, Buffalo.

1966 *Flint Invitational*, Flint, Michigan. *Homage to Silence*, Albert Loeb and Krugier Gallery, New York. *Contemporary Painters and Sculptors as Printmakers*, Museum of Modern Art, New York. *68th American Exhibition*, Art Institute of Chicago.

1967 *Contrasts*, Hanover Gallery, London. *Sculpture: A Generation of Innovation*, Art Institute of Chicago. *American Sculpture of the '60's*, Los Angeles County Museum. *Sculpture in Environment*, City of New York Arts Festival (CBS Building). *The Helen W. & Robert M. Benjamin Collection*, Yale Art Gallery, New Haven, Conn. *The 180th Beacon Collection of Contemporary Art*, Boston. *Guggenheim International*, New York.

1968 *Suites: Recent Prints*, Jewish Museum, New York.

1969 *20th Century Art from the Nelson A. Rockefeller Collection*, Museum of Modern Art, New York. *Tamarind: Homage to Lithography*, Museum of Modern Art, New York.

1970 *American Art Since 1960*, Princeton University Art Museum, Princeton, N.J. *Expo 70*, Osaka, Japan.

1971 *Calder/Nevelson/David Smith*, The Society of the Four Arts, Palm Beach, Florida.

ANNUALS

Pittsburgh International Exhibition, Carnegie Institute: 1958, 1961, 1964, 1970.

Whitney Museum of American Art Annual (sculpture): 1946, 1947, 1950, 1953, 1956, 1957, 1958, 1960, 1962, 1964, 1966, 1969.

National Association of Women Artists: 1952, 1955, 1957, 1959, 1960.

SELECTED PUBLIC COLLECTIONS

Albright-Knox Gallery, Buffalo, New York.
Art Institute of Chicago, Illinois.
Arts Club of Chicago, Illinois.
Birmingham Museum of Art, Alabama.
Brandeis University, Waltham, Massachusetts.
Brooklyn Museum, New York.
Carnegie Institute of Arts, Pittsburgh, Pennsylvania.
City Art Museum, St. Louis, Missouri.
Farnsworth Museum of Art, Rockland, Maine.
Musée de Grenoble, Grenoble, France.
Indiana University, Bloomington, Indiana.
Israel Museum, Jerusalem.
Jewish Museum, New York.
Juilliard School of Music, Lincoln Center, New York.
Rijksmuseum Kroller-Muller, Otterlo, Netherlands.
Museum Boymans-van Beuningen, Rotterdam.
Museum of Fine Arts, Houston, Texas.
Museum of Modern Art, New York.
Museum of Modern Art, Paris.
New York University, New York.
Newark Museum, New Jersey.
Pasadena Museum, California.
Queens College, New York.
Riverside Museum, New York.
Tate Gallery, London, England.
University of Nebraska, Lincoln, Nebraska.
Walker Art Center, Minneapolis, Minnesota.
Whitney Museum of American Art, New York.
Princeton University, New Jersey.
Yale University, New Haven, Connecticut.
Fairmont Park, Philadelphia, Pennsylvania.
Hospital Corporation of America, Chicago.
Albany Mall Project, New York.
Solomon R. Guggenheim Museum, New York.

LOUISE NEVELSON

PROLOGUE

My life had a blueprint from the beginning, and that is the reason that I don't need to make blueprints or drawings for my sculpture. What I am saying is that I did not become anything, I was an artist. Early in school, they called me "the artist." When teachers wanted things painted, they called upon me, they called upon "the artist." I am not saying that I learned my name, animals can learn their names, I am saying that they learned it.

Humans are born from eggs and the shells make these eggs. We are born ready-made. People always ask children, what are you going to be when you grow up? I remember going to the library, I couldn't have been more than nine. I went with another little girl to get a book. The librarian was a fairly cultivated woman, and she asked my little girlfriend, "Blanche, and what are you going to be?" And Blanche said that she was going to be a bookkeeper. There was a big plaster Joan of Arc in the center of the library, and I looked at it. Sometimes I would be frightened of things I said because they seemed so automatic. The librarian asked me what I was going to be, and, of course, I said, "I'm going to be an artist." "No," I added, "I want to be a sculptor, I don't want color to help me." I got so frightened, I ran home crying. How did I know that when I never thought of it before in all my life? I was only following the blueprint for my life. Then, as I matured, I was restless, I needed something to engage me, and art was that something. I knew I was a creative person from the first minute I opened my eyes. I knew it, and they treated me like an artist all of my early life. And I knew I was coming to New York when I was a baby. What was I going to do anywhere but New York? Consequently, as a little

girl, I never made strong connections in Rockland, because I was leaving. I told my mother I wasn't going to get married or be tied down. I planned to go to Pratt Art Institute so I could teach and support myself. Well, I did get married, and when I met my husband, I think I willed myself on him because I knew that he was going to propose.

Marriage was the only complication in my life. In retrospect, it was simple. My environment didn't suit me. I knew where my talents were and where I had to go. My energy, curiosity, and talent went in search of experience. It was the wrong experience for me. I learned that marriage wasn't the romance that I sought but a partnership, and I didn't need a partner. Anyway, I was married and we moved to New York.

My husband's family was terribly refined. Within their circle you could know Beethoven, but God forbid if you were Beethoven. You were not allowed to be a creator, you were just supposed to be an audience. This empty appreciation didn't suit me, and from the beginning of my marriage, I felt hemmed in. I was a creator, and I had to make things. I studied voice, painting, and modern dance during those difficult years. Dance fascinates me because I don't think we know how to control our bodies. We think that walking on two feet controls it. But you can't really control the body, unless you're like Martha Graham, who took all her life to control her body. The body is very intelligent if you know how to use it. I love dance because I think that it freed me, and then I knew that I had to free my voice. I was shy. I used to be so shy I couldn't open my mouth. And I think that the role society creates for women had a great deal to do with it.

I continued my studies, and then my child was born. The greater restriction of a family situation strangled me, and I ended my marriage. For me life couldn't be a complement of master and slave. And so I gave myself the greatest gift I could have, my own life. I could control my own time, and for that very reason I never worked for anybody. I paid a price for that and didn't give a damn if I didn't have shoes, because art was what I wanted. People emphasize the things that matter to them, and for me it was my entire life. I certainly was not happy in all these situations in my life, because I needed control and I paid a very full price. Once I was feeling a little sad, and to cheer myself up I walked up Fifth Avenue and window-shopped. As I recall, Bergdorf Goodman had manikins covered with sheet music and standing in what looked like water, I don't think it was water, it may have been a mirror, but it was pretty fantastic. You could see the influence of Dali in those windows. I then went into Bonwit Teller because of the beautiful things in its windows. Now, I'm not taken by "beautiful things," but I was depressed and I said, "Look, Louise, you don't feel so hot. If the president of Bonwit's came out and said, "If you work for us two hours a day, from 12:00 to 2:00, we will give you half a million dollars for the year"—would you accept it? I said no.

And at that time I wouldn't have, because I needed my full consciousness to project ideas.

I didn't want to make things. I built an empire, and you don't build of that magnitude by cutting time. Those two hours I would have to give to Bonwit's would take away from my total awareness. The energy I would have to cut would make my work suffer.

No obstacle was great enough to keep me from my art. But people always stay where they shine and are happy. In Maine, and at the Art Students League in New York, and then in Munich with Hofmann, they all give me 100 plus. I couldn't have gotten 100 plus in mathematics, could I? You take a painting, you have a white, virginal piece of canvas that is the world of purity, and then you put your imagery on it, and you try to bring it back to the original purity. What can be greater? It is almost frightening. Well, the same thing happens with my sculpture. I have made a wall. You know that before I tune into this I go through a whole tantrum until I break in. I don't know how I have lived this long being such a wreck over these things. But I renew myself every time. I never got over it, and I imagine that if I hadn't done this physical attacking, I don't know how I would have survived. I mean, I think the thing that kept me going was that I wouldn't be appeased. You know some people get appeased, or they buy a dress or they buy a hat or, I don't know, they get something. But I couldn't be appeased.

I went to art school, and yet one only benefits from notes here and there. Creativity shaped my life. Now, for example, a white lace curtain on the window was for me as important as a great work of art. This gossamer quality, the reflection, the form, the movement, I learned more about art from that than in school. I can sit in this room ten years and just look up and feel I've seen miracles. The building across the street is a school-supply warehouse. That may be its practical function, but it has a different one for me. I see reflections, I see lights off, and once in a while lights are left on. In those windows the reflections I see are monumental, enormous, and every minute it changes with different light, the activity is endless. My tastes are satisfied by this. I don't need any more. I am entranced here wherever I look. It is an old street filled with patches, but the pattern satisfies me, and what more do I want?

Other times in my life I have responded to other things, but each time they were things that I found and things that I always knew were there, both from exotic civilizations and my own. At one time, I collected African and American Indian art. It started in Paris in 1931. Someone took me to the Musée de l'Homme and they had an exhibition of African sculpture. There were masks and full figures, and I took one look and saw their power. Those marvelous things made an impression on me. I didn't have to study African sculpture, I immediately identified with the power. When I returned to New York, I would go in the subways and see the black supporting columns and recognize their power and strength standing there. They did something to me. It isn't that I only looked, it was as if they were feeding me energy like the primitive sculpture did. I have always had a good eye, and so it was easy for me to collect good things. I loved American Indian things, and I wanted them around me. I have had them. I identified

with the Indian things. A lot of people speculate as to what they would want to be if they were reincarnated. If I were reincarnated, I would want to be an American Indian. I like the look of them, their whole make-up. There is a kind of strength about them that appeals to me, and I like the fact that we know little about them. You see, I am talking about them visually, those wonderful features and costumes, they are a fantasy. They are a real and lost image of America. Everyone has a personal image of this country. When Arp was in New York for the opening of his show at the Museum of Modern Art, he saw my wall, *Sky Cathedral*. You know, the black wall in the Museum of Modern Art was put in the same day that his show opened. I didn't meet him, but he stood in front of the wall and said, "This is America and I will write a poem to the savage." Then later he wrote a poem to my sculpture.

Just as I recognized the power of the African and Indian relics, I also knew the value of the American artist Eilshemius. When I came from Europe, the Museum of Modern Art didn't yet have a building of their own. They were on Fifty-seventh and Fifth, and I would go there frequently. One of the guards who used to see me all the time said, "Mrs. Nevelson, I have a friend on Fifty-seventh Street who is a very fine artist, and I would like to introduce you to him." I met him at his house on Fifty-seventh Street near Park. Mr. Eilshemius was from a distinguished Dutch family. When the Vanderbilts had four horses, they had eight. I had heard that he was eccentric. But when I met him, maybe because of the way I reacted, I didn't find him eccentric at all. I found him a wonderful gentleman. Most important, he was never a primitive. He was a sophisticated artist, very sophisticated if you really look at his work. His brush strokes are incomparably elegant. He knew music and composed it; maybe he wasn't Bach, but he was steeped in it as well as poetry. I don't believe people are eccentric, I don't fall for those words. Naturally, he wasn't like the conventional people in his class, and he saw through society.

Eilshemius told me that he never sold anything, and he told me of his work. Before he told me these things, I saw the quality of his work. I didn't have a great deal of money. There was a small painting I could afford and I bought it. If I hadn't believed that his works were good, I wouldn't have bought them, because that would have been false on my part. I couldn't afford to buy Picasso, and I thought that Eilshemius was the greatest painter in America. And I would rather have given an American artist my money, because I knew what it was to be an American and not be respected by collectors.

All of these experiences helped make me aware that the artist recognizes existing relationships and arrests them. When Picasso visually gave us Cubism, it was a metaphysical gesture. He is a great visual person, and he arrested a concept. But the thing is, it isn't really original, because the cube existed and was used before. He just arrested it. I feel that what the creative person arrests is dependent upon his total history.

I feel that my works are definitely feminine. There is something about the feminine mental-

ity that can rise to heaven. The feminine mind is positive and not the same as a man's. I think there is something feminine about the way I work. Today, I was working on small things in my living room. The reason I wasn't working downstairs in the big studio is because I've used up all of my large forms. The creative concept has no sex or is perhaps feminine in nature. The means one uses to convey these conceptions reveal oneself. A man simply couldn't use the means of, say, fingerwork to produce my small pieces. They are like needlework.

I have always felt feminine . . . very feminine, so feminine that I wouldn't wear slacks. I didn't like the thought, so I never did wear them. I have retained this stubborn edge. Men don't work this way, they become too affixed, too involved with the craft or technique. They wouldn't putter, so to speak, as I do with these things. The dips and cracks and detail fascinate me. My work is delicate; it may look strong, but it is delicate. True strength is delicate. My whole life is in it, and my whole life is feminine, and I work from an entirely different point of view. My work is the creation of a feminine mind—there is no doubt. What I wear every day and how I comb my hair all has something to do with it. The way you live a life. And in my particular case, there was never a time that I ever wanted to be anything else. I was interested in being myself. And that is feminine. I am not very modest, I always say I built an empire.

This is my empire, and it is my home, it is my life, a feminine mind, and a womanly life, a life of a woman. Perhaps my thinking transcends the traditional concept of what makes something feminine as opposed to masculine. In sports, women compete as well as men. The tennis players have women champs with great endurance, so do the golfers and the swimmers. These women are marvelous in their fields, but they are still females in their fields.

There is a line of difference in the approach and in the mentality. A woman may hit a ball stronger than a man, but it is different. I prize that difference. There are preconceived ideas about the woman and her weakness that are ridiculous. Women through all ages could have had physical strength and mental creativity and still have been feminine.

The fact that these things have been suppressed is the fault of society. And because of that, few women have had the courage to dedicate themselves to art. In a way, it is a sacrifice, but it is a choice. I have met distinguished and accomplished people, and many have said, "Well, you have fulfilled yourself as a woman." But one fulfills oneself. You are a woman, and you fulfill yourself; you are a man, and you fulfill yourself. And there is a price for what you do, and there is a price for what you don't do. It is a two-way deal. I felt, maybe partly through environment but certainly through birth, that I could take my true heritage and pay for it. I wanted this, and I felt rich enough to pay the price. It may sound arrogant, but that is true. I felt that I had the equipment and maybe, say it is a gift, but I knew I had it, and I felt that through this special perception I could live a meaningful life. When I was young, if the Rockefeller wealth had been put at my disposal and someone had said, here, you can have a different job every day and

have pearls from your neck down to your feet, I wouldn't have changed. There's all kinds of money, the banks are full of it, why should I be impressed. I was energetic and healthy, and I didn't care if I only had a piece of bread and butter and cheese to eat. We make our own decisions according to that blueprint. Women used to be afraid. I've met many of the women I studied art with; one of them said to me, "I am married and have three children. I was not willing to gamble." Well I wasn't afraid, I felt like a winner. And even if I didn't sell my work, I still felt like a winner. I am a winner.

In the end, as you get older and older, your life is your life and you are alone with it. You are alone with it, and I don't think that the outside world is needed. It doesn't have much influence on me, as an artist, or on us as individuals, because one cannot be divorced from the other. It is the total life. Mine is a total life.

<div align="right">

Louise Nevelson
1971

</div>

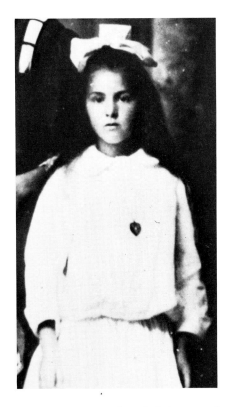

Louise Nevelson's life is such an intricate pattern of fantasy synthesized with reality that separation of myth and fact is nearly impossible. Nevelson rejects the ordinary and conjures her own history, eliminating what is beneath her notice and amplifying the important. A chronology of the artist's life provides the barest skeletal outline of incidents to which she reacted. These reactions, evident in their residual products, or art works, are only the visible and tangible evidence—the key—to the realization that Nevelson's life itself is her greatest work of art.

Nevelson is an artist whose chameleon adaptability has allowed her to live within and travel through the sympathetic but diverse disciplines of dance, music, cinema, painting, and graphics, as well as sculpture. The pattern of her life reveals a tenacious and uncompromising woman who would not allow social mores and accepted values to deter her from her goal—to be an artist.

Even as a child, Nevelson was prematurely aware of her own isolation, and the intense loneliness that she continues to suffer is depicted in her works, with their illusive imagery and space. She is uncompromising in her order of priorities, because, she says, she has already been compromised by life itself. This strong resentment has directed the development of an aesthetic dedicated to satisfying her search for shelter by the construction of a universe of her own. The edifices of that universe, unfamiliar and disorienting, mirror the morals and values that govern her life.

At a meeting in her studio of one of the few organizations to which she lends her support, Nevelson overheard a woman ask another artist what he seeks in his paintings. "I seek truth," he replied. Later, she repeated this story to illustrate the absurdity of being locked into accepted concepts. "What I seek is anything that will work for me," she said. "I'll use a lie if it works, and that's the truth. Look at this skirt I'm wearing," she continued, lifting her blouse to reveal the waistband. "This whole outfit is being held up by a safety pin. That pin is a lie, the missing button is the truth, but the lie works for me."

In 1960, Dore Ashton wrote in the French magazine *Cimaise*,

> If Louise Nevelson were a writer she would be a writer of "romances," spinning tales of the wonderful; tales that transcend reality by insisting on the reality of an imagined universe; tales, in short, that strive toward a mythos.
>
> But Nevelson is not a writer of romances. She is more nearly a poet creating metaphors in the shape of constructions. Her mythos is projected not only in the poetic titles she gives the ensembles of her work, but in the work itself, where key symbols work as metaphors.*

After ten years of a very close relationship as her friend and dealer, I have come to realize that Louise Nevelson is, if not a writer, the author of her own life, and as such, she has been allowed by poetic license to "invent" her own life, retrospectively viewing events that have happened by chance to have been motivated by necessity. For Nevelson, "necessity" means that everything she has done in the past leads logically to the present. Through sifting, discarding facts, and rearranging chronology, the collage of her life takes form much like the construction of one of her sculptures. She views her life retrospectively in themes and values. That is to say, she considers all the elements in each category of living and judges the related merit of the separate incidents. Actual chronology gives way to effectiveness of incident. Quick to realize that inherent in each major decision is past experience, she has no use for dating or remembering in logical sequence the events of her life. When questioned about the various periods of her work, she maintains that she does not pass from one to another, that, indeed, she never leaves any of the media in which she has worked. In her works, Nevelson arrests time. She makes the moment accessible forever, and the fabric of time becomes a Nevelson wall, with each compartment available for discovery and exploration. Nevelson writes her life in terms of light and shadow or ecstasy and pain, losing the elasticity of process between extremes. Yet some facts are indisputable.

She was born in Kiev, Russia, in 1899. The exact date is uncertain, but she celebrates her birthday on September 23. Her father, Isaac Berliawsky, was a contractor and a lumber mer-

* Dore Ashton, "Louise Nevelson," *Cimaise*, No. 48 (April–June, 1960).

chant, as was his father before him. In 1902, he emigrated to America, leaving his wife, Mina Ziesel, and his children, Louise, Lillian, and Nathan, in Russia until he could establish a home for them in Rockland, Maine. The trauma of what amounted psychologically to desertion by her father affected Louise dramatically. She stopped talking for six months.

Two years later, the Berliawsky family sold their possessions of value, and that money, added to the money received from Isaac's earnings in America, bought passage for the family to Boston and eventually to Rockland.

Once, when discussing her childhood, Nevelson was asked to recall her earliest memory. It occurred during her passage from Russia to America, when she was four years old. The ship stopped at Liverpool, and Mrs. Berliawsky took her anxious children into the depot and bought them candy. They had never seen a candy store, and Louise was indelibly impressed by the incident. Her earliest memory is of stacks of shelves filled with glass jars containing candy, the accumulative effect of which was a rainbow of color. This collage of color and transparency was being seen and remembered by an already selective and hyperaware eye.

Concentration on the candy and the memory of the different shelves and jars could indeed have been a protective fixation to relieve the child from her apprehension of the voyage, not unlike counting the tiles in a floor or panes of glass in a window in moments of extreme tension. What is important is that this incident impressed her enough to retain its memory, a memory that remarkably describes her mature works. The child was already Louise Nevelson. For whatever reason this memory became fixed, it indicates that for Nevelson the creation of art has always been the process of heightened selection.

Nevelson's mother was a woman of great beauty and high fashion. "When my mother walked downtown in Rockland, everybody stopped to watch her walk. She also dressed us in very expensive clothes—fancier than I found comfortable for Rockland." The Berliawsky children arrived in Rockland dressed in Persian-lamb coats and hats. This great disparity of dress, their inability to speak English, and the fact that there were only thirty Jewish families in Rockland did not make assimilation into a society based on Puritan restraint easy or really possible.

In Rockland, a fourth child, Anita, was born, and having a baby in America helped root the family to their new home. For Louise, it had been a life of great uncertainty from the time her father left Russia through the first years of reunion and reconditioning herself to, for all purposes, a new father. Isaac Berliawsky's business prospered, first under the patronage of Rockland's Jewish community and then the community in general.

Nevelson recalls her early feelings toward her family (Fig. 2). "I adored my parents, my mother was freethinking and had strong socialist ideas. My father believed in equal rights for women, and I remember everyone said that he was a business genius—but he was just too busy and I didn't see enough of him." By the age of six, she was assembling and carving scraps of

27

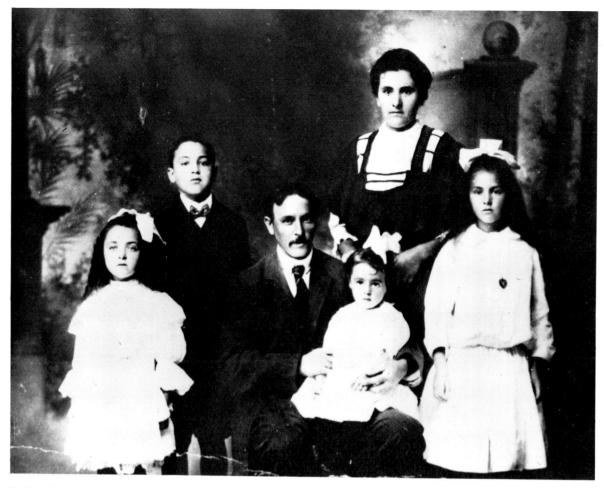

2. Family of Nathan Berliawsky, Rockland, Maine, 1908 (Louise far right).

wood she found in her father's lumber yard. Her early affinity for wood continued a family tradition; or a family affinity for wood directed the young Nevelson toward the material.

School was not easy for Louise; she had few friends and maintained average grades. Her sister Lillian Mildwoff remembers, "Louise always had one close friend at a time. When she was at home she was always moving furniture around, dabbing paint on things or dressing up and acting. We always knew that she would be an artist." When asked about her difficulty in relating to other children, Nevelson said, "Look, dear, when I was a baby I knew that I was going to be an artist. As long as I wasn't so smart, I was going to be great! What else could I do? I never made friends because I didn't intend to stay in Rockland, and I didn't want anything to tie me down." In retrospect, her unequivocal statement is another perfect puzzle piece, but in reality, Louise did find difficulty relating to other children.

As Louise grew up, the gap widened between herself and other children. Her mother's treatment of fashion as an art led to Louise Berliawsky's wearing expensive dresses to school that evoked the envy of her schoolmates. This reinforced the barrier between her and other children and directed her toward art for the fulfillment of her fantasies and even for companionship. A slow reader, even to this day, she read only the minimum school requirements and never

identified with literary characters. Her childhood fantasies were much more interesting to her than those of other authors, and they were relevant to her visual frame of reference, providing immediate stimulation. Even if she had not been a slow reader, the process of reading was agonizingly slower than her rapid visual associations. But the young Louise could not know this and directed herself toward goals that may have to her seemed more feasible, to the creation of a life style suited to her needs alone. "To be brilliant you had to read," she said, "but I had a visual mind and I wanted depth, not intellectual dazzle, I wanted to build a universe."

Nevelson's wants were necessities that did not present options or alternatives. As a small child, she was always cold, especially during school hours, the exception to this somatic reaction to school being the time spent in the art room, in which "I was always warm."

In the second grade, her art teacher brought a sunflower into the class. The children were asked to draw the sunflower from memory at home. Impressed by the center, Louise drew a large circle surrounded by tiny petals. In reviewing the drawings, the teacher pinned up Louise's and called it the most original. "I didn't know what original meant," she confesses, "but it made me feel very good."

Nevelson excelled in sports, and in the ninth grade she was elected captain of the high school basketball team. Asked if this didn't indicate a certain popular status among her peers, she says the honor only served to remind her that she was the tallest girl in the class. Besides, at the time basketball wasn't the activity in which popular girls participated. "All my life," she says, "I was elected to offices I didn't want, but I was too shy to refuse the election. This goes from the ninth grade to the presidency of Artists Equity in 1961."

Piano, voice, dance, and painting lessons substituted for social interacting, and she became obsessed with what she calls "freeing her body of its inhibitions and limitations." Nevelson insists that from the age of five she knew she was going to be an artist, and that by the age of seven she had decided upon sculpture. Asked when she made her first serious work, she answered, "I don't know, but they were mud cakes." This singlemindedness of purpose never allowed Nevelson the luxury of a compartmented existence. It was far more important and comfortable to indulge her spirit in art than to compete socially on the level of frivolity that leads to expected role-fulfillment.

Nevelson has always been a visionary. She grasps concepts quickly and, almost simultaneously, sees or imagines results. Her interest is greater in product than it is in process. Nevelson believes that she wills her destiny. She is capable of such rapid consecutive ideas that she tends to forget and negate the actual period of constructive process and imagines that she arrives readymade at the result. The truth is, rather, that process is so instinctive to her that it isn't a conscious effort, and during process, she relies only upon the highly developed aesthetic response of her eye. In other words, there is no separation between idea and completed product.

Deliberately forgotten is the physical working out of the idea. For Nevelson's purposes, this does not exist, and psychologically she wills the product into reality from idea to example. This magic thought-pattern is very important; it has enabled Nevelson to tolerate the confinement of childhood, the disappointment of marriage, and the early neglect that her art suffered. Only after thirty years of being a productive artist did Nevelson first sell her work, and her anger became a catalyst that reinforced her continued need to create. She felt a need to compensate for the time spent on activity nonessential to her art; time that we all normally spend developing or in process. Although this is important positive time, to Nevelson it has seemed nonessential.

The most distinctive and fascinating aspects of Nevelson's persona are her enormous capacity for intellectual reasoning and profound philosophical attitude toward life, coupled with intuitive creative processes upon which she draws to make her sculpture. There appears to be a strong but compatible separation between the almost animal nest-building instinct of making her art and the sophisticated cognition of her intellect. Nevelson is a combination of primitive impulse and sophisticated evaluation. Actually there is for her no separation between intuition and intellect; intuition is instant intellect. Her highly sensitive perceptual mechanisms perform like computing devices that allow her the luxury of making immediate aesthetic decisions. In fact, these seemingly impulsive reactions are comparative, based upon reasoning and previous experience. This dual process is asserted by Rudolf Arnheim: "My contention is that the cognitive operations called thinking are not the privilege of mental processes above and beyond perception but the essential ingredients of perception itself."*

During her senior year in high school, Louise worked part time for a lawyer in Rockland. The school's policy was that each student received practical work experience for five weeks before graduation. One evening, her father brought home for dinner a friend, Bernard Nevelson, who was in Rockland overseeing the repair of one of his ships. He was one of four brothers involved in the family cargo-shipping business, the Polish American Navigation Co. Impressed by the young Louise Berliawsky, he told his unmarried brother Charles about her. Soon after, Charles visited Rockland, and at the age of eighteen Louise Berliawsky went out on her first date. They were engaged almost immediately and two years later, in 1920, they were married. Louise and Charles Nevelson moved to New York.

"She knew then that she would continue her studies in the arts, and we all thought that she would be in the theater," her sister Lillian recalls. In New York, Nevelson studied voice with Metropolitan Opera coach Estelle Liebling. She also continued her dramatic studies. Her only child, Myron, was born in 1922, and this had a profound impact on Nevelson (Fig. 3). Until now, she had always considered herself in control of her time and destiny; she could project her

30 * Rudolf Arnheim, *Visual Thinking* (Berkeley and Los Angeles: University of California Press, 1969).

3. Louise Nevelson, c. 1922,
New York.

future out of her past. She even believes that she willed herself upon her husband; before they met she confided to her mother that she would marry him.

With the birth of her child, she was responsible for another life and resented that responsibility. She did not fit into the life style of her husband, she could not take her place among the mah jong–playing, tea-drinking young matrons of upper-middle-class society, but was rather searching for her own identity and fulfillment as an individual. She recently said, "How can we bring children into this world when all we can give them is mortality?" The birth of her child exacerbated her inability to accept the limitations of human existence.

For the next five years, in addition to art, she continued studying dance and singing. For several years, her art instructors were William Meyerowitz and Theresa Bernstein, until, in 1928, she enrolled at the Art Students League. She was oppressed by her marriage, which intruded upon her freedom. "He expected me home at 7:30 for dinner," Nevelson says, still incredulous. " 'But what do we have a maid for if not to get your dinner,' I told him." This

was not as much irresponsibility as it was uncompromising responsibility to her art, which is synonymous with herself. In an interview, Nevelson said, "I wanted this [art] and I felt rich enough to pay the price." There is an urgency or desperation about an artist who has so narrow and direct a vision that peripheral images deflecting her from the ultimate result are not seen, or are seen and not allowed to alter the necessary course. She often says that we were born to be free, and fulfillment comes through freedom.

After eleven years of marriage, it was impossible for Nevelson to continue living with her husband and be an artist. In 1931, they separated, and Nevelson intensified her studies at the Art Students League, where her painting instructors were Kenneth Hayes Miller and Kimon Nicolaides.

Nevelson asked no alimony or support from her husband. "I wanted to leave him, I'd have paid him for my freedom, so how could I ask for money?" Her extreme shyness made it easier for her to refuse the alimony rather than chance a legal confrontation. Separated but still married, psychologically exhausted, Nevelson took her son Mike to stay with her parents in Maine and went to Munich to study with the most important teacher of her generation, Hans Hofmann. She recalls: "I had seen reproductions of the Cubist works of Picasso and knew their power. The purity and clarity of Cubism fit perfectly. At the League I heard of Hofmann. Everyone was talking about this great teacher in Germany who taught the subtleties of Cubism—I knew then that I had to go to Germany."

Nevelson also reasoned that if she went to Europe and returned disillusioned, the resentment that had been destroying her marriage would no longer be an obstacle to reconciliation. Perhaps the logic of this reasoning allowed Nevelson's conscience the comfort necessary to wrench herself out of the safe life as a responsible New York Society matron; a life that was insufficient to fulfill the force within her. But then she was never really a part of this life, for she was just as much an immigrant in New York as she was in Rockland. Nevelson could only make a place for herself on terms that corresponded to her own values.

The turning point in her life-career was abandoning the restrictions of her life in New York. Further, in removing herself to another country, whose language she didn't know, Nevelson was free to make choices that would indulge her aesthetic response. This trip was a confirmation of the option of richness, both hostile and inviting, that the world could offer to embellish her life and her art. It was also an attempt to reject the bourgeois values that constricted and protected her. In leaving her husband, child, and family, Louise Nevelson proved to herself that she possessed the strength to fulfill herself as an artist-person and that there was indeed a place for her in the world "past the third dimension." Nevelson recalls, "In Germany I knew that to me art was life. Some people walk across the street to get somewhere, but in Martha Graham, walking across the street is life."

32

I. *Sky Cathedral*, 1958. Wood painted black, 11¼' x 10' x 1½'.
Collection The Museum of Modern Art. Gift of Mr. and Mrs. Ben Mildwoff, New York.

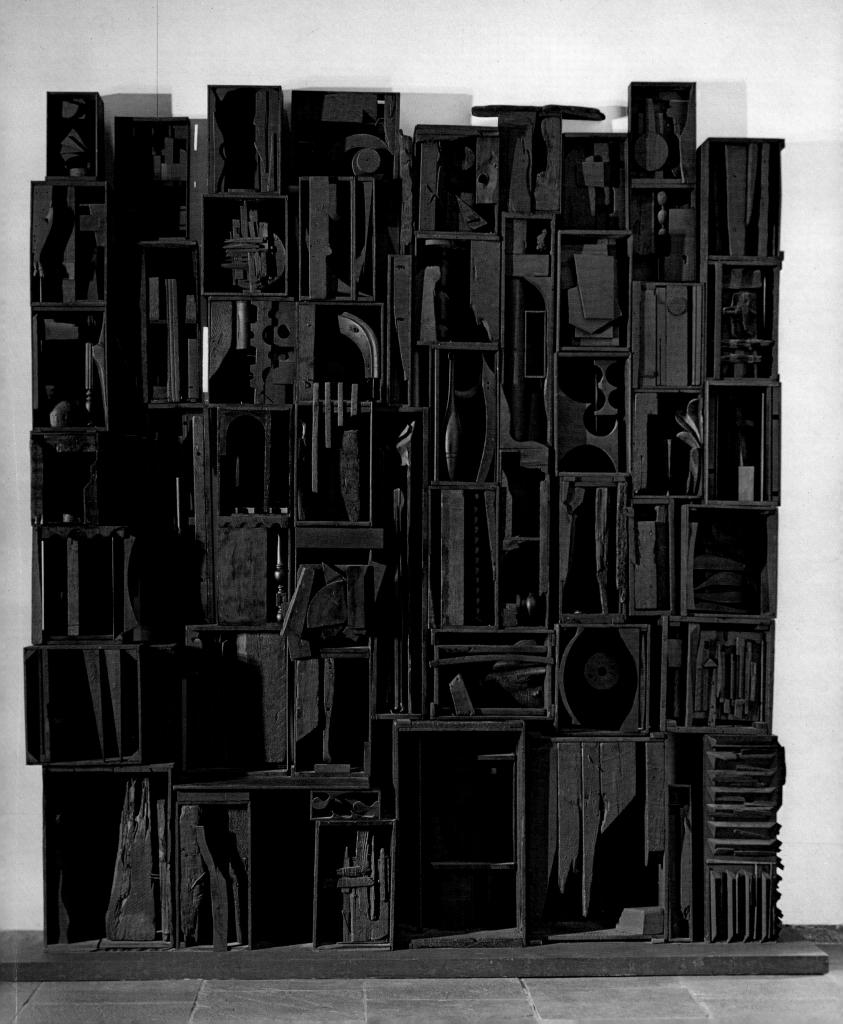

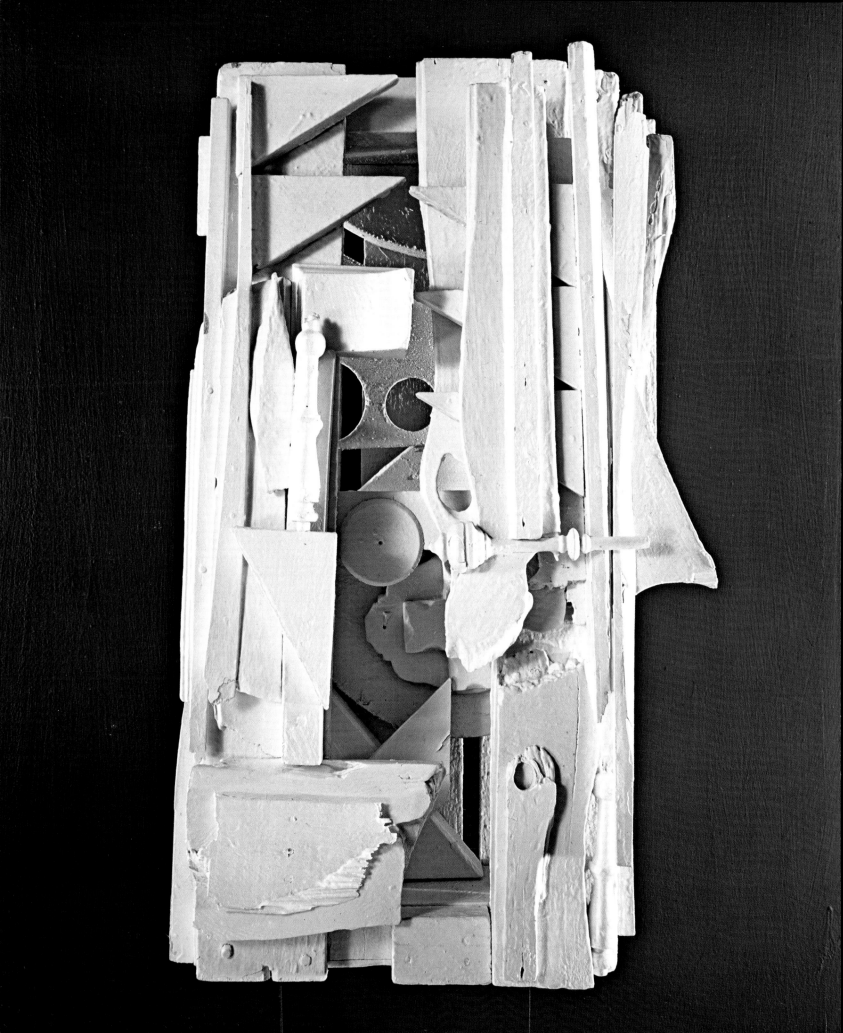

In Munich, Nevelson attended drawing classes daily. There were only about twelve students in her class including the American painter Ludwig Sander. Hofmann visited the class once a week, but his assistant was there every day. Although her stay in Munich assured her of freedom, she was disappointed by Hans Hofmann. Perhaps it was because Hofmann was preparing to leave Munich that his legendary enthusiasm was at low ebb. "When I was in Munich Hofmann was trying to get out of the country and I'm sorry to say that he paid attention to the students who could benefit his goal," Nevelson recalls. "I don't blame him for that but I had made my own sacrifice to come and I was disappointed." It was also difficult for Nevelson to accept a situation that was less than a dream projection, since she had made irrevocable changes in her life to study in Germany.

Nevelson had been in Munich only six months when rising Nazi political pressures forced Hofmann to close his school. She was not yet ready to return to New York without some of the riches she had hoped to glean from this adventure. In Munich, Nevelson's evenings were spent with other artists and students in cafés and cabarets discussing art and politics and singing American music. Prewar Munich was obsessed with American jazz and popular music, and Nevelson knew all the new songs. Her popularity reinforced her self-confidence. Immersing herself in the artistic milieu, she met several people involved in the cinema and was invited to go to Vienna with a friend who was a scenarist.

Nevelson's brief career in the movies developed the nascent quality of theater in her work. She immediately responded to the trappings of moviemaking, preferring the cameras and lights to the acting exercises. However, it was the frontality of the sets, the illusion of space, and the arresting of time on celluloid frames that most strongly impressed her. What Nevelson was reacting to was her first involvement in an art the very nature of which is collage. The multi-elements, synthetic and organic, being directed into a total work corresponded to and indeed may have led the way to the technical evolution of Nevelson's work process; for her mature art parallels cinema in that it is cellular, additive, and an illusionistic projection of space whose very scale rivals the cinema screen. Most of all, it is an art of collage and environment.

Unsatisfied by minor roles in several films, the names of which she cannot remember, Nevelson became bored with the limitations of being an actress; perhaps a lifelong desire to free herself from the limitations of her body was incompatible with a career in which the medium was dependent upon the body itself. More confident, Nevelson left Vienna, traveled through Italy, and finally went to Paris, where she independently studied the masters at the Louvre and the primitive art at the Musée de l'Homme. Alone in Paris, she became subject to periods of severe depression and began to write poems that expressed the essence of her agony, which derived from guilt and self-doubt. The following poem describes the confusion and indecision of the moment:

35

II. *Dawn's Wedding Chest*, 1960. Wood painted white, 27″ x 15″ x 6″.
Collection Mr. and Mrs. Alvin Lane, New York.

PARIS 1931

Why should he who independent be
Go through the universe at sea?
Searching from port to port at sea
Forever for the spot where he belongs.
By every fiber of his being
He searches always where he can
And search for the home that is my destiny.

God made the world and he made me
Then why am I always, always at sea?
Where, where can it be
In space or time.
I can conceive even of flying to a heaven
But no, it is not so!
Humanity is so slow
Far too slow they go.

I continue to be at sea
When I feel reality is no more
Then I do not know which shore to come to.
I do not hear the boats that hum
 to the waves at sea
I do not know which land to land at for
 all to see
And worshipping dead idealtry not reality.

Now can there be such stupidity
In this so-called world of reality
Reality it may be
If all the dirt was burned from there
They that we could really see
At least the hope of reality.

My child, why did it have to be
So that we together be in such mystery
 to each other.
Was it your father?

He who longer than his nose could see
And that too was far too short for reality
When you are older do not scold her.

The need to find a place for herself and the fear of failure was too great and oppressive to bear. Her psychological isolation, coupled with the physical isolation of being away from home, pushed Nevelson to the brink of suicide. There was no alternative other than to go home and, in a sense, end her old life. At the age of thirty-one and with no possibility for a reconciliation with the past, Louise Nevelson was about to fulfill her "readymade" destiny.

Her return to New York was unsettling and forbidding. In emotional upheaval her marriage ended (she was not legally divorced until 1941), and she returned to her classes at the Art Students League. After living in a loft for nine months, painting, sculpting, and drawing, she decided to give Europe another chance. After all, on her last trip conditions in Munich had not been favorable. In the summer of 1932, Louise Nevelson pawned her jewelry, the only tangible asset of her marriage, and used the money to return to Paris (Fig. 4).

4. Louise Nevelson on
 board the *France*, 1932.

Crossing the Atlantic, Nevelson met Louis-Ferdinand Céline and Jean Gabin, who were returning from Hollywood. Céline had been in Hollywood to discuss making a film of his book *Journey to the End of the Night*. He was a Nazi sympathizer, and, as a result, negotiations with the film company had been terminated. With no hope of extending his career into film in America, he returned to France. Nevelson was impressed by Céline's intellect but was totally naive about his philosophy. They became friends. She saw him infrequently in Europe, and their friendship lapsed. Some years later, Céline was in New York and visited Nevelson. Now aware of his philosophy and opposed to it, she received him; they talked about art and Paris. Finally, he proposed marriage to her, basing his proposal on the rationalization that their arts would complement each other. Nevelson knew that Céline really wanted to stay in New York, and marrying an American was the simplest way to achieve this aim. Infuriated, she refused, telling him that he was worth more dead to her than alive, and showed him out. They never met again.

In Paris, Nevelson lived modestly, studying the history of art, painting, and drawing. She was most impressed by Picasso, feeling that he had a special passion absent in most School of Paris art. "Picasso has a Spanish fire and restlessness: he has the soul of a pioneer. French art is too cultivated, each brushstroke contains a tradition of greatness." However, although many opportunities were present, she was too shy to meet Picasso. (Even today, Nevelson rejects refinement, in people and objects. In 1966, when she began to work in plexiglass, a material of extraordinary refinement and elegance, she deliberately marred its perfection by bolting rather than invisibly gluing the elements together.)

Nevelson realized that the aesthetic accomplishments of Paris were history and the vitality of America was the future. "I could be a leaf on the tree in Paris," she said, "but I could be that tree in America." After a few weeks she returned to the United States.

A very different life awaited Louise Nevelson upon her return to New York. Tired, her attitude synchronous with the climate of New York in the throes of the Depression, she moved to a rooming house on Sixty-fifth Street at York Avenue.

She returned to the Art Students League, where Hans Hofmann was now teaching. Nevelson reasoned that, although Hofmann's promise was unfulfilled in Germany, she wanted to study with him in America, where conditions were radically different. Among her fellow students were George McNeil and Burgoyne Diller.

She painted and continued to make the life drawings that are the only works remaining of that period. Perhaps it was easier to keep small drawings, because they could be stored in portfolios, but in retrospect, it is coincidental that inherent in the early line drawings she made from 1930 to 1936 (Figs. 5 and 6) is a sensibility compatible more with sculpture than with painting. Lines traverse and intersect to describe the space. Eccentric scale and proportion are invoked, and usually the head, feet, or hands are deleted for the sake of the composition. In these automatic works, Nevelson is concerned with the relationship of mass to rectangle rather than with the formal anatomical considerations of life class. To her, the figure was clearly the presentation of a complex flexible form to be rearranged or packaged into the rectilinear format of the page. Seemingly influenced by Matisse, whose work was stressed by Hofmann, these drawings do not have the sensitivity of line or the description of contour vis-à-vis that line implicit in Matisse. They also evoke the drawings of Lachaise in their repetition of female subject

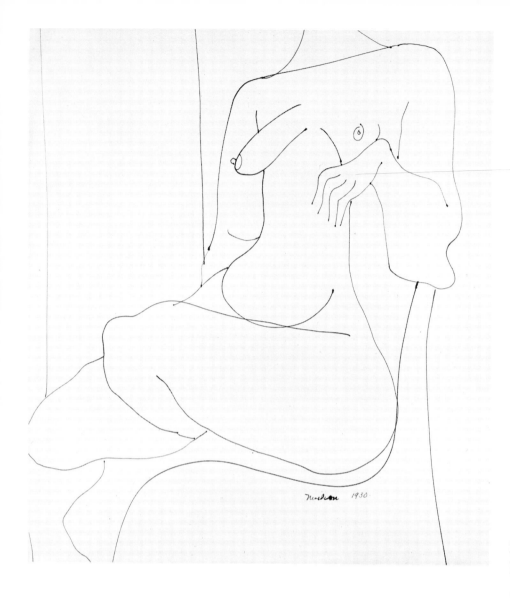

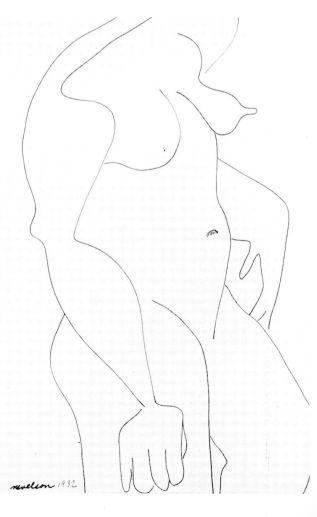

5. Untitled, 1930. Ink on paper, 14¾″ x 12¾″.
 Collection Whitney Museum of American Art,
 New York. Gift of the artist.
6. Untitled, 1932. Ink on paper, 10¾″ x 7¾″.
 Collection Whitney Museum of American Art,
 New York. Gift of the artist.

matter. Like Lachaise's figures, Nevelson's seem larger than life. These drawings are unique to Nevelson, dated only by the simplistic overtones of 1930's style. Most important, they are the first visual indication of Nevelson's compositional preoccupation with packaging the rectilinear or box format.

The New York art world was composed of people who were all immigrants psychologically, and with them Nevelson was able to be more sociable. The artists she met accepted her on her own terms. Her dramatics instructor, Princess Matchabelli, introduced her to the artist-architect Frederick Kiesler, who was part of the refugee-artist influx to the United States and taught stage direction in Princess Matchabelli's school.

The actress and painter Marjorie Eaton, who was in Louise Nevelson's class at the Art Students League, recalls, "I was fascinated by the intensity and beauty of this young woman, and after a week I spoke with her. She invited me to tea at her house on East Sixty-fifth Street, and we became friends. I was impressed by her independence and her ability to remove herself from a destructive situation. She had left her husband, and her son was in military school at the time."

Marjorie Eaton had moved to New York from Taos, New Mexico, where she had spent five years living and painting on an Indian reservation. Nevelson was fascinated with American Indian art. "I love the geometry of their form and the shallowness of their space. They only work in terms of positive space." But, more than this, Nevelson reacted to their act of painting. "The sand paintings are made in a religious context, and they only exist until the wind blows them away." Although her own works are physically permanent, their visual experience is ephemeral.

Through Marjorie, Nevelson met Diego Rivera, who was living in New York while painting the controversial socialist-oriented murals for Rockefeller Center, the Rand School, and the New Workers School on Fourteenth Street (Fig. 7). There was an empty floor in the loft building on West Thirteenth Street in which Diego Rivera and his wife lived and worked. Marjorie Eaton and Louise Nevelson pooled their financial resources and rented the loft space. Together with Ben Shahn, Nevelson became one of Rivera's assistants. The work was not creatively satisfying and drained her own creativity. To compensate for this loss, she studied modern dance with Ellen Kearns, who also had a loft in the same building.

Nevelson has never abandoned the discipline of dance. She has always equated the gymnastic body movements of modern dance with tapping primal instincts in ritualistic celebration. She believes that dance is not only a natural expression but also a natural form of communication. When she began to study dance, it was very difficult for her to overcome the extreme shyness that inhibited her total participation. "We were given an exercise to get down on the floor and leap like a frog. How could I lie on the floor when I was such a lady?" Soon she realized the liberation that came with abandon and could leap like a frog. "Dance made me realize that

air is a solid through which I pass, not a void in which I exist." For Nevelson, the negative does not exist, shadow and solid, visible and invisible, are positive and equal. Colette Roberts, who was her dealer at the Grand Central Moderns Gallery from 1954 to 1959, recalled: "When she was finished installing *Moon Garden Plus One*, her 1958 exhibition, Louise started to dance with her assistant Teddy Hazeltine. You know Teddy was a dancer before he met Louise. It was really like a ritual dance, with slow hieratic gestures."

It was necessary for Nevelson to apprentice herself to Rivera, but she disliked her mundane involvement in techniques and the process of copying small sketches faithfully into a large mural, a method she considered anachronistic. "I mixed paint and applied washes for Rivera," she said, "but there was no life in an art that has no immediacy." She remembers the tedious researching that went into establishing historical fact for Rivera's social-protest paintings and how she felt that it had nothing to do with art. But just as Pollock derived the sense of wall from Rivera's murals, so must Nevelson have become aware of scale while working in her apprentice-

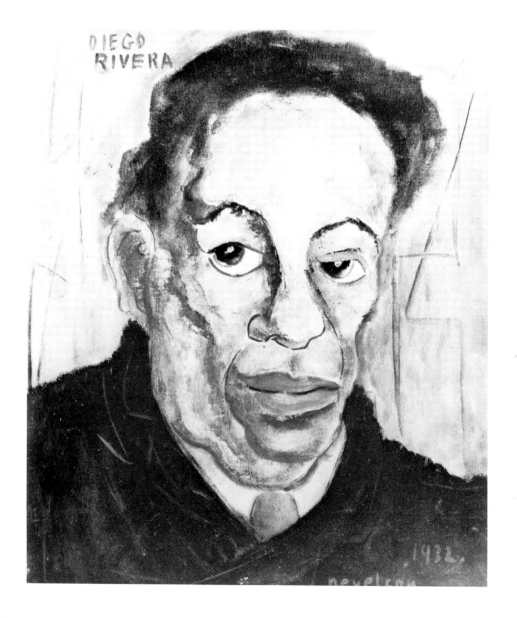

7. *Portrait of Diego Rivera*, 1932. Oil on canvas. Collection unknown.

ship. She was captivated by Rivera and his wife, Frieda, who was a Surrealist painter. Artists and diplomats visited the Riveras, and Nevelson spent most of her evenings at these impromptu salons and learned about the art of Mesoamerica before Columbus.

Nevelson is impetuous, and her impulse is for original ideas rather than techniques, as the life of her own art is in the immediacy of its realization. Her refusal to conform to established disciplines was the impulse for the creation of a discipline of her own.

New techniques are sometimes invented and directions taken because it is impossible, given the temperament of the artist, for him to master the skill or process traditional to craft. It is doubtful whether Nevelson could have existed as so major and influential a talent at a time less tolerant of new ideas. Nevelson herself would probably explain this phenomenon of a sensibility for a certain time by having willed herself upon that time. In fact, it was the virginal climate of New York that made the difference between fulfillment and frustration for her.

Nevelson left the Art Students League in 1933, but as a life member, she had the privilege of attending drawing classes, and she often did. Occasionally, she showed in group exhibitions; in 1935, she showed a Cubist-influenced terra-cotta figure in a group exhibition at the Brooklyn Museum, arranged by the Secession Gallery. This piece was later destroyed, and no photo of it exists. However, it is related to the existing sculptures *Two Figures* (Fig. 8) and *Ancient Figure* (Fig. 9), from the same period.

In the spring of 1936, Nevelson showed a sculpture in a competitive exhibition at the A.C.A. Galleries on West Eighth Street in New York. She was one of four young artists selected from the show who were given an exhibition the following September. The sculptures were made of wood, and her special pictorial concern was evident to the anonymous critic who reviewed the show. "Miss Nevelson, who rounds out the favored quartet, shows drawings and several pieces of roughly stylized sculptures in polychrome wood," the Sunday *New York Times* of September 12, 1936, reported, and continued to describe and assess the works that were subsequently destroyed:

Louise Nevelson is the most interesting of the contest winners. She contributes twelve drawings which, despite their jagged, uneven line, oddly suggest strength and solidity, somewhat in the manner of George Grosz's things. But far more important are five wooden sculptures unlike anything else we've ever seen before, with the exception of one of her figures in the original competition. They are small wood sculptures conceived abstractly and with special concern for the tensions of planes and volumes.

But they are coated with multicolored paints. For example, one arm of a figure is painted blue and another yellow. Or one-half of her chest is one color and the other half another. Now the idea sounds startling. But colored sculpture is far from a new thing. The ancients always colored their figures. The figures on the Parthenon frieze were tinted. But

43

Miss Nevelson uses color as it never has been used before. She applies it abstractly, so to speak, even as though she were working on canvas instead of in the round.

She uses it plastically and structurally to emphasize some planes and de-emphasize others, to increase the volume of a certain section as it stands in relationship to another.

This critical recognition was important to Nevelson, as it confirmed her own self-confidence.

During the 1930's, Nevelson was nomadic; she lived in no one place longer than a year and a half. Just as soon as she established herself in a studio and made it her own home by the accumulation of her own works, she moved on. Critical of her work, the plethora magnified her dissatisfaction and gave rise to the need for territory to fill by building sculptures of greater harmony. The process of environmental accumulation was already operant in the early 1930's, more than ten years before her first environmental exhibition, *The Circus*. Nevelson was actually evicted from each studio by the awareness that she could no longer create new episodes within the environment of that studio; she constantly needed new stages on which to perform.

Many artists were working on mural commissions for the Works Progress Administration project. To work under the WPA, an artist had to be on relief, and Nevelson was certainly qualified; however, the victim of her own pride, she debated for a year before applying. When at last she joined the WPA, only a year before the program's suspension, there were no mural or sculpture commissions left to be done. Instead, she was appointed to a teaching position at the Educational Alliance School of Art in lower Manhattan.

Nevelson says, "The thirties and early forties were very important to me. More than any specific events standing out, it was a time of searching and finding myself as an artist. I was often depressed and alone, but I was functioning as my own person and that kept me going."

Nevelson continued to work in clay (Fig. 10). Running, dancing, or hieratically posed, right-angled figures, mostly women and often self-portraits, took their energy from the boldness and eccentricity of their over-all outline. It was the direct influence of Picasso that Nevelson was feeling, and the visual approximation of these sculptures to Lipchitz and Laurens is only that of a shared influence.

Nevelson was financially impoverished. She had lived by selling her jewels piece by piece and on money her family sent her; but by the late 1930's, the jewelry was gone. Some sculpture was made in plaster and then cast in stone because she could not afford bronze. Actually, the casual loss or destruction of most of the works of this phase suggests that even had she been able to, Nevelson would not have cast them in bronze, thereby giving them the longevity that attends the medium. Several years later, she cast two or three pieces in bronze and deliberately discarded the others or left them in plaster to disintegrate. This body of works, which began in 1932 and continued through 1941, filled the basement and living quarters of her house on Twenty-first Street.

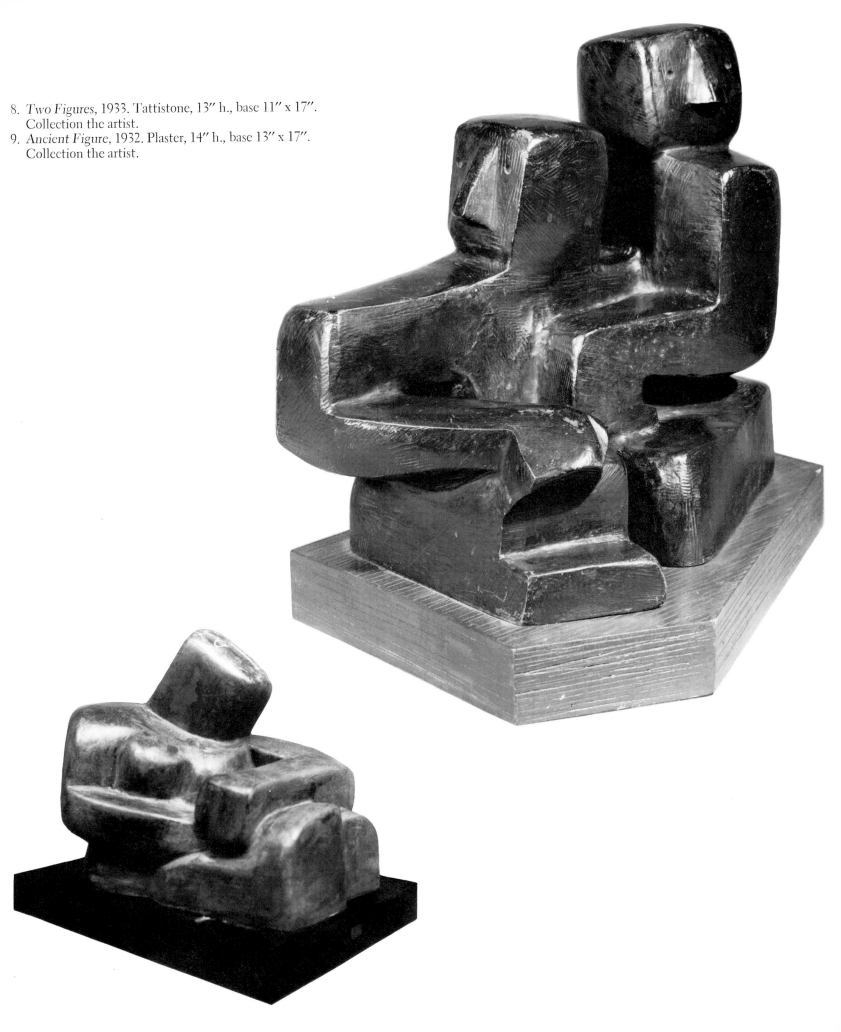

8. *Two Figures*, 1933. Tattistone, 13″ h., base 11″ x 17″.
 Collection the artist.
9. *Ancient Figure*, 1932. Plaster, 14″ h., base 13″ x 17″.
 Collection the artist.

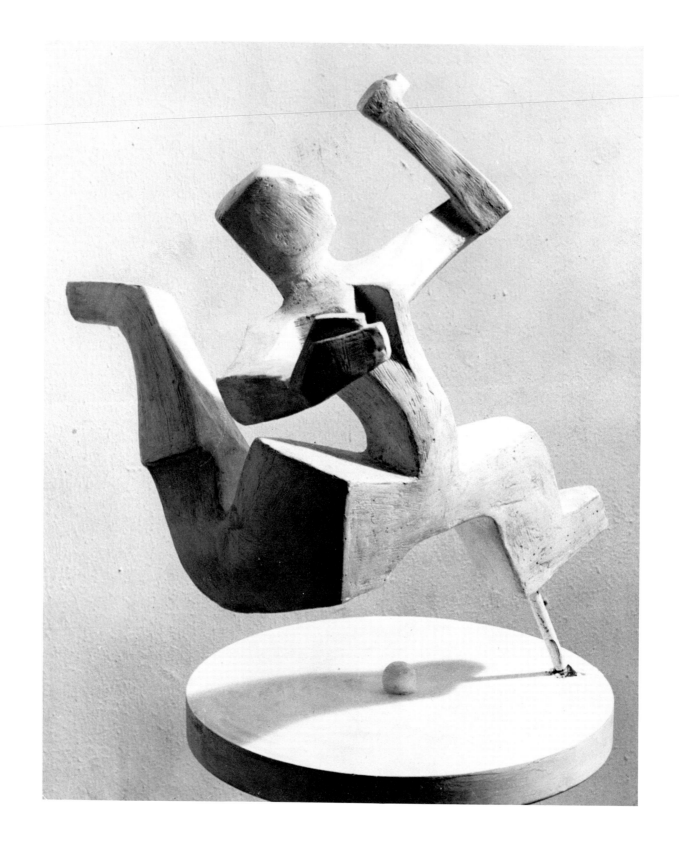

10. *Flight*, c. 1940. Painted bronze cast from original clay model. Collection unknown.

Once during this period, a friend from out of state visited Nevelson in New York. He was newly rich and invited her to dine with him at the Plaza Hotel, where he was staying. "I didn't have five cents but I had an outfit that I could wear and it had been a long time since I had a dinner at the Plaza. It was summer and after dinner a car and driver took us to Montauk, Long Island, where we stayed a couple of days. I suddenly realized that while I was having trouble sustaining myself, he had spent a thousand dollars in two days."

Nevelson reacted violently to those two days and returned to the city determined that the time had come to arrange for an exhibition of her sculpture. The financial and emotional waste of her two-day vacation reinforced Nevelson's convictions, and she felt ready to show the world what she had created and the reason that she had redirected her life.

The next day, after determining that Karl Nierendorf was the most important dealer in New York, Nevelson went to the Nierendorf Gallery on East Fifty-seventh Street. She told him her name, her address, that she was a sculptor and wanted to show in his gallery. Slightly taken aback by her candor, Nierendorf agreed to come to her studio that evening and see the work. "I was so mad that if I had a gun and Nierendorf had said no, I won't come to your studio, I'd have killed him," Nevelson remembers. Nierendorf saw the work, was completely convinced of its quality, and agreed to show it within a month. This was very unusual, as galleries normally plan their calendars a year in advance. Perhaps Nierendorf had canceled another show or co-incidentally had an opening at the time; in any event, he was sufficiently impressed to become Louise Nevelson's representative. "I always go to the best" Nevelson said. "I went to Europe to study with Hofmann. I studied with the best vocal, dramatic, and dance teachers; who else could I go to but to Nierendorf?"

For the next two weeks, Nevelson cleaned and repainted the works. After intensive editing, she selected a compatible group of sculpture and mounted her first one-woman exhibition. This was Nierendorf's first exhibition of an American artist, and it met with a generally favor-able press. *New York Times* critic Howard Devree wrote:

Modern indeed are the forms and rhythms employed by Louise Nevelson in her first exhibition, currently at the Nierendorf Gallery. Having approached her work through the medium of drawing, the artist makes her line felt even when employing heavy low masses that at times are reminiscent of Mayan and certain Near Eastern work. This linear treatment does not prevent her, at times, from indulging in solid, massive, somewhat cubistic figure effects which are embellished with color and topped off with a wax finish. A cat (wood) with thumb-tack eyes seems a trivial inclusion among the more serious and massively architectural pieces, and the color is rather a dubious benefit to some of the pieces. But Miss Nevelson has originality and a rather personal approach to her real problems and has made an interesting start.[*]

* Howard Devree, *New York Times*, September 28, 1941.

47

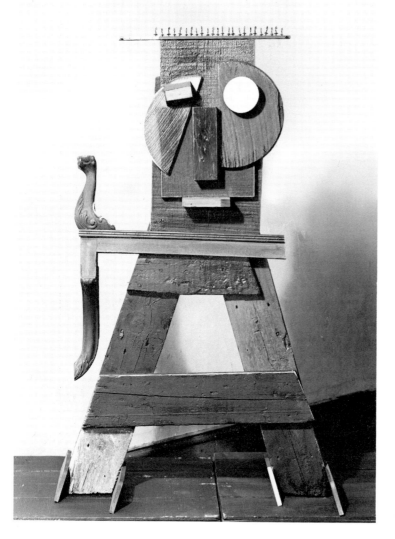
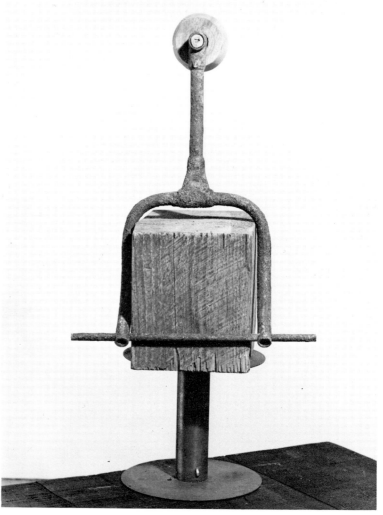

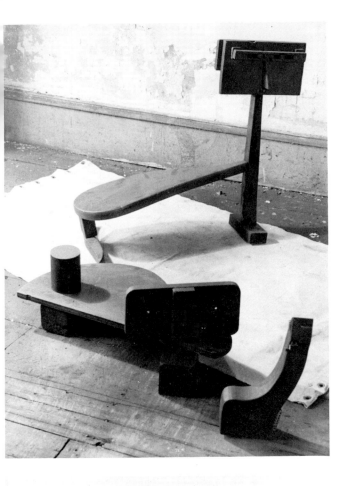

11. *The Circus, Menagerie Animal*, 1942.
 Wood and metal, 48″ x 48″ x 36″. Destroyed.
12. *The Circus, Menagerie Animal*, 1942.
 Wood and metal, 55″ x 45″ x 36″. Destroyed.
13. *The Circus, Seals*, 1942. Wood. Destroyed.

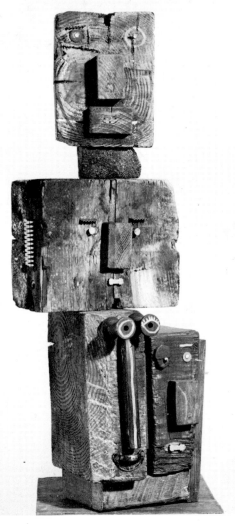

14. *The Circus, Clown*, 1942.
 Wood and metal, 60″ x 36″ x 7″. Destroyed.
15. *The Circus, Clown Tightrope Walker*, 1942.
 Wood and metal, 55″ x 38″ x 24″. Destroyed.
16. *The Circus, Audience Figure*, 1942.
 Painted wood and metal, 60″ x 30″ x 18″. Destroyed.

49

The anonymous reviewer in the *New York Herald-Tribune* wrote:

> Louise Nevelson, who began her professional career as assistant to the Mexican muralist Diego Rivera, is receiving her first exhibition of sculpture at the Nierendorf Gallery. Miss Nevelson injects, about equally, wit and a feeling of the primitive in her work which is stylized almost to the end of pure abstraction—but not quite. One of her heads suggests the majesty of a Mayan Goddess. A composition of closely massed human forms has, on the same trend, a remote suggestion of the mysticism of ancient Mexican art. Cats, with thumbtack eyes, are relatively whimsical, and there is a dancing figure that symbolizes a zestful interest in movement. The work is well off the beaten track, a little mannered, and cleverly done.*

Both reviews refer to Mayan or Mexican art, which continues to hold Nevelson's admiration. The lightly or whimsically dismissed "cat with thumbtack eyes" is of particular interest, since it already makes use of collage elements rather than inherent sculptural line or carving. However, to Nevelson this exhibition was important as a total assemblage rather than as an opportunity to consider the merits of the individual works. There are no photographs of the installation and, to the artist's knowledge, no works remain. It was, however, the first time that Nevelson deliberately created an environment out of her individually made, non-environmentally intended works. The installation affirmed an already present affinity for assemblage. Her only previous total collages had been her studios and their evolutionary accumulations.

Nevelson began experimenting with mixed media and created larger sculptures assembled from wood, metal, and fabric. Chimerical creatures and phoenixes rising from debris began to take form. The individual pieces were in themselves original and accomplished, but as a menagerie, they were unique.

In 1943, they were exhibited in her third one-woman show, a guest exhibition at New York's Norlyst Gallery. She created an environment—a tableau—a theater-piece entitled *The Circus—The Clown Is the Center of the World*. The gallery was hung with antique circus posters, and she placed, within the described arena, wood, metal, and glass assemblage figures. The exhibition announcement divided the show into three categories: *The Menagerie* (Figs. 11, 12, and 13), *The Clowns* (Figs. 14 and 15), and *The World Outside* (Fig. 16). Three-dimensional in fact but largely frontal in attitude, some of the figures moved and contained multicolored electric lights. Nevelson describes *The Circus* and the process of its creation: "I had a circus exhibition at Norlyst called *The Clown Is the Center of the World*. It was partly inspired by a clown's head that I bought in a Third Avenue junk shop. I also used an element, from floor to ceiling, that was once an old sign. It was an enormous pair of scissors that I

* *New York Herald Tribune*, September 28, 1941.

III. *Royal Tides II*, 1961–63. Wood painted gold, 94½″ x 126½″ x 8″ Collection Whitney Museum of American Art, New York.

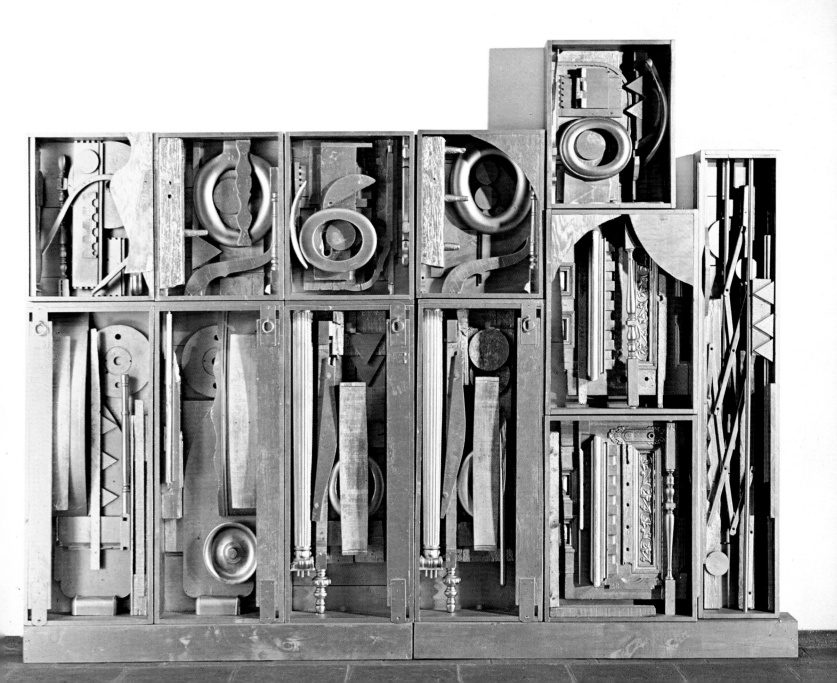

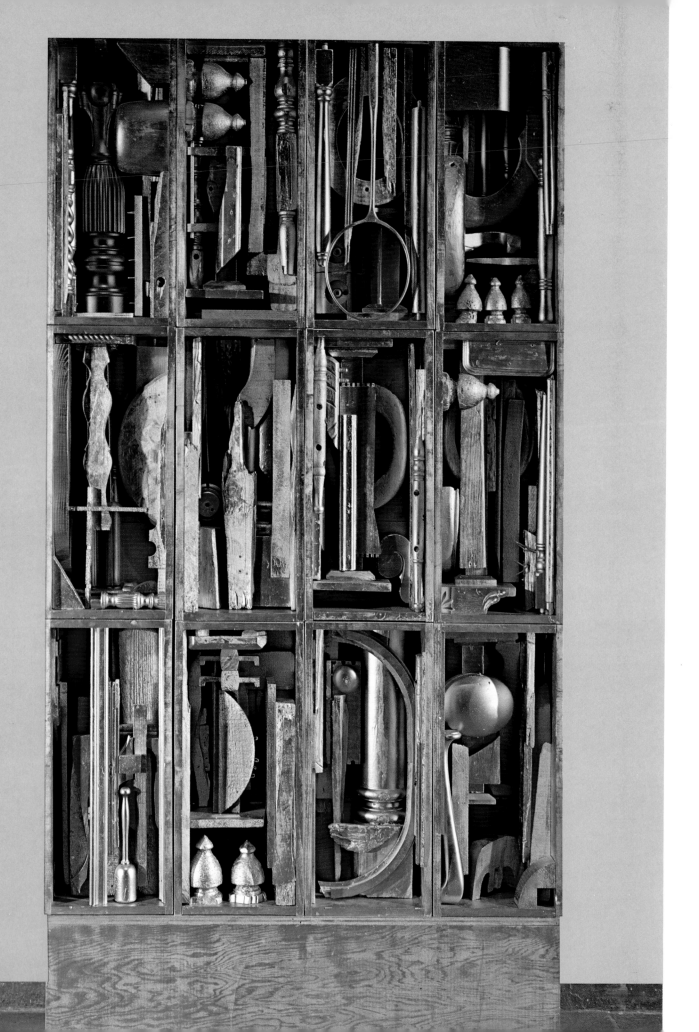

bought on the Bowery. I attached it to the grinning clown so that she appeared to be cutting and sawing. Then I had a group of figures, taller than I am, and I painted them white. One figure was weeping and on its head there was a gold piece of furniture for a hat. I broke up mirrors and drilled and attached them so that they became tears of different shapes; few at the top and full at the bottom. I used the headboard of a bed and I put lace on it. I took the up-holstery off a chair and used the frame for the figure's head. The head could move from side to side because I never attached it. And then there were animals. This was the world, so of course there were animals. I placed them on big round tree slices. Underneath the slice I attached furniture casters and a rope so that you could pull them and move the animals all over the place."

Nevelson's circus was influenced by Surrealism but not the psychoanalytic Surrealism of Breton, Magritte, and Dali. She was intrigued by the surreal tableaus of isolation that could be found in window displays. The frontality of window space, a painterly concern, has always been in Nevelson's work. She was aware of the Surrealists for years, but she was not consciously sympathetic to them. In 1936, she attended the exhibitions *Fantastic Art—Dada and Surrealism* and *Cubist and Abstract Art*, organized by Alfred Barr at the Museum of Modern Art, but it was not until 1942 that she began to construct her own unfamiliar landscapes, the same year as the exhibition of the First Papers of Surrealism. It was the automatism of Surrealism's technical procedure, as it differed from the chance concept of Dada or the detached rationalism of abstract geometric art, that most influenced Nevelson. This intuitive manner of process dominated the works of the painters Masson, Matta, Gorky, and, most important, Pollock. However, automatic procedure seems to be the antithesis of assemblage, the art of finding forms within the environment and semiconsciously arranging them. It is the process of arrangement that changes with Nevelson. She dips her hand into piles of debris, like a brush into pots of paint, and, without plans other than a natural predilection for vertical and horizontal axes, automatically assembles a fabric charged with the energy of its feverish construction.

Nevelson's early assemblages lacked finesse of craft. They did not merely break with the tradition of familiar image reference, they also broke with the tradition of craft and materials. In 1943, American art was still in its youth, and, by comparison, appeared superficially amateurish and vulgar. The extreme experimentation that dominated the scene was aided by the absence of a market to satisfy the financial needs of the artists and inhibit the natural evolution of their work. Had commercial recognition come earlier it could have stultified the growth of American art or at least fixed the artistic pattern too early in its development. Commercial recognition and financial rewards can confirm an artist's direction and prematurely end experimentation, just as too much critical attention can destroy the developmental pattern of an artist's work. The danger is the promotion of virtuosity at the expense of adventure. The Abstract

V. *Night Music A*, 1963. Wood painted gold, 95″ x 51″ x 9½″.
Collection Mr. and Mrs. Richard H. Solomon, New York.

Expressionists in general were reassured by the fact that their art did not have the approval of the bourgeoisie.

"Ours was an immigrant generation of artists and there will never be another quite like it. We were curious about technology but we were spared its infinite limitations." Nevelson's statement is an indication of the extreme self-knowledge of the New York art world of the 1940's and the early 1950's. Artists were driven by intuition and intellect to create a rich indigenous art. Absence of any great art ancestry and predigested history nourished the experimentation and the extension of sensibilities and perceptions already insinuated by or emerging from European artists, including Breton, Masson, Léger, Mondrian, Hofmann, and Matta, who transported the European art center to New York during the war. There was never a generation more susceptible to new ideas or more predisposed to their assimilation and original application than the artists who emerged during the Abstract Expressionist era. The need to succeed on a superior level has always been a positive quality of the immigrant, and this quality was greatly compounded in an immigrant woman artist. Louise Nevelson's sense of personal history and her entire identity have been nourished by her roles in the establishment of precedents for women artists. In 1941, a review of Nevelson's first show at Nierendorf by *Cue* magazine revealed a bigoted attitude and outraged her:

> We learned the artist is a woman, in time to check our enthusiasm. Had it been otherwise, we might have hailed these sculptural expressions as by surely a great figure among moderns. See them by all means—painted plaster figures and continuous-line drawings that take much knowledge from Picasso and Ozenfant and from Mayan and Indian expressions. I suspect that artist is clowning—but with what excellent equipment artistically.*

Although the initial reception of Nevelson's clown show was favorable, it was not surprising that none of the pieces were sold. At the end of the exhibition, a dejected Nevelson dismantled the installation, and the works were trucked to her Tenth Street loft, already crowded by the artist's new work. This proliferation of sculptures left little room for her to work and less room to live. Her necessity to continue creating new works resulted in her decision to destroy the entire circus. After saving elements that she would again use, she set fire to all the other sculptures in the lot in back of her loft building. The absence of these works is a loss, as they would help document the complex development of Nevelson's art. To Nevelson, they were unimportant, for she does not feel the need to save her works for documentation. The fact that she deliberately burned this show and that so few works exist from her early development implies that, in 1943, her editorial hand was assuring that history would only record precisely what she intended.

* *Cue*, October 4, 1941, p. 16.

17. *Self-Portrait*, 1938.
 Oil on canvas, 48″ x 36″.
 Collection the artist.

18. *Portrait of Mike Nevelson*, 1938–39.
 Oil on canvas, 36″ x 24″.
 Collection the artist.

Nevelson has always been very prolific, and the way she works is suited to evolutionary refinement within a series. Nevelson does not continue working on a single piece, refining and remaking the same elements over and over again. She rather sees and enjoys the "flaws" and is inspired by them to create successive pieces. Piece number ten in a series may be more simplified than number one, for as the series progresses she reduces the images to their essential geometry. This does not diminish the quality of the earlier effort but sets up a discipline that keeps Nevelson fresh and agile, juggling and removing elements but still maintaining the energy she began with. The result is basically ten fresh works for most artists' one.

Apprehensive that the critics and the general art community would be outraged and aesthetically unprepared for the clown show, Nevelson simultaneously exhibited her familiar line drawings at Nierendorf. This was an unnecessary antidote to public reaction to the circus, but she was taking no chances.

Nevelson is an artist of extremes, whose work is volatile to the point of unpredictability. One year after the circus exhibition, she exhibited a series of oil portraits of herself (Fig. 17), her child (Fig. 18), and her friends, painted during the preceding few years. A synthesis of the discipline of Cubist space and the irrational form and color distortion of German Expressionism resulted in paintings reflecting current stylistic trends. As in the line drawings of the early 1930's, her concern is for the rectangle of the frame rather than the concept of special images placed within a magic window. Color only differentiates forms, as layer upon layer of overpainting almost cancels out color completely as a vital spatial force. For Nevelson, texture was the most important element in her paintings. Multiple layers of glazes reflect light from the smooth surfaces, and, in contrast, the highly textured surfaces absorb light. Uncertainty and spontaneity are both readily visible in these works. Decisions were made and altered directly in the paint, and occasionally Nevelson's impatience with the medium reveals itself in excessive overpainting to the point of murkiness. The two-dimensional surface could not satisfy her. She was confined by the limitation of painting, but fascinated by its spatial illusions. But for Nevelson, painting was an object within the room and not the space itself. Although her contemporaries were painting in heroic scale, Nevelson never created paintings larger than 3 by 4 feet.

In October, 1944, Nevelson's show of abstract wood assemblages opened at the Nierendorf Gallery (Fig. 19). The following is a review by Emily Genauer:

A second show at the Nierendorf consists of sculpture and montages by Louise Nevelson. In few instances has Miss Nevelson carved her own shapes. Instead she has taken existing objects, a wooden duck decoy, a hatter's block, a chair rail, a ten pin, sanded them down and assembled them into complex constructions of astonishing interest and variety [Figs. 20 and 21]. Sometimes she gets confused, as in "Half Moon," where the architectural elements she secured from a woodcarver's shop are too complicated for her larger design,

but in "Three-Four Time" [Fig. 22] she is very successful. Here again she uses machine-carved motifs, but here, used wrong-side up, they marvelously suggest, in their repetitions, the string section of an orchestra.*

They were ghostly, surreal landscapes filled with bouquets, phantom skyscrapers, and frozen temporal balancing acts. In retrospect, these were miniature environments. However, the works still related to familiar sculptural concepts in that they were brilliantly compositional, interacting with equal emphasis on positive and negative space.

As this series and subsequent related works continued, Nevelson evolved a greater density of forms and a less obvious compositional relationship between these forms. The works of this period were small, reaching a maximum scale of 30 by 40 inches. In 1946, they were in her last exhibition at the Nierendorf Gallery, entitled *Ancient City*. Nevelson's greater concern was for the designation of a name for an entire series (usually in an exhibition) than for naming individual pieces. *Ancient City* is a completely unfamiliar structure that allows contemporary retrospective fantasy. Robert Rosenblum wrote about this work in 1959:

> In a wooden construction of 1945, "Ancient City" [Fig. 23] (now destroyed, like most work of this period), the premises of her later achievement are apparent. Raised on a primitive wooden pedestal, the weathered majesty of an exotic ancient metropolis is re-created by a pair of ceremonial lions and a totemic baluster column which still ennoble these strange, hovering ruins.†

Nevelson's landscapes evoke the sculpture of Giacometti, although she was not familiar with his work. There is an immediate association with *The Palace at 4 AM* (1932–33). However, it is his work of the late 1940's, specifically *City Square*, that bears closer comparison to Nevelson's landscapes. Giacometti's plazas and Nevelson's landscapes both appear to be viewed from a great distance, and the extreme miniaturization of landscape isolates the works and makes them inaccessible. His later sculptures of a disembodied arm and leg suggest fragments from ancient civilizations. In this same absence of specific time, Nevelson's works convey an intense loneliness.

Karl Nierendorf was a man of vision and provided Nevelson with the luxury of protection. She did not really spend much time with Nierendorf, but his attention was in itself supportive. In 1948, Nierendorf went to Germany on a business trip and upon his return made an appointment to see Nevelson to discuss her next exhibition. The night before her appointment, Nevelson received a call from a friend who announced, by way of consolation, Nierendorf's death.

* Emily Genauer, *New York World-Telegram*, October 28, 1944.
† Robert Rosenblum, *Arts Yearbook*, III (1959). *Ancient City* has subsequently reappeared and is now in the collection of the Birmingham Museum of Art.

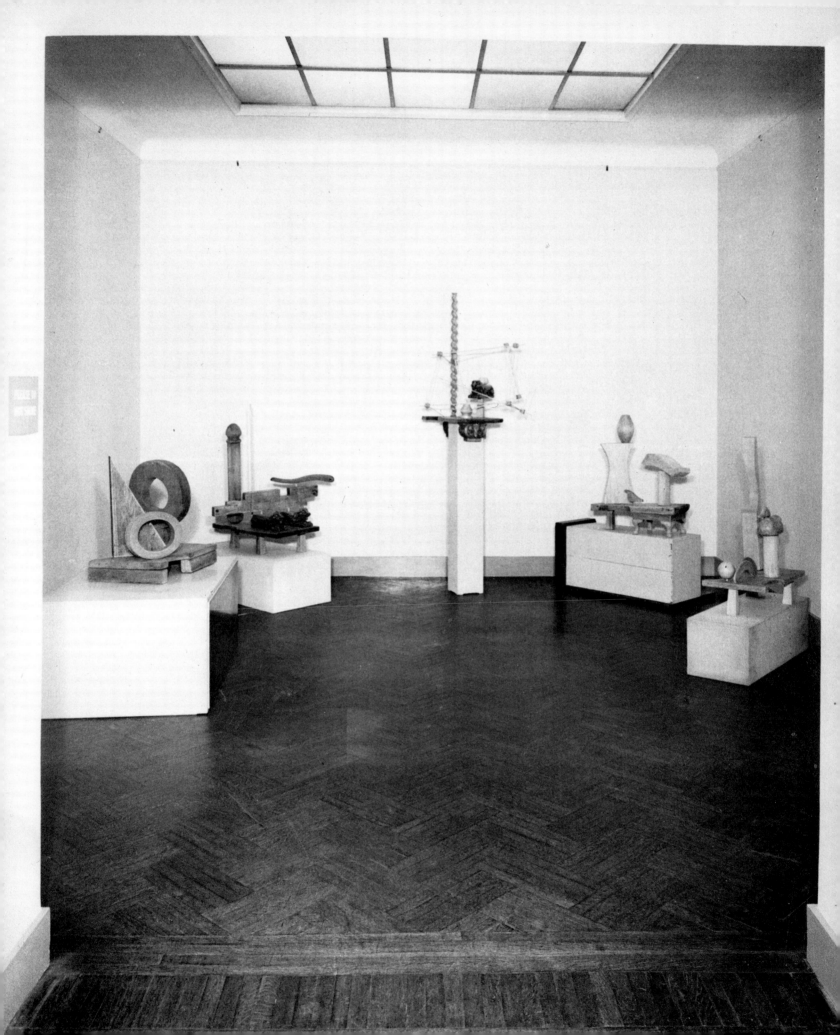

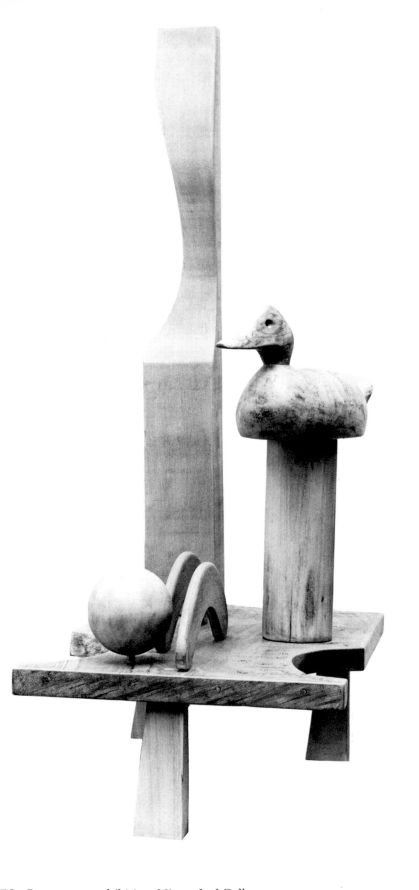

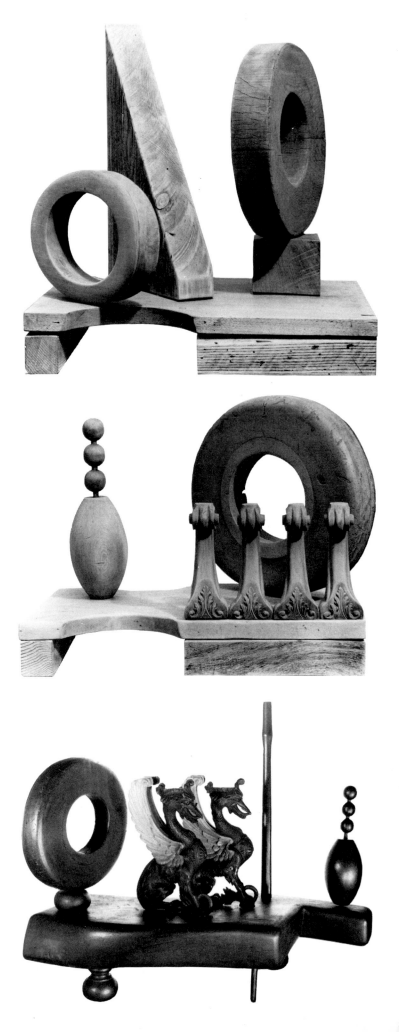

19. One-woman exhibition, Nierendorf Gallery,
 October–November, 1944.
20. Untitled, 1944. Wood, approx. 40″ x 24″ x 24″. Destroyed.
21. *Time to Spare*, 1944. Wood, approx. 24″ x 36″ x 18″. Destroyed.
22. *Three-Four Time*, 1944. Painted wood, approx.
 20″ x 40″ x 16″. Destroyed.
23. *Ancient City*, 1945. Wood, 36″ x 42″ x 20″.
 Collection Birmingham Museum of Art, Birmingham, Ala.

In disbelief, she waited for the morning papers hoping that the force of her natural instincts could fulfill her wish and avert reality.

Nierendorf's death was debilitating for Nevelson, and she produced less and less work. She became ill and underwent surgery for the removal of an internal tumor that she feared was malignant. It was not. After a period of recuperation, Nevelson and her sister Anita Berliawsky went to Europe, traveling through England, France, and Italy.

Uncertain of her future, without assistance, and unable to manage the heavy pieces in a weakened condition, Nevelson stopped working in wood. Concerned friends suggested that she work at the Sculpture Center on Eighth Street.

At the Sculpture Center, she worked in clay, but rather than directly sculpting a total image as is usually done in the medium, Nevelson spread the clay flat and cut unmolded forms like cookies from dough. Textures and surface lines were applied by pressing fabrics and drawing

24. *Personage One Plus Two*, c. 1947. Ceramic, incised black glaze, 24″ x 16″ x 9½″. Lydia and Harry Lewis Winston Collection (Mrs. Barnett Malbin), Birmingham, Mich.
25. *Moving-Static-Moving-Figures*, c. 1947. Terra cotta, 18″ h. Collection Whitney Museum of American Art, New York.

with a sharp tool into the wet clay. She intuitively made an inventory of images that she would later rediscover and utilize as components for additive totems. Stylized faces, triangles, rectangles, and torsos combined into totemic pieces called "Game Figures" (Figs. 24, 25, and 26), later renamed. The elements were stacked one on top of the next and attached with dowels that allowed most of the elements to turn on their axes in changing relationships. The stacking of the elements was premonitory of the stacking of the box assemblages; however, the visual configurations of the total images related more to Nevelson's early line drawings and paintings.

In these unexpected works, there is a minimum of spatial consideration and the artist's dominant interest is in their flatness and frontality, and the few figures that do not move have been fixed frontally, the side view offering no interest or image, only a vertical presence in the thickness of the clay.

26. *Moving-Static-Moving-Figures*, 1947–48. Terra cotta, 23½″ x 19½″
 x 9″. Collection Whitney Museum of American Art, New York.
27. *Cat*, 1949–50. Marble, 12″ x 13″ x 14½″. Collection the artist.

28. *Flower Queen*, 1953. Etching and aquatint, 20″ x 15½″.
Collection Pace Editions Inc., The Pace Gallery, New York.

Concurrently, Nevelson produced four marble sculptures. "There was a courtyard to work in at the Center," she recalls. "It was summer and I could sit out there in the sun with my shoes off and let the stone decide the form." Nevelson does not seem to master the medium in these works, but their isolation within the context of her work implies that the medium did not interest her. She submitted too easily to the form suggested by the outline of the stone. After completing the modeling process, she drew or superficially cut into the surface and indicated such visual signposts as the eyes of a cat (Fig. 27). The line seems superfluous to the carved form. However, Nevelson is not a carver, and by the time she finished laboriously carving and smoothing the marble, the lack of immediacy in the process made her respond by impetuously applying surface detail in order to claim the work as her own, an action not unlike carving graffiti on a tree. It is an assertion of the two-dimensional surface that is perceived frontally and separate from the whole. Later, in 1955 and 1956, she produced wood assemblage landscape pieces and randomly applied linear pattern to the surface. The pieces were stained black and dark brown, and india ink was used to marbelize the surface. As the carved lines detroyed the totally natural effect of the marble, so did Nevelson overpower the natural grain and internal organization of the wood with ink.

The period from Nierendorf's death through the clay and marble pieces was difficult. Her own poor health, though temporary, appears to have abruptly and unexpectedly contributed to the interruption of the logical evolution of her sculpture. Just when she had claimed the properties of assemblage as her own and started to employ them in a totally personal direction that should have logically led to the production of her wall sculptures, eight to ten years before they happened, Nevelson came to a standstill. She was helplessly treading water and re-evaluating herself in techniques that never interested her and with which she was philosophically discordant.

In 1947, Nevelson worked at Stanley William Hayter's Atelier 17, a studio established by the English artist for etching. She recalls, "There were so many tools to use on this line and that field that I wondered if I was learning to make etchings or to be a surgeon." Hayter's approach to etching was ritualized and classical, and Nevelson was not ready to work within so confining and, for her, uncreative a discipline as etching appeared to be. She worked there a short while, to return three years later, in 1953, after Hayter went back to England. Only then did Nevelson produce a series of visually and technically original aquatints. This time she disregarded the prescribed use of the tools and etched lace and rag imprints into copper plates (Fig. 28). She was once again bending the medium to her sensibility of collage, the art of selection that dominates her life.

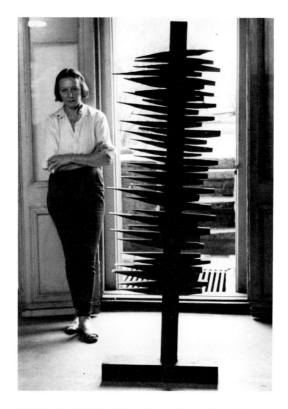

In 1943, Nevelson bought a house on Thirtieth Street with an inheritance left by her father and rooted herself, installing objects she had accumulated since the 1930's, notably her large collection of Eilshemius's paintings, and African sculptures (Figs. 29, 30, and 31). "It wasn't grand but it suited me," she recalls. "The neighborhood was known as politician's row, with lace-curtain Irish. The house was simple, it had spacious rooms flowing into each other that created a large space. Even then I didn't have big rooms, dining rooms, bedrooms. I had space to live in and a bed to sleep on. The most remarkable part of the house was the garden. There were twisted scrap-metal sculptures scattered about and lots of metal tools stuck in formation in the ground (Fig. 32). On one side I had the different tools and opposite I had what was like a Japanese garden. There were wood chunks, great big chunks, painted black, placed one next to another (Fig. 33). Then I took all kinds of wooden cooking spoons, and I painted them black. You could buy them four for a quarter. In one area where I clustered all these different spoons, I called it the Farm, because the house had a red barn bordering the property facing the garden. I placed pieces of found discarded wood on the barn wall and I made a whole mural of found objects (Fig. 34). I also used mirrors, and there were trees, radishes, and cucumbers. The earth was rich and I had snowball trees. I got mirrors and I stuck them in the earth so that they reflected the sky. The most interesting thing was that there were strange unexpected light sources in the earth, and I reversed heaven and earth. It was, because they weren't too big and they were unexpected and they were a surprise.

"There was a ledge that was made of stone which I used for a table. I used to work all summer on sculpture out there (Fig. 35) . I would never go away summers, spring, or fall. So eight months a year I was working in the garden using this sculpture table.

"And as I said, I called this the Farm. With this endless environment, most people would have felt that they had reached something. I am going to tell you that I didn't reach what I wanted. It was not that good. I enjoyed living with the collection of paintings, African sculpture, and other artifacts and I must say that they lived well in that house."

Many of the African sculptures that Nevelson collected were made of raffia, shells, and wood, and it was the use of the materials along with, to quote Nevelson, "their faults, their powers, and their mystery" that appealed to her. Perhaps her affinity for ancient or alien civilizations is based upon her ability to see their active life as a mysterious reconstruction or an illusion. Recently, Nevelson said, "Illusion permits anything, reality stops everything." She

29. Studio in Nevelson's house on East Thirtieth Street, 1955.

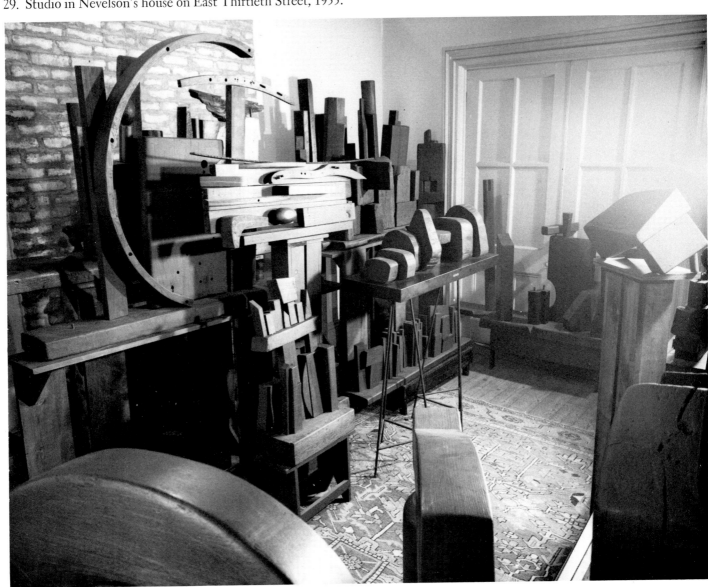

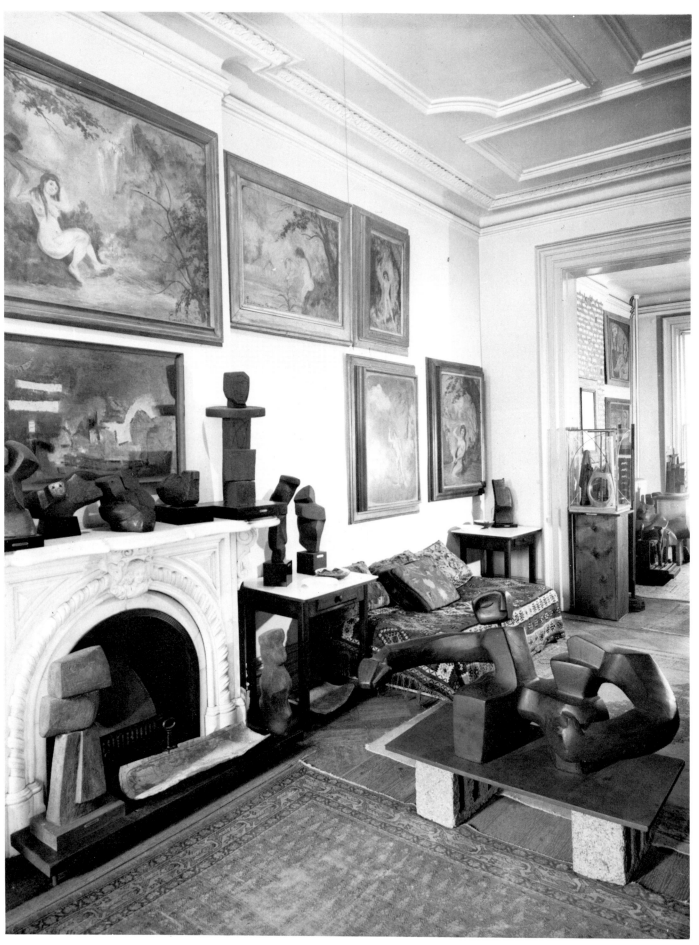

30. Nevelson's living room in her house on East Thirtieth Street, with Eilshemius painting collection.

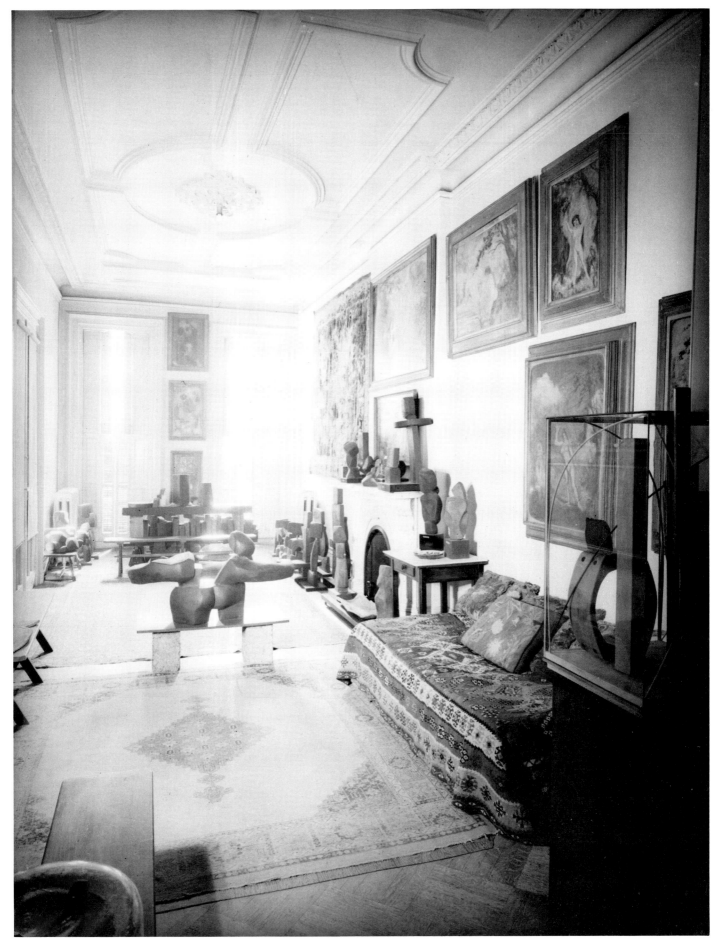

31. Nevelson's house on East Thirtieth Street.

32–35. Nevelson garden at East Thirtieth Street.

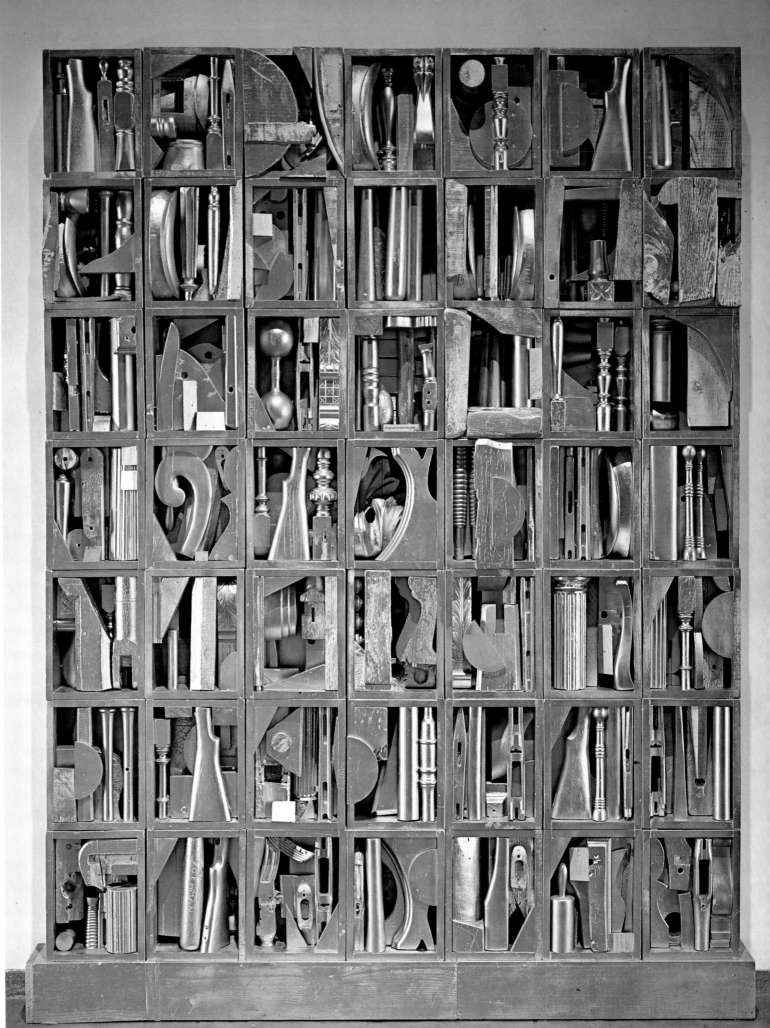

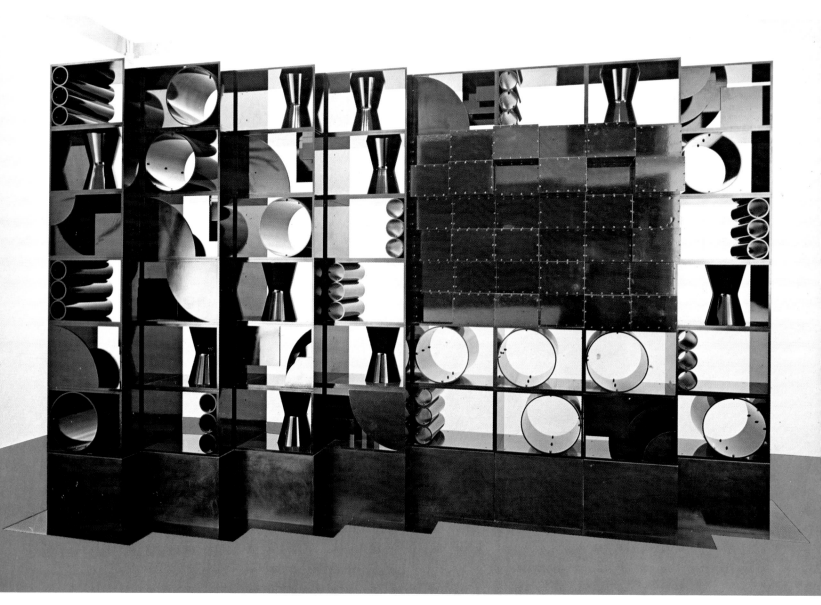

does not believe in words like "inspiration," "masterpieces," and "perfection"; she believes in constant creation. She says, "If you are in a state of creativity you are constantly in that state. Within it there are cycles and when you exhaust that cycle you go on to another one. Everyone has his own powers of recuperation."

In 1950, Nevelson's special recuperative powers were reinforced by two trips to Mexico. Mexico City she found interesting, but Yucatan was the affirmation of her fantasies, and the structural harmony that her own work had been moving toward, before the disruptions that began in 1948. She returned to New York and once again began assembling wooden sculpture and expanding her scale. Anxious to know more about Pre-Columbian art, she visited an exhibition of two monumental Pre-Columbian steles at the American Museum of Natural History in New York. The structural descriptions of surface calligraphy and geometric imagery so impressed Nevelson that she returned to Mexico to see the actual sculptures. She and her sister Anita traveled inland by train and stayed on a banana plantation for a few days. The original steles were disappointing. They lost the scale and spatial imposition that their presentation in the confined space of the Museum of Natural History gave them, and the surrounding natural landscape was an intrusion. "The power of Pre-Columbian art was an immediate identification," she reflects. "In my consciousness I always knew they existed and they were only a confirmation of that awareness." Underlying this immediate identification was her relationship with Diego Rivera and his introduction to the art of Mesoamerica. "I say Egypt and you see Egypt—I say Mexico and you see Mexico," she said. The later, so to speak, real confrontation with the images reconfirms her awareness of them but can never equal the fantasy of the photographic illusion as it existed at a given time. Nevelson reads images in terms of light and shadow, which is in itself an illusion of the third dimension. The real, insistent, three-dimensional object is less real or spectacular than the frontal flatness of its reproduced image and infinite possible options. She does not acknowledge that the reproduction is less real than the object itself; rather, she senses that the expanding consciousness of man continually changes the concept of reality. It is this concept that continues to alter her vision.

Once her friend and early patron Howard Lipman showed her an early American rocking chair that he had just acquired. He asked Nevelson's opinion of the chair. "I couldn't care less about the chair," she said, "but look at its shadow." She moved to the window, and, looking at the panoramic view of New York, she said, "Why do you need this when you could buy a penny postcard?"

"If you believe that the act of creation is living, you don't demand perfection. You only try to get closer to great harmonies." Like the archaeological discovery of a Pre-Columbian city,

71

V. *Dawn*, 1962. Wood painted gold, 127″ x 94½″ x 7½″.
Collection Pace Editions Inc., The Pace Gallery, New York.
VI. *Atmosphere and Environment I*, 1966. Aluminum, black epoxy enamel, 78¼″ x 144⅜″ x 48″.
Collection The Museum of Modern Art, New York. Mrs. Simon Guggenheim Fund.

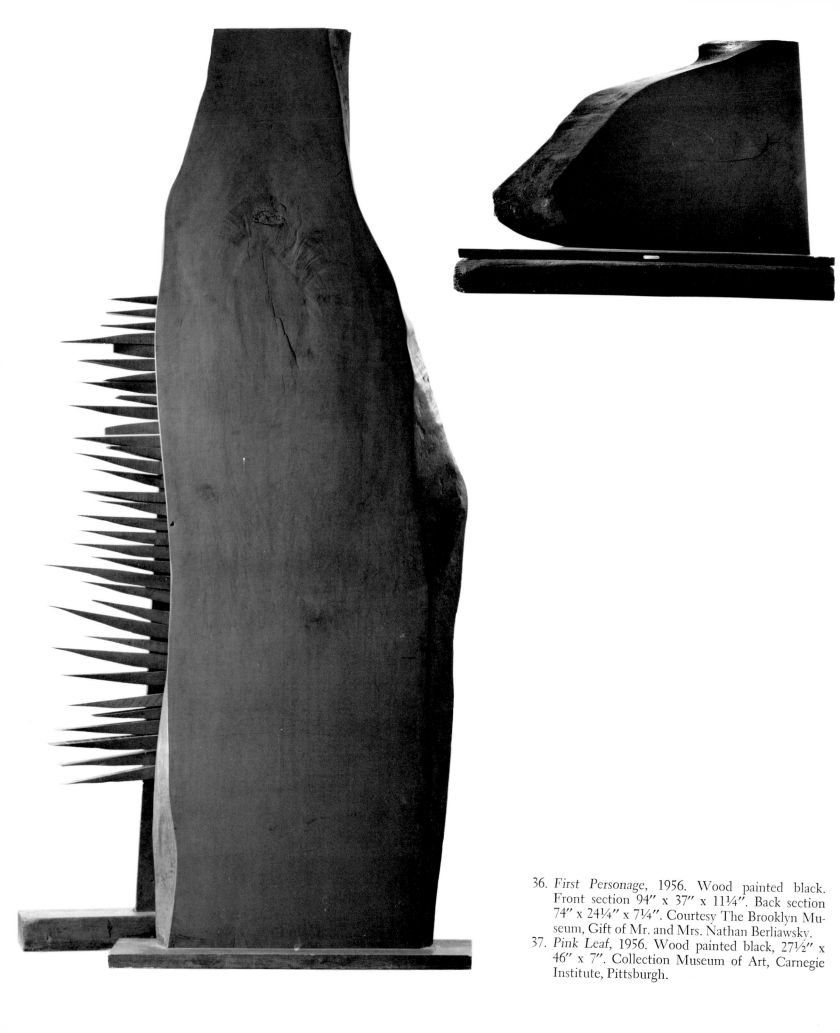

36. *First Personage*, 1956. Wood painted black. Front section 94″ x 37″ x 11¼″. Back section 74″ x 24¼″ x 7¼″. Courtesy The Brooklyn Museum, Gift of Mr. and Mrs. Nathan Berliawsky.

37. *Pink Leaf*, 1956. Wood painted black, 27½″ x 46″ x 7″. Collection Museum of Art, Carnegie Institute, Pittsburgh.

stilled by time and devoid of life, Nevelson unearthed her vocabulary in the more recently abandoned artifacts of society. Momentarily lifeless, the presumptive language in the form of duck decoys, chair legs, and furniture-factory waste products became media. Table landscapes, closely related to her work of the late 1940's, appeared in a seemingly unbroken continuum of places that, in their loneliness and economy, serve as plazas for the silent coalescence of geometric and organic forms. As the landscapes simplified from recognizable elements to a repetitiousness of spikes and cubes and, finally, to single found natural forms selected and presented with almost no alteration, Nevelson now unified all of her images with a single bonding layer of black paint. Previously, she would occasionally allow the history of the elements, the natural patina, to interact within her compositions. The most impressive and stylistically isolated work of this period is *First Personage*, dated 1956 (Fig. 36). This landscape piece, through enlargement, is metamorphosed into a figurative image, in much the same manner that a cloud suggests a configuration. Like *Pink Leaf* (Fig. 37), of the same year, it is a slice of wood, the silhouette of which is the natural outline of the lumber slab itself. The slab in *First Personage* is placed in front of a vertical two-by-four of the same height, which appears to have horizontally skewered a complement of wooden thorns. This is Nevelson's first single large-scale work.

After Nierendorf's death, Nevelson made no firm gallery affiliation, and public awareness of her work diminished. Her friends generally considered that her moment of greatness had passed unfulfilled, a situation not uncommon among artists. Between 1946 and 1955, she seldom exhibited, and then only minor sculptural works and prints.

Despite her withdrawal from the gallery scene, Nevelson's house on Thirtieth Street became the salon for a weekly series of panel discussions on the arts known as the Four O'Clock Forum. It was organized in 1952 by Will Barnett and Steve Wheeler to disseminate ideas other than the dominant aesthetic currency of Abstract Expressionism. They were hard-edged painters, specifically interested in integrating North and South American Indian iconographic imagery into abstract American painting. They called this the Indian Space School. Will Barnett recalls, "We were interested in the Indian use of negative space which was on equal terms with positive space. We sought to abolish negative space. The magazines like *Art News* were deeply involved with the Abstract Expressionists, and we needed a vehicle of our own." Sundays at four o'clock, artists were invited to listen to a panel discussion. One artist was invited to moderate a panel of his own selection. Ad Reinhardt, Peter Busa, Willem de Kooning, Mark Rothko, Max Weber, and Richard Lippold were among the panelists. There was no membership, and this loosely organized group was tolerant of all contemporary sensibilities. The Four O'Clock Forum lasted through the late 1950's and had a role in the development of Nevelson's work.

One of the group exhibitions that Nevelson participated in was held at the Grand Central

Moderns Gallery in 1953. During the next two years, a rapport developed between Nevelson and the director of the gallery, Colette Roberts; in 1955, Nevelson formed an exclusive association with Grand Central Moderns Gallery.

Nevelson's first one-woman exhibition at Grand Central Moderns in 1955 was entitled *Ancient Places, Ancient Games*. Colette Roberts recalled, "There were figures with movable parts [game figures]. And some were attached to bases of bakelite which had very subtle relationships to the figures. There were wooden pieces of found objects that seemed isolated; linked only by the base. They were standing together like miniature Stonehenges."

The most interesting characteristic of this exhibition in relation to Nevelson's involvement with total environment was that although these individual works were primarily pedestal sculptures, the treatment of the pedestals distinguished this exhibition. A few of the terra-cotta works, the more fragile in visual terms, were placed on ordinary gallery stands. Some works were unexpectedly placed on the floor and others on awkward bases that were actually harmonious but unrelated sculptures. For these bases she used found crates. She altered them by eliminating some of the joining boards, adding triangular corner supports and painting them black. This elimination of pedestals by stacking two unfixed elements and the flexibility of construction within the exhibition were prophetic of her mature style (Figs. 38 and 39).

Two and a half years later, Nevelson's first consciously controlled environment was exhibited. It was named *Royal Voyage* (Fig. 40). Dore Ashton wrote:

> There, kings, queens and things of the sea were symbolized in blocky, rough-hewn forms that gained a dimension with the introduction of associations adhering to the theme. In this visual tale, the royal ship is reduced to its essentials; the royal guests ranged frontally as if in formal 19th-century photograph. The sea and the gifts the royal couple bears are characterized with a mixture of satire and fantasy. The pieces were united by the matte black paint with which Nevelson drenched all her sculptures. In this 1956 exhibition, she experimented with tiered forms that were later to become enormous walls.[*]

Of *Royal Voyage*, Colette Roberts recalls that "a totally environmental world appeared, filled with components called gifts of the King that were placed on the floor in front of the window near a sculpture called the 'Queen of the Sea.' She had lots of anthropomorphic pieces painted black that previously hadn't found their way to any given sculpture. They were interesting forms in themselves and she simply placed them on the floor, in a random happening."

As the title implies, the exhibition is more than a show of sculptures, it is a voyage, a mood, a nearly successful attempt to extend the boundaries of sculptures past the limitation of posi-

* Dore Ashton, "Louise Nevelson," *Cimaise*, No. 48 (April–June, 1960).

38. *Eclipse*, 1955.
 Wood painted black, 61½″ x 48″ x 8½″.
 Collection unknown.
39. *Forgotten City*, 1955.
 Wood construction, 85¾″ x 30¾″ x 11¼″.
 New York University Art Collection.

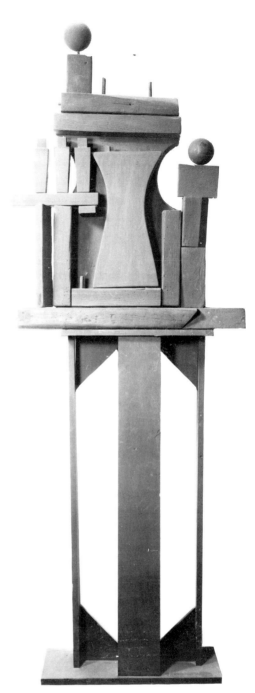

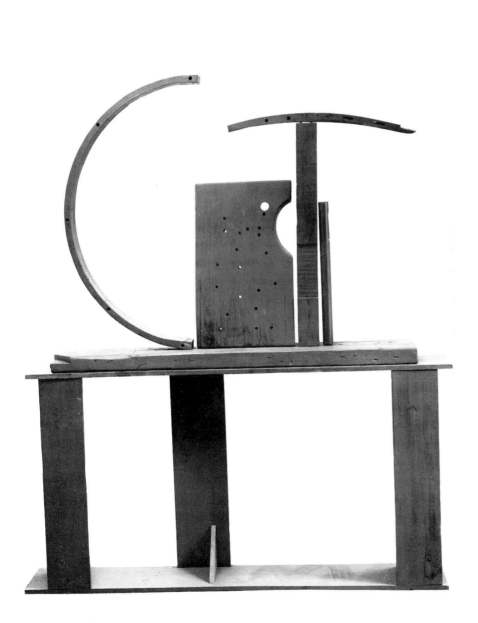

tive and related negative space and into an environment where all the components share equal importance.

Nevelson's rate of production increased enormously. There were really no media alternatives. Wood was the only material that allowed her the spontaneity and impulsiveness her characteristic impatience required. Direct welded metal, at that time, was alien to her sensibility, and she frankly admits that it offended her femininity. But she was impressed by the works created in this medium by Gonzales and Picasso, and she admired the later works being produced, under their influence, by David Smith. There were also practical problems of welding, not the least of which was the expense of materials and the reliance on an assistant to help

40. Exhibition at Grand Central Moderns Gallery. *Royal Voyage*, 1956.

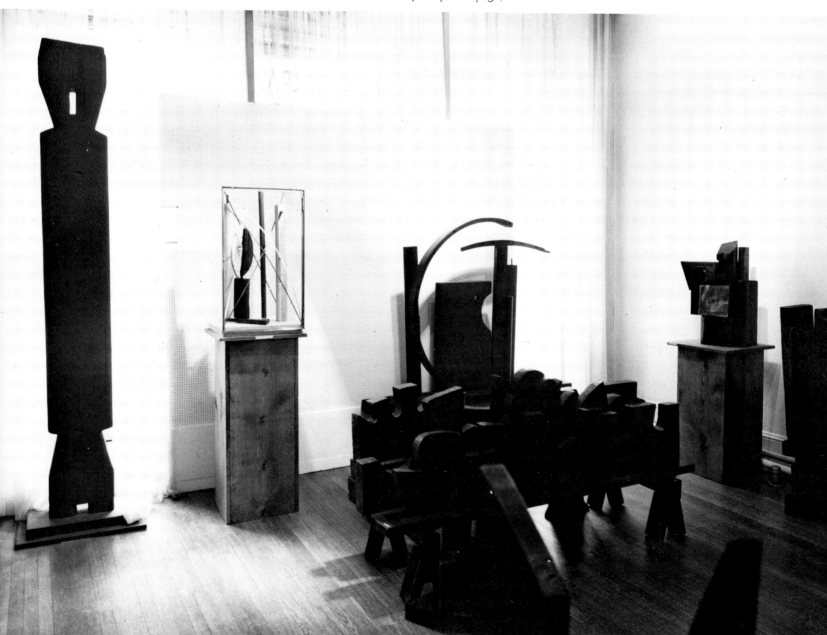

41. *The Towers of Simon Rodia in Watts.*
 Courtesy Los Angeles Cultural Heritage Board.

her lift and secure heavy pieces of steel. The inherent limitations of the medium as it applies to the more experimental sculptural problems that she was to explore environmentally also bear responsibility for her rejection of welded metal and, of course, wood had historical associations.

Nevelson gleans the forms from the detritus of society that satisfy the selectivity of her eye and from which, in a system of interdependency, she creates new images. In some respects, she is a folk artist, akin to Simon Rodia, the Italian tile-setter whose Watts Towers in Los Angeles rise to majestic scale in a tracery of Gothic weightlessness, encrusted with bits of broken crockery, colored glass, mirror fragments, pebbles, and shells supported by an armature of steel and concrete (Fig. 41). Rodia's obsession, not that of a conscious artist, shares with Nevelson's work the unorthodox and obsessive use of material that can only occur without an awareness of art history, or, rather, with the awareness of art history and the ability to overcome it. She views the elements or images that are combined in her work as virginal; she erases all their

77

previous history. The elements are painted black before she begins to work them, equipping her with an inventory of ready forms to combine them instinctively first into units and then complete walls. Even the nails used to fasten the forms together are painted black to prevent any element from revealing its original identity, which, in turn, might superficially and accidentally influence the evolution of the total composition. It is in this manner that the artist eliminates the possibilities of chance that so intrigued the painters of her generation.

For Nevelson, the object's original history does not exist. Exemplary of this was the visit of a major New York architect, who wanted a bronze-casting of a wood wall for a city cultural complex. In an effort to convince her to cast the wood into bronze, he assured her that there would be no restrictions or modifications to her selection of forms. She was against this process at that time, because she considered it alien to her aesthetic. Nevelson was then working in gold, and the oval form that repeated itself most frequently was in origin a toilet seat. The architect said, "You can use all of the balustrades, hat-forms, and toilet seats you wish." Nevelson's unflinching and immediate reply was, "Isn't the halo around the Madonna a toilet seat? Mine are images, not toilet seats."

Beginning in 1956 and continuing into 1957, Nevelson concentrated mostly on shallow relief sculptures, playing natural or organic elements against smooth, machine-cut geometric forms that absorbed or redirected the light. The play of black against black in a delineated space conveyed an unexpected illusion of nondelineatable depth. Nevelson was working within the area of illusion; the shadow places in between the light-directing forms, as the forms themselves were only conductors of light.

Reliefs and free-standing assemblages proliferated—more than she could store. For Christmas, 1957, Nevelson received a case of liquor and instantly recognized that the crate, with its cellular divisions intended as bottle separators, was in itself a sculpture. The compelling play of shadow working within the cellular interior suggested the enclosure of her existing reliefs. Further extending the illusory space of the reliefs by enclosure or shadow-boxing, they became compound found, readymade objects: Milk boxes, lettuce crates, and any other available enclosures were utilized. Occasionally, in a deep box, she encased an existing three-dimensional sculpture, thereby negating the three-dimensionality of the sculpture by permanently fixing it frontally.

These boxes, momentarily considered separate pieces, began to overflow the studio, and in order to provide more working space, she began to stack them one atop the other, against the wall. Constantly shifting and changing the relationship of these units during the addition of new ones, Nevelson became aware that the process of assembling the individual cells or units, for storage, was a further elaboration of the natural process of the work itself. Nevelson created her first wall.

IV "My total conscious search in life has been for a new seeing, a new image, a new insight. This search not only includes the object, but the in-between places, the dawns and the dusks, the objective world, the heavenly spheres, the places between the land and the sea . . . Whatever creation man invents, the image can be found in nature. We cannot see anything of which we are not already aware. The inner, the outer equal one."*

In 1958, Nevelson prepared works for an exhibition of boxes and columnar units at the Grand Central Moderns Gallery, entitled *Moon Garden Plus One* (Figs. 42, 43, and 44). So far, this was her most important work, as the title implies: a place rather than individual sculptures. The installation of the exhibition itself was integral to the evolution and formalization of the sculptures. The production and exhibition of works have traditionally been distinct and unrelated acts for artists, but for Nevelson they are one. She spontaneously improvised *Moon Garden Plus One* from the elements of her own construction that she rediscovered or found again in the gallery. The changing light coming through the deep-set windows seemed to alter the space and also provided the viewer with a point of comparison between Nevelson's world and the outside. Nevelson sought to establish an unfamiliar landscape that would disorient the viewer and question the sufficiency of his perception. To achieve this, in *Moon Garden* she cov-

* Louise Nevelson, from John I. H. Baur, *Nature in Art* (New York: Whitney Museum of American Art, 1957).

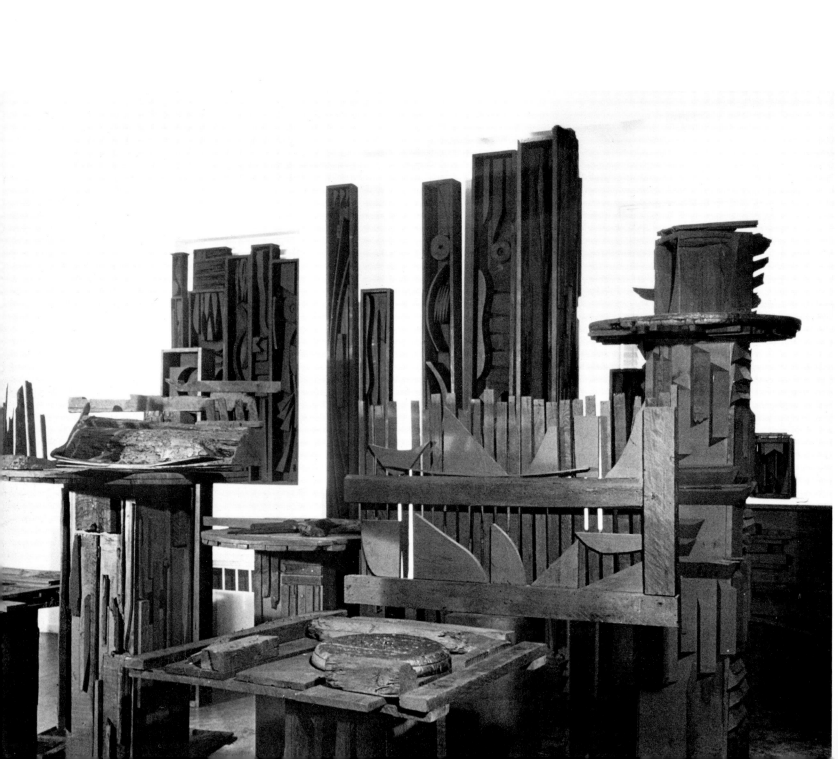

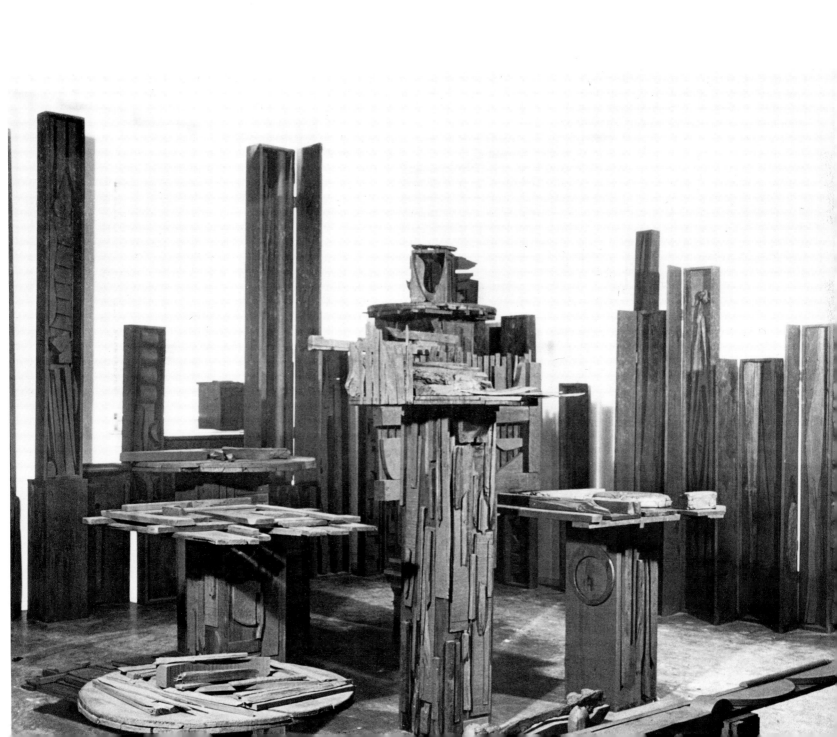

42–44. Exhibition at Grand Central Moderns Gallery. *Moon Garden Plus One*, 1958.

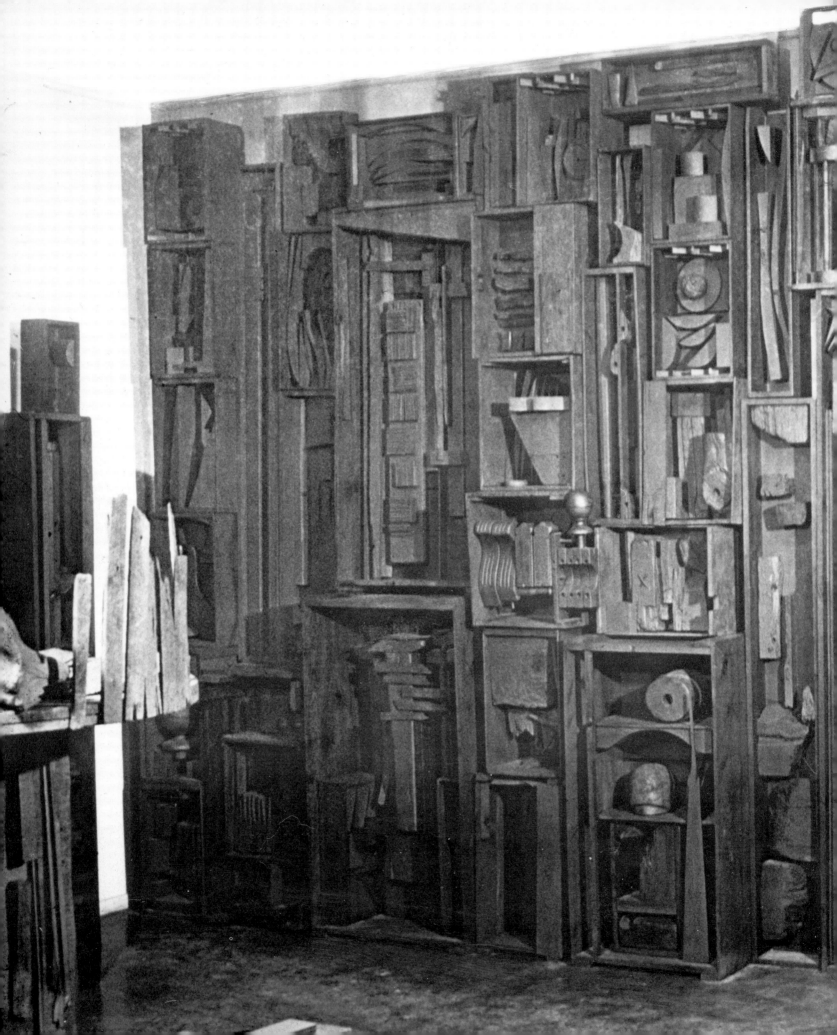

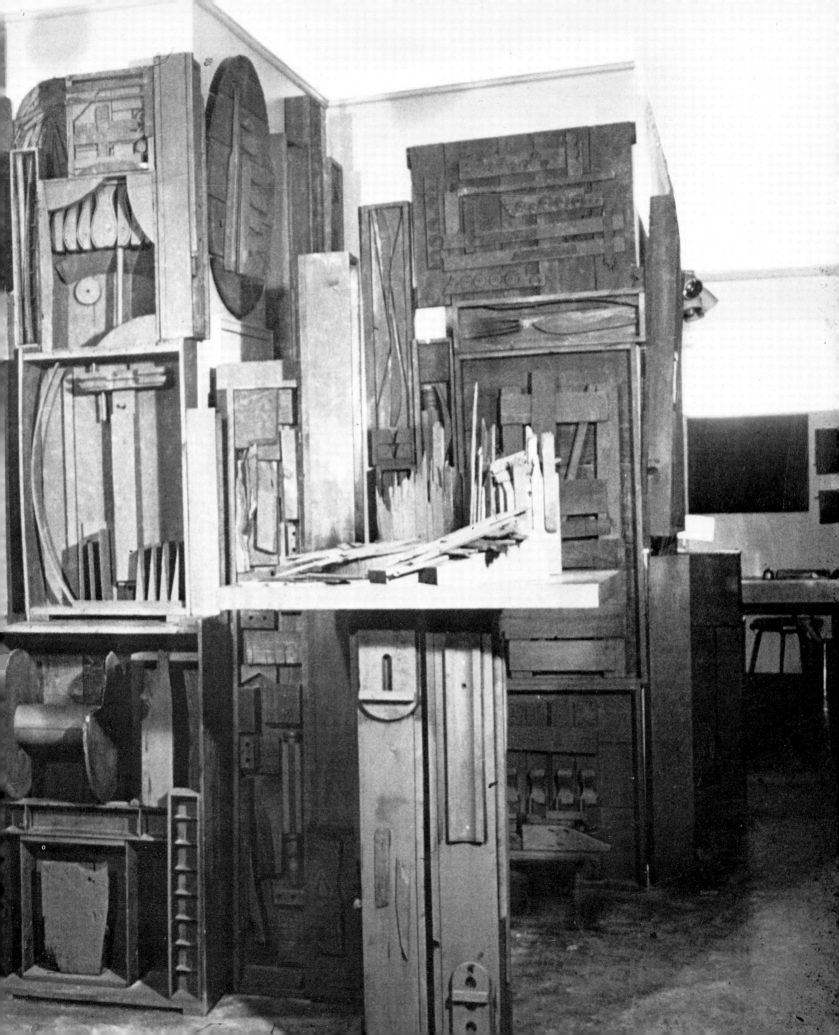

ered the windows with paper and stacked boxes along their ledges, filling the negative window spaces with sculptural assemblages. The window frames themselves became enclosures, and all of the physical properties of the space were designated a part of the exhibition.

Within this exhibition, she composed one of her greatest works, *Sky Cathedral* (Color Plate I). Nevelson wanted the gallery dark—absolutely no light. The viewer would enter her universe, slowly get used to the dark, and perceive the spectral presence and mystery of the space—like a natural phenomenon that never reveals the process of its history. As this was at best difficult for the gallery and expecting a great deal from the viewer, she accepted the advice and assistance of the gallery staff and illuminated the environment with blue light. The aura of cold light, and the intensification of shadow caused by that light, further differentiated her world. This was a magic window that allowed the viewer to walk through into a private universe. The photographs of the exhibition were taken in strong light and reveal the structural components of the environment that were only its skeletal supports. Hilton Kramer described the exhibition far better than the photographs:

> In the current phase of Mrs. Nevelson's production, there is little doubt that the *pièces de résistance* are the two enormous sculptural walls, the *Sky Cathedrals*, the first of which was shown at Grand Central Moderns in January, the second of which has just been completed in her studio this spring. If the *Skyscape* can be described as a Nevelson anthology, then the *Sky Cathedrals* are her Collected Works, for nearly everything that has ever occupied her mind as an artist is invested in them. (No photograph can even approximate their appearance or suggest the feelings they induce.) They are appalling and marvelous; utterly shocking in the way they violate our received ideas on the limits of sculpture and the confusion of genres, yet profoundly exhilarating in the way they open an entire realm of possibility. They follow the lead of current abstract painting in projecting an image so large that the spectator is invited to feel "placed" (or trapped perhaps?) within it. For myself, I think Mrs. Nevelson succeeds where the painters often fail. Where they have progressively emptied their image in order to enlarge it, she insists on proliferating more and more detail, arresting the eye with a brilliant or subtle "passage" wherever its glance falls. Where her contemporaries are on the side of frugality and emptiness, she has moved swiftly into a kind of gluttony of images. The results are sometimes ungainly but still overwhelming in force, and what redeems the ungainliness is the exactitude which sustains her hand even at the outer reaches of extravagance. The *Sky Cathedrals* seem to promise something entirely new in the realm of architectural sculpture by turning the tables (or the *walls* perhaps?) on the architects and postulating a sculptural architecture. Whether the austerity and sterility of contemporary architectural practice can take up this challenge remains to be seen. In the realm of sculpture, anyway, the achievement is already there.*

* Hilton Kramer, *Arts, Special Sculpture Number*, Vol. 32, No. 9 (June, 1958).

Moon Garden Plus One was a phenomenal occurrence in itself but its importance is clarified with the realization that *Sky Cathedral* is a synthesis of the two dominant directions in American painting of the late 1940's and early 1950's: action and color-field, and Cubism. As has already been discussed, the scale of Nevelson's walls was indirectly influenced by her brief career in films and her apprenticeship with Diego Rivera. The architecture of Mexico, with its surface embellishment, and the paintings of Pollock, Rothko, and Still exerted their influence equally. Like the Pollocks of the late 1940's, Nevelson's walls were composed of interpenetrating shapes that form an open tactile screen that offers no center of interest because of the all-over proliferation of detail. Both their work is linear and achieves a feeling of infinite space. Nevelson does this by the projection of shadow and illumination of edge that dissolves the mass and creates a sense of weightlessness. In 1951, Pollock produced a series of semifigurative black-and-white paintings, in which a drip pictograph or note taken from his previous paintings is enlarged.

In applying watery pigment to unsized canvas, Pollock allowed the form to bleed and stain the canvas to a shadowy gray edge. Nevelson's forms also spill their shadows across the field, staining the other forms of her "walk-in paintings." Although Pollock creates a continuing field of activity, the edges of his paintings turn in upon themselves to regenerate that activity. Unlike Pollock, Nevelson's field continues outward, beyond the confines of the wall, more in sympathy with the paintings of her friend Mark Rothko. In his paintings, Rothko places his symmetrical rectangles near the edge to minimize the edge and create an outward thrust. However, in the atmospheric field, Rothko blurs the edges of his floating rectangles to unify the single-plane frontality of his paintings. Unlike Rothko's paintings, Nevelson's walls have multispatial levels, revealing the influence of Picasso rather than of Rothko's influence, Matisse.

In the late 1940's, Clyfford Still produced a series of large monochromatic black paintings. He sought to create paintings devoid of psychological color association. The upward thrust of Still's forms is similar to the activity of *Sky Cathedral*, but Still never connected his forms horizontally, as he avoided any Cubist reference. The possibilities of Cubism had clearly been exhausted in painting, but they had only begun to be explored in sculpture. Nevelson said, "Pollock, Still, and Rothko were important to me mostly because the freedom they took allowed me to go ahead in my own way."

Nevelson never attaches the units with nails but rather lets their weight and size guide their placement within the assemblage. In *Sky Cathedral*, each box diminishes in weight and size as its position is closer to the top. In total structural interdependence, gravity is used for mortar, making it difficult if not impossible to extract one box without the whole wall collapsing. Each separate unit is created within the framework that appears casual but that together becomes a unified spatial fabric, anticompositional in nature and illusionistically conceived as an archi-

tectural totality. This is the consummation of the collage sensibility in Nevelson's work that begins with the selection of materials and ends with the installation, perhaps years later, of the wall, walls, or environment. Separate units may be idle for years before their consummate incorporation into structures.

The logistics of creation in Nevelson's work is that of an architect of temporal substances: light and shadow. The most astonishing aspect of this manipulation is that it occurs within the deliberate delineations of Cubist space to create formal Cubist sculptures. Laurens, Lipchitz, Zadkin, and other sculptors produced their work after the establishment of Cubist painting. That is, the sculptures were cubed to convey stylistically the impression of economy and form. In reality, with abstracted Cubist imagery, they continued to occupy the rich three-dimensional space that classically has been the domain of sculpture. Positive and negative forms operate in familiar relationships, and the sculptures are the result of cutting away excess materials. Nevelson's sculpture, like Cubist painting rather than Cubist sculpture, delineates the shallow space within which the forms coalesce to build up additively the formal substance. The box enclosure is constructed a predesignated depth, and selected forms are arranged to reflect, absorb, and interfuse light and shadow. The absence of color, as well as the quality of light absorption, asserts only positive form, which, in turn, compounds the visual weight of the sculpture and causes the shadow to become as positive and equal as its reflecting support.

In 1937, Mondrian beautifully described the equality of importance among the elements in a work of art:

> Throughout the history of culture, art has demonstrated that universal beauty does not arise from the particular character of the form but from the dynamic rhythm of its inherent relationships, or—in a composition—from the mutual relations of forms. Art has shown that it is a question of determining the relations of forms. It has revealed that the forms exist only for the creation of relationships; that forms create relations and relations create forms. In this duality of forms and relations neither takes precedence.*

In Nevelson's work, the residual effect of this balance is the extension of sculpture into the realm of illusion, a territory previously reserved for painting. This is the greatest contribution of Nevelson's sculpture. The work is not meant to be viewed from all sides and not meant to reveal a multitude of changing forms and relationships. On the contrary, its secretive, spectral blackness requires that the viewer be willing to devote his entire perception to the sculpture for the revelation of some of its component images. Time is integral to these ephemeral experiences, making it impossible for the viewer to leave with a total formal image of the work. The

* Piet Mondrian, *Plastic Art and Pure Plastic Art*. First published in *Circle*, Naum Gabo, J. L. Martin, and Ben Nicholson, eds. (London, 1937; rev. ed. London, New York, 1971).

VII. *Canada Series V*, 1968. Plexiglass, 16½″ x 13″ x 8″.
Collection Mr. and Mrs. Sidney L. Solomon, New York

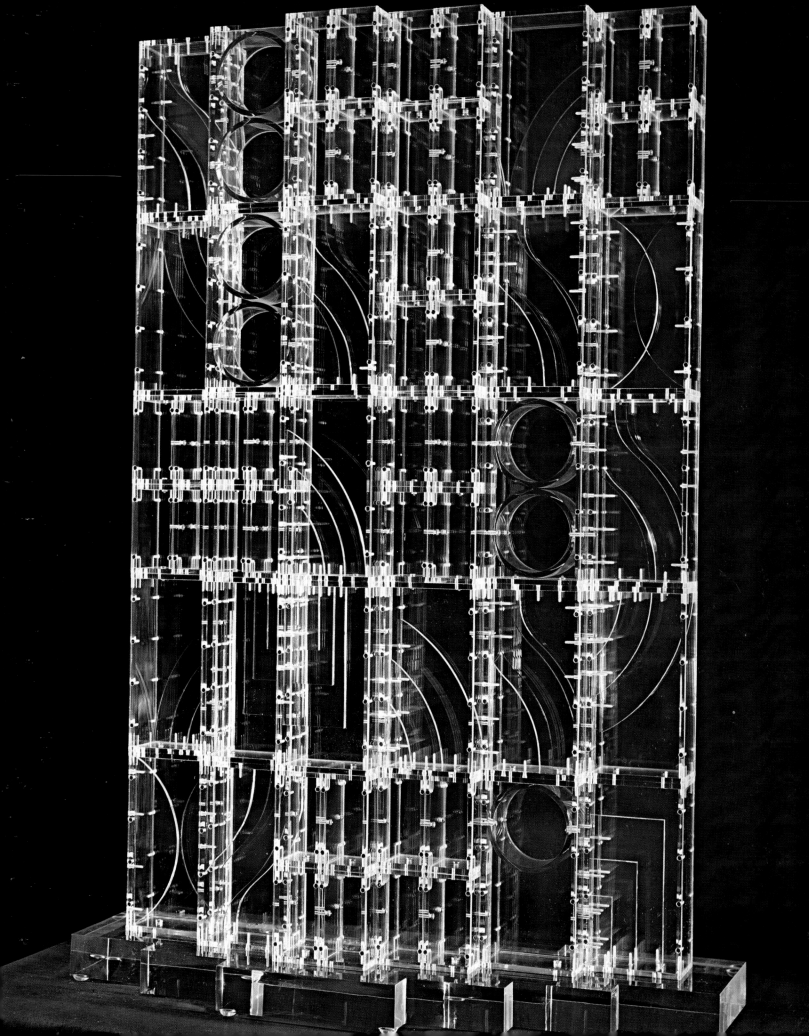

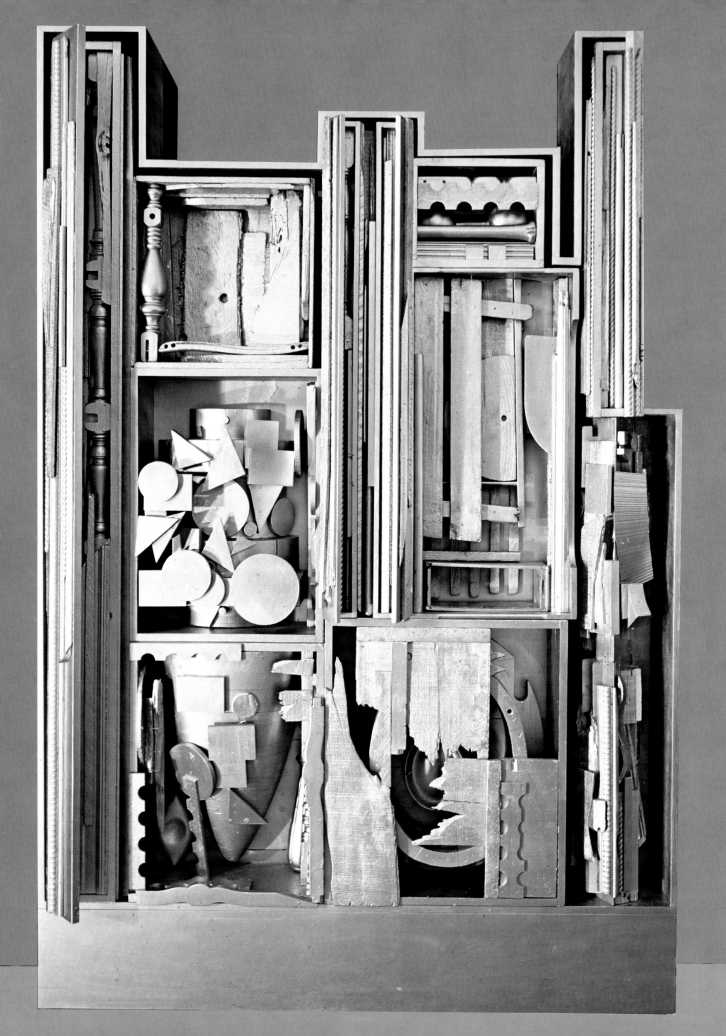

impression exists only during the period of contact, and in this manner, her work approximates theater.

For example, it is possible to possess the near total image, if not the impact, of an Arp sculpture, even when not viewing it. Light and contemplative time provide subtle changes, but the essential form will not be altered. Nevelson's sculpture is visually temporal. There is a dichotomy between the restricted delineated space that reveals each physical level and the possible illusion of infinite space established by the infinity of reflected shadow. Another ambiguity prevails in the monumentality of scale in Nevelson's sculpture. Although the works are large in two dimensions, the third dimension of depth is physically little deeper than a painting. The real third dimension of Nevelson's work is illusion, and these works thereby extend sculpture beyond the concept of a special collectable objects and extend perception to a new consideration of relative phenomena. In 1959, Robert Rosenblum wrote:

> In some ways, Louise Nevelson's newest and most astonishing achievements—her vast wooden walls—recall the iconoclastic innovations of the new American painting rather than the more tradition-bound character of the new American sculpture. In scale alone, the architectural magnitude of these forests of black boxes parallels the awesomely large paint expanses of Rothko, Still or Newman, which similarly impose upon the spectator an engulfing sensuous environment. In sculpture too, Nevelson's creative heresies evoke pictorial rather than sculptural analogies. Like the churning labyrinths of Pollock, her shadowy façades are inexhaustibly complex, affording endless explorations to the eye. Looked at in detail, each visual focus is caught in a separate adventure that involves a unique configuration of regular shapes and unfathomable depths. Looked at as an entirety, her walls, like Pollock's mural spaces, are boundless for what we see is only a fragment of elements that are infinitely extendible and in imagery as well, these walls suggest, like so much recent painting, organic metaphors.*

Although Picasso is the major influence on Nevelson's development, specifically the Cubist period, the early Arp reliefs arranged according to the laws of chance are also important in Nevelson's evolution. Rosenblum observed this relationship in 1959:

> The Bouquet [Fig. 45] of 1957 is a case in point, establishing as it does her characteristic elegance of detail and her familiar interplay between her organic and manmade structures. Working here within a painter's rectangular framework, Nevelson opposes the given geometry of reason with the burgeoning, irrational forms of nature. With a delicate yet vital pressure, the tendril-like fragments of the Bouquet expand towards and even beyond their rectilinear confines, creating a nuanced tension between the forces of nature and the control of man that can withstand comparison with Arp's finest reliefs.†

* Robert Rosenblum, Arts Yearbook, III (1959).
† Ibid.

III. Golden Gate, 1961–70. Wood painted gold, 96″ x 64½″ x 12″.
Collection Mr. and Mrs. Arthur A. Goldberg, New York.

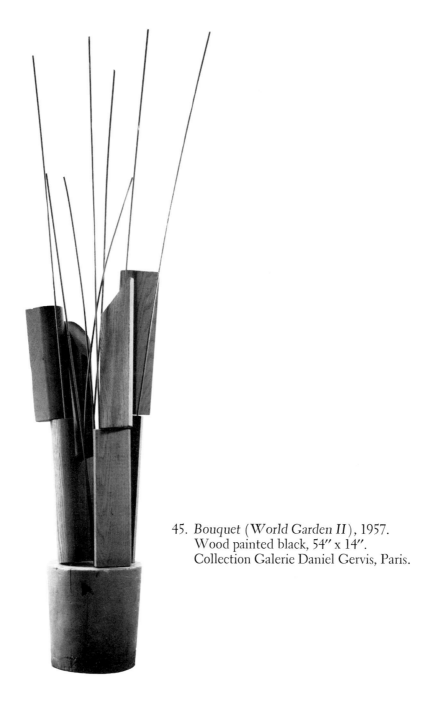

45. *Bouquet* (*World Garden II*), 1957.
Wood painted black, 54" x 14".
Collection Galerie Daniel Gervis, Paris.

In 1961, there was an exhibition of Nevelson's sculpture at the new Pace Gallery in Boston. During the installation a piece was nicked, and the wound revealed the interior color of the wood. When it was apologetically called to Nevelson's attention, she said, "Just paint it black, it's all in the life of the work." Her concept of the independent life of her work closely coincides with the philosophy of Marcel Duchamp. When his large glass *The Bride Stripped Bare by Her Bachelors, Even* was broken, Duchamp accepted the alteration as an evidence of natural evolutionary process.

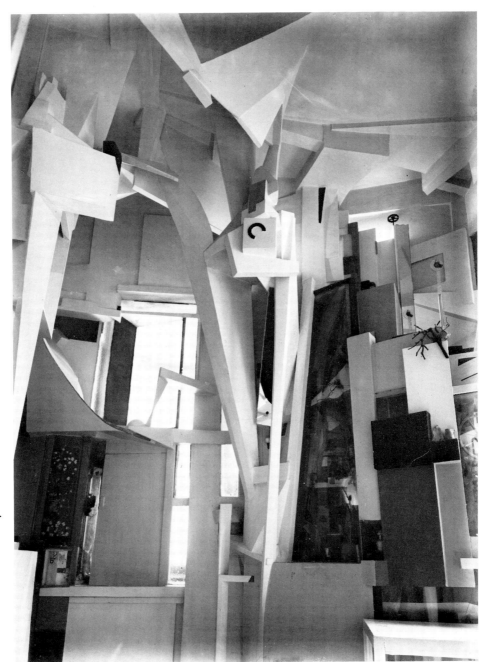

46. Kurt Schwitters.
Merzbau.

Nevelson extended the legacy of collage and the readymades (found objects) of Duchamp, already major modernist tendencies, into architectural scale. Total environment as an art experience was initiated in the monumentally encompassing work of Kurt Schwitters, *Merzbau* (Fig. 46), and in the architectural spaces of other artists, including Theo van Doesburg and Mondrian. However, with the exception of Schwitters, these environments were tangential to the major tendencies of these artists' works and not representative of their total œuvres. When Schwitters constructed the *Merzbau*, it was the culmination of his history of color and collage. In 1920, Schwitters wrote in the introduction of his catalogue for the exhibition *Merz*: "I have taken a step in advance of mere oil painting for in addition to playing off color against color,

line against line, form against form, etc., I play off material against material, for example wood against sackcloth."*

Although it is tempting to extrapolate a conscious influence of Schwitters on Nevelson, it is likely that she was not even aware of his work. (Nevelson does not admit to conscious influences, and she does not remember if she even knew the work of Schwitters.) Nevelson is a three-dimensional artist; Schwitters was a two-dimensional one whose orientation was color and painting. Nevelson shares the playing off of texture against texture with Schwitters, but Schwitters reveals the human association of his images and symbolically freezes and bonds the moment with its internal human relationships. He said that "Merz" meant "I," and he became the builder of a work that encompassed within himself all of his friends. If a friend left his shoes, socks, or tie, they were incorporated into Schwitters's work and his being. Nevelson uniquely creates an "I" or self-extending piece that excludes other people and encompasses that space within which she functions.

While Schwitters and Duchamp preserve the found or natural condition and life of their elements, Nevelson completely eradicates previous history. In 1913, Duchamp created the first totally free-standing collage object by mounting a metal-wire bicycle wheel on a wooden stool. Nevelson could never leave unchanged the natural state of the component images. Instead, by cleansing her forms with the application of a new color, she restores their virginity and by painting, she sculpts them into existence. There is a need to remove all frame of reference, and finally, within the finished assemblage, she accomplishes an isolation and freshness indicative of a new experience and unfamiliar landscape. Unlike Schwitters, Nevelson theoretically works *new* elements; the incarnations of past existences.

The poem that Arp wrote to Nevelson also made an association between her work and Schwitters's by designating Schwitters as her spiritual grandfather.

> Dans le grand univers terne de la nuit
> du crepuscule, de l'imagination, a l'eveil
> ou le coq du reveil-matin change, les
> bibelots-monstres de Louise Nevelson se
> promenent.
>
> Voici *Paysage Ancien* [ancient landscape]
> —un paysage ferme par des planches
> d'ou l'esperance a pu s'enfuir en
> demolissant une.

* Kurt Schwitters, Foreword to *Merz*, translated and quoted in *Dada Painters and Poets*, Robert Motherwell, ed. (New York: Wittenborn, Schultz, Inc., 1951).

Voici des sacs à papier pleins d'air
des bibliothèques ambulentes
 d'anachorètes
des muscles à cocons
des cases debordantes de cossons*
des casiers à pyramides maniables.

Le reveil a la vie du jour face aux volets,
le contre-jour ou tout est perdu *fors*
l'honneur, la cascade empaillée, vous
eblouissent.

La grille que nous portons en nous
[the inner-gate] par laquelle entre et sort
the noble being, le noble personage.

Ou sont les bouteilles grises empliés de
poussiere des catacombes?

La valise de la mariée [the wedding chest]
lous le bras, je disparais dans la
Cathédrale du ciel.

Louise Nevelson a un grandpere sans
probablement le connaître: Kurt Schwitters.†

Specific accomplishments in art produce new territory and experimentation just as the discovery of scientific truths or answers give rise to new questions. Nevelson and Schwitters were both, at different times, receptors of Picasso's influence conducted by similar sensibilities. Both artists were inspired by the same source, however, the specific internal and external stimuli are contaminated by their own personal histories and private reactions. An elaborate evolutionary puzzle of occurrences directed Nevelson to exclude the objects' personal history from her work.

* Cosson (ou cossonus) n. masc. Genre d'insectes coleopteres, famille des curculionides, comprenant des charançons de petite taille, allongés roux ou bruns, luisant, vivant dans le bois carie, surtout dans les saules et les peupliers. Nom donne au bruches qui attaquent les pois, les lentilles, etc. On dit aussi en ce sens "cosse." (Dictionnaire Larousse du XXe siècle.)
† Jean Arp, *XX Siècle* (March, 1960).

V *Moon Garden Plus One* gave Nevelson critical accolades that, while not essential, were enormously satisfying. Art collectors were unable to deal with these works as isolated sculptures because their originality was not really compatible with the concept of collecting separate examples of an artist's work. The confines of the works themselves were unclear, resulting in little chance of sale. The illusion of enormous scale (in actuality, they were not larger than most Abstract Expressionist painting) and temporal imagery questioned the verticality of art disciplines: Were they painting, sculpture, event, or theater? They did not appear to be collectable works or concrete experiences.

Meanwhile, Nevelson was enjoying the new-found attention of museum directors and curators. Colette Roberts was a friend of James Johnson Sweeney, then Director of the Guggenheim Museum, and she decided that this was the most prudent time to invite Sweeney to see Nevelson's work in the artist's studio. Sweeney arrived and studied all the works slowly. He said nothing, and Nevelson misinterpreted his silence as negative comment. She invited him into the small garden behind her house, from which could be seen Grand Central Station and the Empire State Building. She said, "Look, there's Grand Central Station and behind the Empire State Building is Penn Station—from these two places you can go anywhere in the world. Good day." Nevelson's arrogance was earned. She was bitter toward museum directors, as not one championed her during the difficult years. Once, another museum director was ten minutes late for a visit to her studio. While Nevelson waited, her anxiety turned to hostility.

When he arrived, the director apologized for being late; Nevelson said, "What's ten minutes. Where were you ten years ago?"

Grand Central Moderns was a showcase for new talent, but it was not financially equipped to undertake the promotional expense of handling an artist with the financial requirements of Nevelson.

Colette Roberts discussed the inevitability of losing Nevelson to a gallery that could invest in her and promote her work. "First of all, our position as a nonprofit gallery was that when people's ambition reached beyond what we could do for them, we hoped to have them go where they belonged. It didn't start that way. Our director-manager, Erwin S. Barrie, would have liked to keep people, because obviously that is the only time we could capitalize on our efforts. But I was terribly conscious of the fact that nothing in the world of modern-art-dealing can be done without investment, and we did not invest. What we did was work as hard as we could, but there was no investing to do the final promotion for an artist. I knew that there was a limited action. Louise is dedicated to her work, but if she had been able to afford it, she would have stayed."

In 1958, the Martha Jackson Gallery was one of the most prestigious and best-financed galleries in America. They gave Nevelson a contract that guaranteed her substantial yearly sales or purchases, and the gallery became her representative. Jackson represented several major talents, and for the first time since Nierendorf, Nevelson was in a gallery that reflected the international art scene. She was very satisfied with her relationship with the Jackson Gallery. Here was a dealer who not only liked her work but was willing to advance money on the basis of that confidence.

In 1959, the Jackson Gallery presented their first Nevelson exhibition, *Sky Columns Presence* (Figs. 47 and 48). The sky columns are related to the earlier monolithic wood sculptures *Chief* (Fig. 49), 1955, and *First Personage*, 1956. However, unlike these visually accessible and compositional works, the sky columns operate outside of the compositional realm, of sculpture. Constructed like blocks, the columns consist of a closed triangular or square core, upon which elements have been fixed in layers of wood encrustation. Rather than interacting spatially or creating an illusion of space as do the walls, the columns impose themselves upon the space architecturally, displacing space rather than interacting with it. The quantity and density of additive forms becomes so complex that the columns' elements merge in a single, unified form not revealing the individual components. The columns usually consist of two or three sections. Like the walls, Nevelson constructed a series of separate sections as completed units. She then stacked one to three units on top of each other, usually diminishing in scale as they reached the top. These are the only sculptures of her mature style that approach figurative suggestion. Especially in groups, the columns assume the attitude of a conclave of mystical

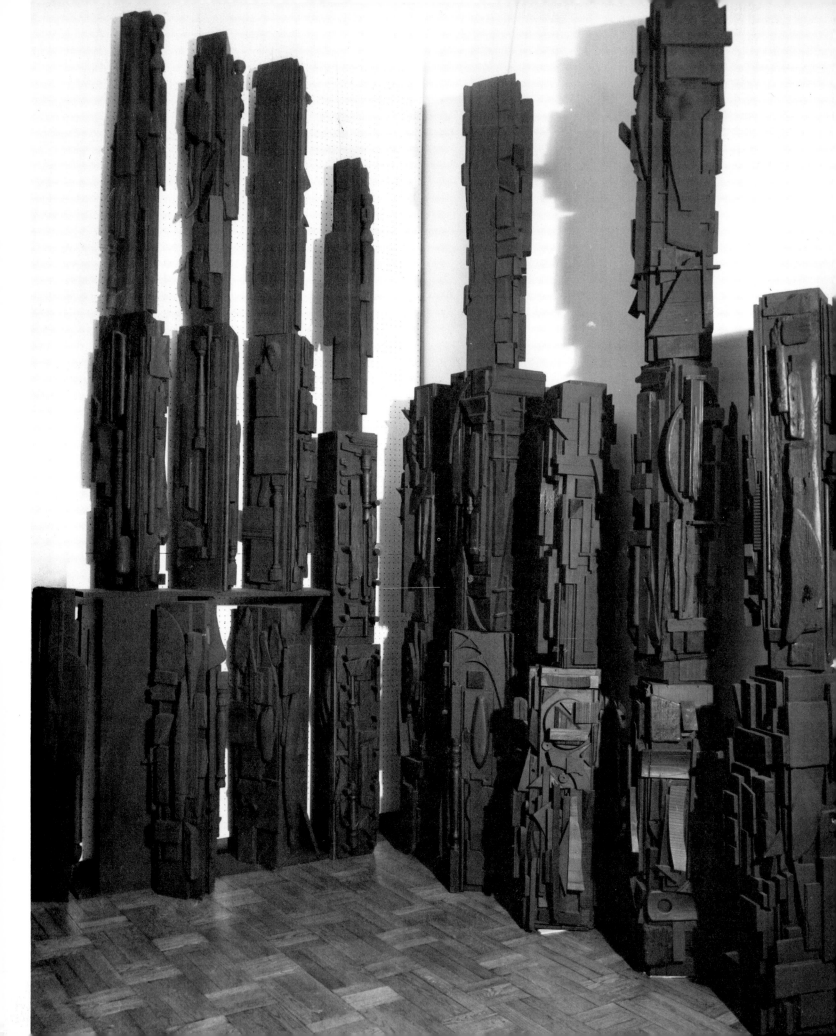

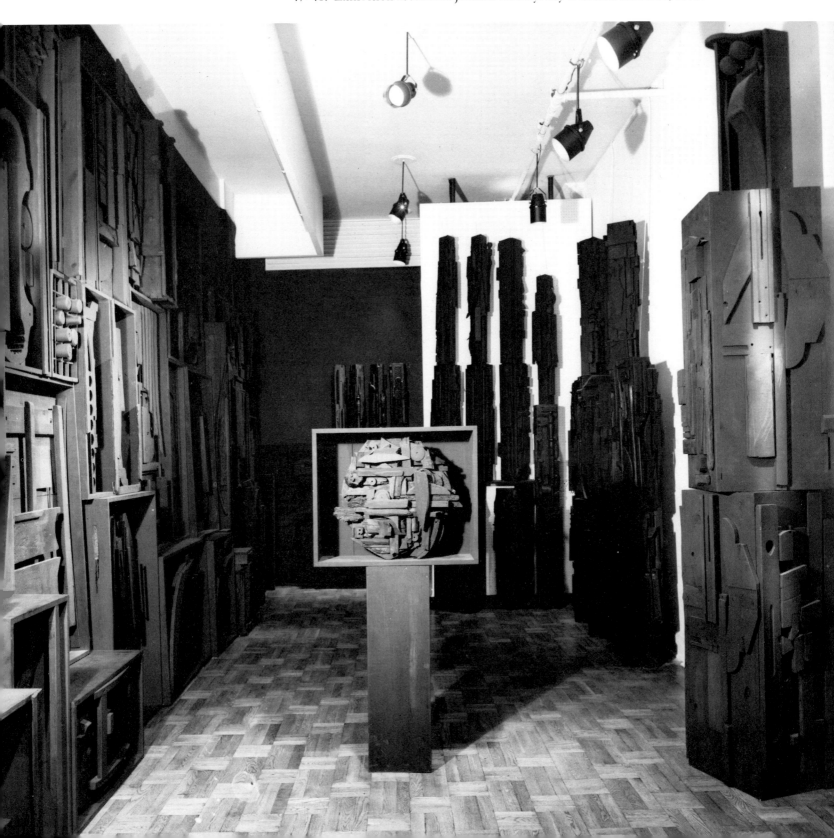

47–48. Exhibition at Martha Jackson Gallery. *Sky Columns Presence*, 1959.

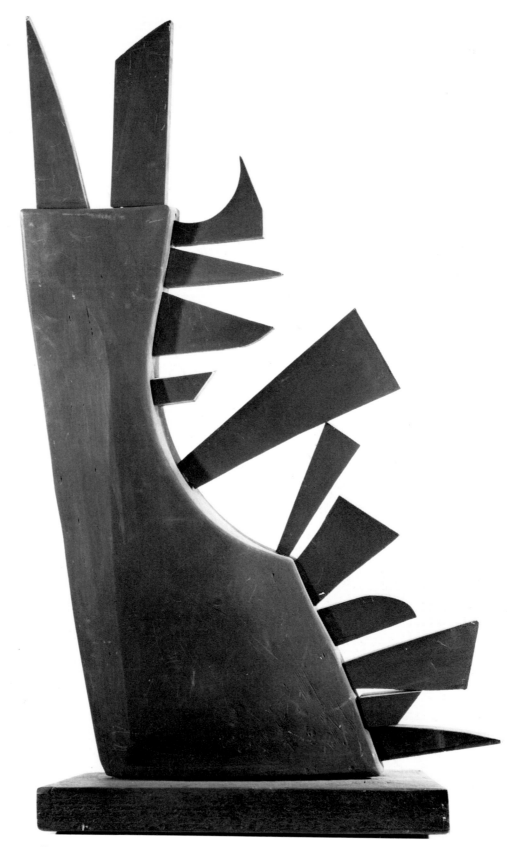

49. *Chief*, 1955. Wood painted black, 48″ x 27″ x 8¾″.
Courtesy Martha Jackson Gallery, Inc., New York.

presences. It was not Nevelson's intention to imply an anthropomorphic image; it is rather the essential verticality of the sculpture that too easily supplies the viewer with his own figurative associations.

Most interestingly, the sky columns remarkably suggest an arrested moment in a continuum of natural organic decomposition. Like images of ruins that evidence a history of grandeur, they end unfinished, abruptly, and suggest a rudimentary functional existence as caryatids. Like all of Nevelson's work, the columns are architectural; yet unlike most of her work, they are not so much derived from Cubist painting as they are directly influenced by the Spanish architect Antoni Gaudí. It is interesting that two of the major aesthetic influences on Nevelson —Picasso and Gaudí—are Catalonians, both of them passionate expressionist artists. Nevelson first saw the works of Gaudí in an exhibition of drawings and photographs at the Museum of Modern Art. She was taken with the deliberate asymmetry of his columns and their contrast to the Western ideal of perfection, as exemplified by the columns of ancient Greece. In 1968, she traveled to Spain and, for the first time, saw the architecture of Gaudí; as in previous experiences, she was disappointed by reality.

Nevelson assimilates aesthetic stimuli from reproduced images so quickly that a confirmation of the real is unnecessary. Her response is strongest to fresh or unexpected stimuli. If this evolved because of her inability to accept or place herself within the conventional world, then it would be reasonable to assume that some of her aesthetic influences are to be found not in classicism but in other visionaries, such as Picasso and Gaudí, who are the real affirmation of her vision.

In the exhibition *Sky Columns Presence*, two walls of the gallery were painted black and the space dimly illuminated. An enormous construction transversed the longest gallery wall, disappearing in the darkness of each room-corner; the irregular profile at the top was not discernible in the blackness of nonspecific space. The adjacent black-painted wall was lined with columns identical in height that merged into the field they hugged. The third wall (opposite the wall construction) remained white, and columns of different heights, the silhouettes of which were easily perceptible, were grouped against it. Curiously, these three-dimensional works were placed against the walls. Nevelson indicated a structural role for the pieces by integrating them into the architecture of the space within which they were exhibited. They did not exist as much like a colonnade as like a wall made of columns. In the center of the room on an unadorned black base, she placed a box, on its side, containing a half-spherical compound form. This moon or sun form, presented like a nineteenth-century easel painting for frontal inspection, was closed and unadorned at the back. As in other works, this naive, fixed frontality of presentation is extended even to the three-dimensional sculptures. Paradoxically the totally frontal moon piece was exhibited in open space and the three-dimensional columns

were not. This is a typical instance of value reversal that has intrigued Nevelson from her first found-object sculptures to the gilding of her works in 1961.

By the late 1950's, Nevelson had emerged as a public figure of extreme personal style. It became apparent that the woman was as unique as the works that she created. Her manner of dress is the most homologous synthesis of the personal collage aesthetic that encompasses her self and its extension—her art. The bourgeois direction of external fashion was always too self-conscious for the immediacy of Nevelson's sensibility. It was natural for her to assemble her wardrobe from a collection of sophisticated and primitive antique fabrics. A skirt made from a Pennsylvania Dutch patchwork quilt, under an eighteenth-century Chinese imperial robe, encased in a floor-length Persian coat of magenta, red, orange, and black embroidered paisley, is one of her favorite ensembles. To the opening of her retrospective at the Whitney Museum of American Art in 1967, Nevelson wore a poncho fashioned of two deep-purple silk Japanese tapestries, each embroidered with an enormous white crane, gray branches, and pink cherry blossoms. They were pinned together at the shoulders, sandwich-fashion, protecting a long multiflounced black pleated Mexican skirt and a white, embroidered peasant blouse. Around her neck, her black eyeglasses hung on a silver safety chain accompanied by a large, black wood and sheet-gold brooch of her own creation and a primitive necklace made of boar's teeth. On her head, fabric tied in the manner of an ancient Egyptian *nemes* was concocted from a turquoise cotton-damask table napkin. No concept of external occasion ever influences the selection and assemblage of costume. Any of the described clothing may be worn to the studio for work and continue to be serviceable through dinner and sometimes for sleeping.

VI Nevelson had established herself as a major figure in the New York art community. The only component lacking to fortify her critical position was a museum exhibition.

Dorothy Miller, the Curator of Paintings and Sculpture at the Museum of Modern Art, had initiated in 1942 a series of exhibitions of American painting and sculpture at the museum, in which she showed the most promising new talent and lesser-known mature artists. In February, 1959, Dorothy Miller, her husband, Eddie Kahill, and Louise Nevelson were having dinner together, and Dorothy asked Louise if she would be in the forthcoming *Sixteen Americans* exhibition. Although they were very close friends, Mrs. Miller was uncertain of Nevelson's reaction. There was a momentary pause, and then the reply: "We'll do a white show; keep it secret, I want it to be a surprise."*

Nevelson had been working in black for years, and consequently the black sculptures were the vehicle of her critical acceptance. She seized this opportunity to challenge the sensibilities of her public and to test the stability of her own position by displaying extraordinary versatility. It took a greater self-confidence than she had in 1943, when she insured herself against the potential criticism of the *Circus* show at the Norlyst Gallery with a simultaneous exhibition of line drawings at Nierendorf. Nevelson rented space in a building and painted it all white. "When I am thinking black or thinking white, I don't want to be confused," she said. The

* Harriet Janis and Rudi Blesh, *Collage* (Philadelphia: Chilton Book Co., 1967).

50–51. Exhibition at The Museum of Modern Art. *Dawn's Wedding Feast*, 1959.
52. *Dawn's Wedding Pillow*, 1959. Wood painted white, 6½" x 36" x 13".
 Collection Dr. John W. Horton, Houston, Texas.
53. *Dawn's Wedding Mirror*, 1959. Wood painted white, 26½" x 31" x 7½".
 Collection Mr. Rufus Foshee, Camden, Maine.
54. *Case with Five Balusters*, 1959. Wood painted white, 28" x 63" x 8".
 Courtesy Martha Jackson Gallery, Inc., New York.
55. *Dawn's Wedding Cake*, 1959. Wood painted white, approx. 20" x 36".
 Destroyed.
56. *Dawn's Wedding Chapel II*, 1959. Wood painted white, 115⅞" x 83½" x 10½'
 Collection Whitney Museum of American Art, New York.
 Gift of Howard and Jean Lipman.

50

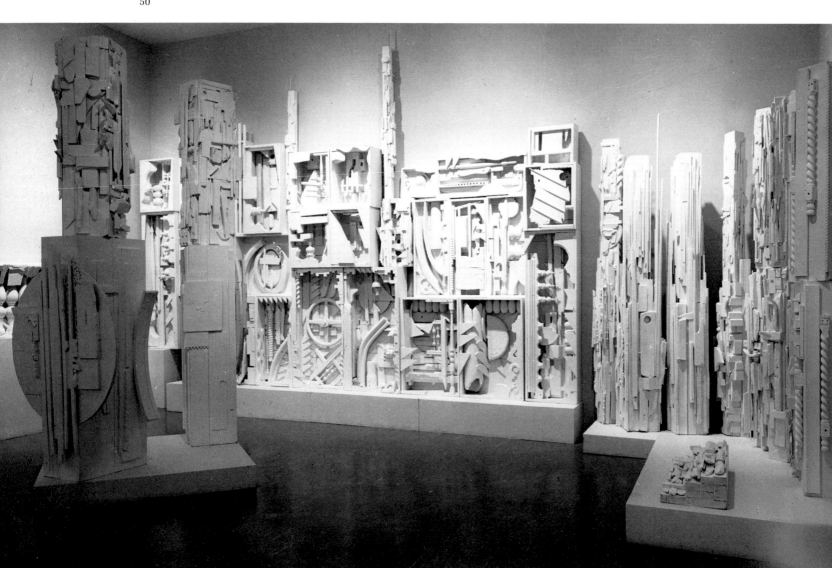

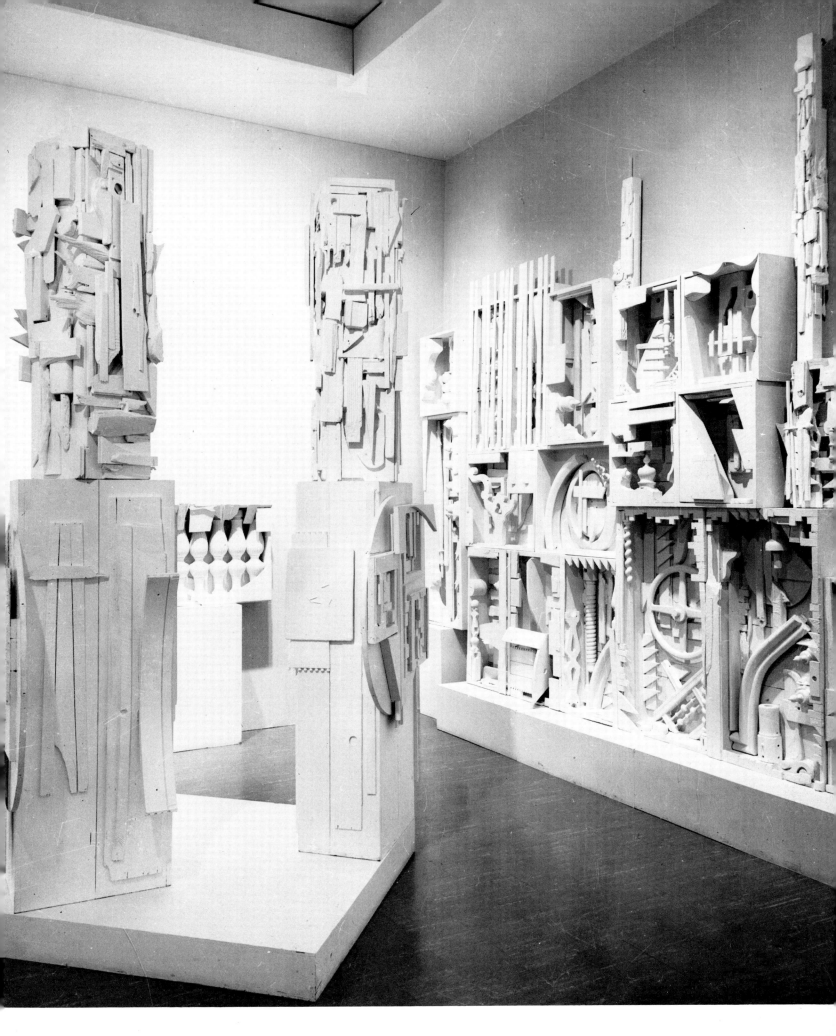

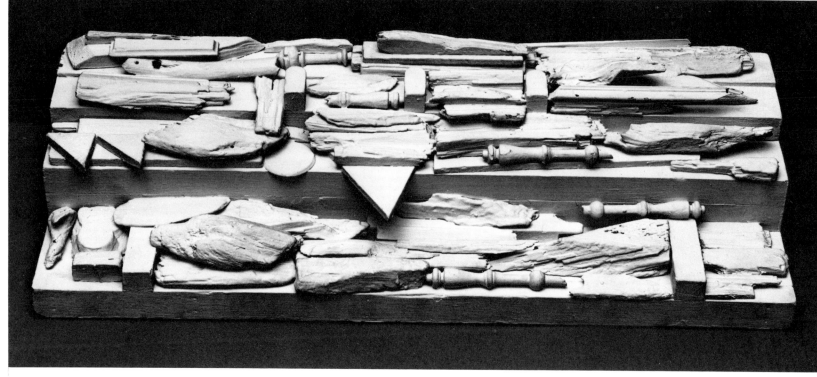

52

53

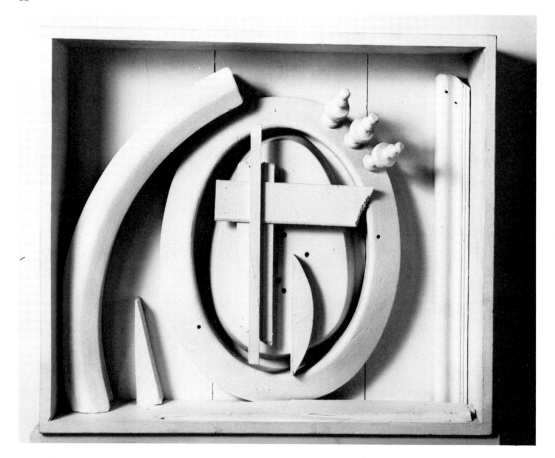

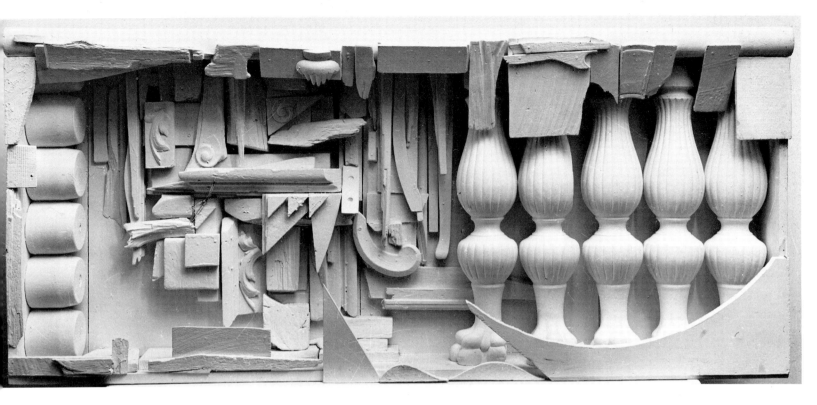

54

55

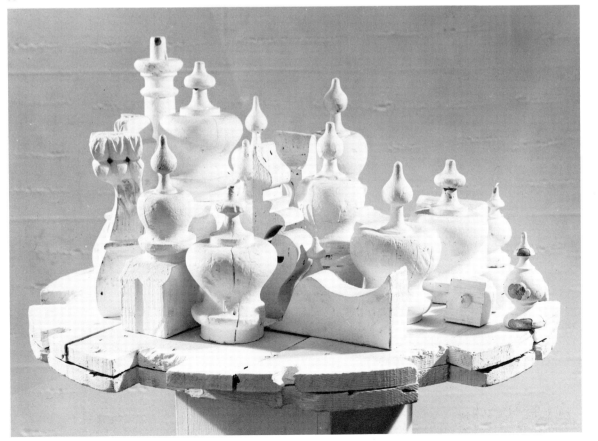

105

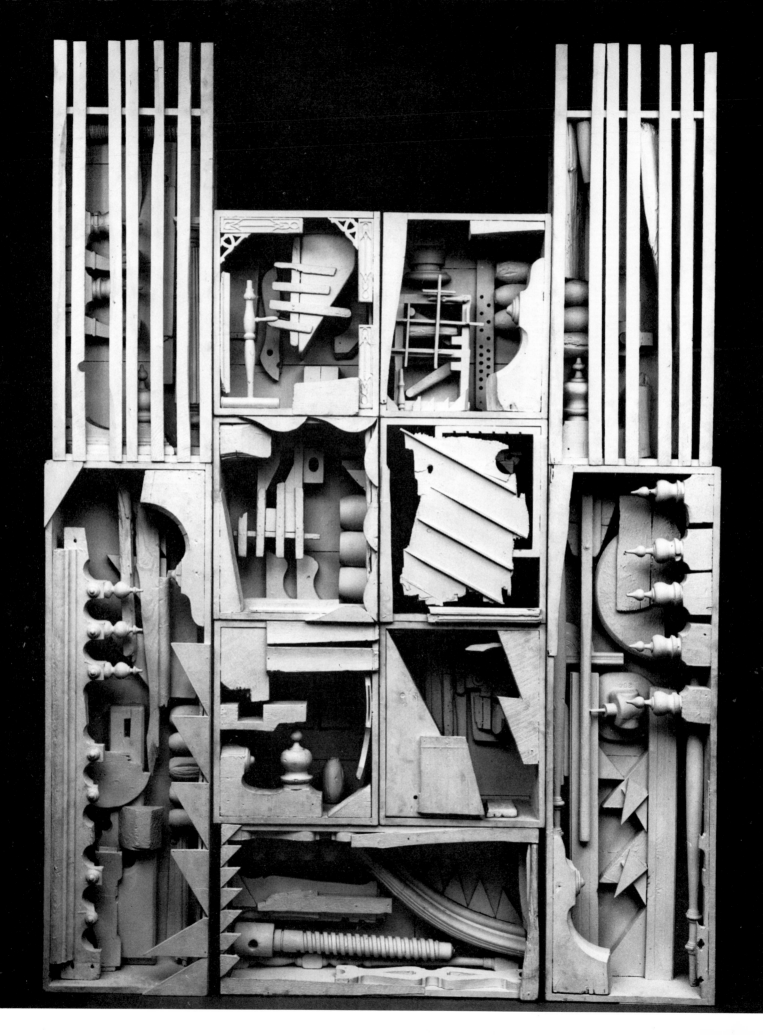

56

found objects and boxes were painted white, and from them she assembled the units that would eventually become her exhibition. For three months, she worked intensively on columnar units, boxes, and free-standing objects. Her work-process made it impossible to provide Dorothy Miller with the photographs that she needed for the exhibition catalogue. The total work could not be solved until the constituent pieces were assembled in the exhibition space. Two columns were quickly improvised for the benefit of the catalogue, and a temporary wall was also assembled. The same elements were not again paired or grouped in the exhibition.

The works were completed and trucked to the Museum of Modern Art. Late enough in the afternoon to ensure privacy, Nevelson and her assistant, Teddy Hazeltine, along with two helpers from the museum staff, installed *Dawn's Wedding Feast* (Figs. 50 and 51). The entire installation took four hours. "It was like eating a beautiful dessert after preparing a splendid meal," Dorothy Miller remembers. Nevelson had prepared three months for the visual decisions that took place in four hours. *Dawn's Wedding Feast* is the first and, to my knowledge, the only time that the artist created units for a specific environment. In the past, she had utilized works that were in the studio, sometimes waiting for years to incorporate them into an environment or single work. Perhaps this explains the deliberate and unusual similitude of the forms and units within the total work.

As the antithesis of the black sculpture, the white suggests some visual comparisons. If the space of the black work is indeed infinite in illusion and distant in perception, the white works are finite, nonillusory, and hyperactively accessible. Each element is richer in form and more baroque in juxtaposition than those within the black sculpture. The black sculptures challenge our ability to perceive the forms at all; the white sculpture is a perceptual challenge to our ability to focus on specific areas of the dazzling activity that is created by the panoramic plethora of forms. One is not drawn into the field of white with the same, almost physical absorption of the black. The stillness of dawn is rarely witnessed, and our dreams are less familiar with this cold, shadowless setting that overexposes every gesture. Consequently, the inability to enter the white increases its scale. The black, regardless of scale, is inhabitable and therefore more humanistic.

Dore Ashton viewed the exhibition as an entire village:

Of course, like most women, Nevelson has her little surprises. One was her extraordinary white room in the *16 Americans* show at the Museum of Modern Art. Called *Dawn's Wedding Feast* this ensemble was a very different mood. The baroque finery—lacy and latticed like a small Victorian town with its wooden houses and daintily fenced garden— seemed peculiarly American. In fact, New England. And the first thought I had when I saw it was that Emily Dickinson might have described such a place as she peered down from her wooden tower in Massachusetts. In this gay fantasy, Nevelson makes extensive

use of porch posts, skewered moldings, lion-footed legs and finials. The wall is like a house, with half-opened windows, others nearly closed, others shuttered. A "square" before the "house" has two large semaphoric posts. An isolated "stoop" is made up of two steps with various wooden forms nailed on their surfaces. Hanging are two slender "totems" that in this context are like old lighting fixtures. Bizarre, humorous, and at the same time, resplendent as all Nevelson's dream places are, this group stresses once again her versatility.*

The square before the house (platform in front of a wall) that Dore Ashton describes is the base of two totems that are unique in Nevelson's work. Here, free-standing totems have been constructed from two huge elements each; the lower or base sections are rigid in their geometric discipline, while the top sections are the convergence of soft scraps and bits of wood that have been molded by the sea. They were placed within the environmental arena, against the backdrop of a huge white mural with very little space between them. These two largest columns are each between 10 and 12 feet tall. The base columns are adorned with shields and moons, and they assert the rectangular construction of the base. The top elements, randomly encrusted with small asymmetrical pieces, balance the austerity of the base. One column is placed on an angle and diagonally across from it the other is scribed to the corner of the base. Other columns, with startling contrast between units, ascend to great heights sometimes diminishing in girt to a single wood lath. At the foot of a cluster or wall of columns on an extended base there are various small separate pieces. A flat "pillow" (Fig. 52), a circular "mirror" (Fig. 53), and an open "wedding chest" (Color Plate II) appear to be the spores of new columns. There is an easel picture or shadow box on a base that is filled with Victorian newel posts; as if to ensure their imprisonment, small thorny angles of wood cluster around the edges of the enclosure that the newel posts too snugly occupy (Fig. 54).

The most unexpected and opulent piece was a *Wedding Cake* (Fig. 55), comprised of perhaps a dozen Victorian wooden finials and chair legs on a circular tray. It was placed upon a small pedestal like a garden birdbath. The *Wedding Cake* recalls the 1954–55 black landscapes and, less directly but unforgettably, the photographs of Arp's studio with white plasters and marbles standing in clusters.

It was Nevelson's hope that someone would buy the entire environment and that she would be able to keep one of her environments, one of her most major statements, together. During the exhibition, no single Medici appeared to save *Dawn's Wedding Feast*. However, several collectors, some of them trustees of the museum, wanted single pieces, and at the end of the exhibition, some columns were sold separately. Over several years, from units within the great wall, Nevelson reassembled two smaller walls; *Dawn's Wedding Chapel I* (Color Plate III)

* Dore Ashton, "Louise Nevelson," *Cimaise*, No. 48 (April–June, 1960).

and *Dawn's Wedding Chapel II* (Fig. 56) . Most of the other boxes and the spectacular *Wedding Cake* were dismantled and used in other sculptures. Nevelson has never forgotten her disappointment. "If any museum would have just been interested, I'd have given it to them." The largest portion of *Dawn's Wedding Feast*, metamorphosed into *America Dawn* (Color Plate IV) in 1967, includes most of the original *Dawn's* columns and the addition of hanging columns constructed in 1961.

White reappeared briefly in 1963 in the creation of *New Continent* (Color Plate IV) , one of Nevelson's most lyrical works. This re-evocation of the atmosphere of dawn distills the robust Victorian lushness of the 1959 imagery into an ascetic interplay of flat arabesques and ovals that maintains the silhouettes of many of the *Dawn's Wedding Feast* pieces. The gold sculptures created between 1959 and 1963 influence the regular grid format of the total work.

VII Nevelson sold her house on Thirtieth Street to the developer of Kip's Bay Plaza, which now occupies the entire city block. She moved to the house she still occupies on Spring Street, painted one wall gold, and began to assemble gold elements and construct the units that would later be exhibited in *Royal Tides* at the Martha Jackson Gallery. The metaphorical tide cleanses the forms and, ironically, the rejected, battered, discarded elements are elevated, by gilding, to the value of gold. Schwitters shared Nevelson's pleasure in the reversal of social values when he wrote:

> I did not understand why one could not use in a picture, in the same way one uses colors made in a factory, materials such as old tramway and bus tickets, washed-up pieces of wood from the seashore, cloakroom numbers, bits of string, segments of bicycle wheels, in a few words, the whole bric-a-brac to be found lying around in a lumber room or on top of a dustbin. From any standpoint, it involves a social attitude, and, on the artistic level, a personal pleasure.*

That the gold period is the most actively disliked, underrated, and, unfortunately, dismissed group of Nevelson's mature works can be explained partially by the superficial vulgarity associated with the color in a country that still subscribes to the Puritan ethic. It is a vulgarity observed in a climate critical of a blatant display of riches. The concealment of riches is alien to

* Kurt Schwitters, in his magazine *MERZ*, No. 20 (Hanover, 1927).

Nevelson's sensibility, which is satisfied only with abundance and detail. Gold did not seem to have the purity of white or the mystery of black, and the aesthetic currency of the 1960's was tough, raw color and rusty metal. Unexpected combinations of jarring colors, somber colors, or no colors (as in Franz Kline and Ad Reinhardt) were in vogue. John Chamberlain was making his crushed automobile sculptures, Richard Stankiewicz was working with scrap metal, and David Smith was scrubbing on colors, not totally covering the metal. But in an extrapersonal and intellectual mode, Nevelson was in total sympathy with the common aesthetic. The gold sculptures were the quintessential objects of this sensibility, which invested ugliness with beauty, thereby reversing their meanings. These revolutionary sculptures seemed isolated in the same way as the late 1940's paintings of Jean Dubuffet. In their aggressive vulgarity, his works appeared to be the products of a madman. Today, the same works have acquired a patina of respectability and reverence, the result of Dubuffet's own ability to turn the concept of taste and awareness in his direction. Nevelson observed that discarded, useless forms were, in her work, noble and beautiful and equaled the rarity, splendor, and metaphorical value of gold.

Interesting formal innovations take place in the gold works. Nevelson abandoned the staccato composition of angular forms for new harmonies of volumetric roundness and curvilinear flatness. The optical density of the color intensifies the textural richness or lack of it in the component forms, and a driftwood chunk assumes the visual weight of a solid gold nugget. The sculpture assumes optical weight and seems to be made of gold rather than surfaced with the color.

The forms that best became the vehicles of reflection were, before reincarnation, hat forms, toilet seats, gun stocks, baseball bats, sometimes cut into sections, and tennis rackets. Now magically transmuted into gold, these forms no longer merged with each other as they had in the endless spatial illusion of the black sculpture and no longer enjoyed the distance and isolation of the white, but arrested themselves in the arrogance of total delineation and exposure. There is a more deliberate compositional totality to the walls than in any of Nevelson's other mature works. In this period, she develops a regular "grid" system of stacking same-size units. Although most of the walls are still irregular, she has produced four evenly stacked, same-size-unit walls. This is a very important development in the simplification of the total silhouette of the pieces and the minimalization of its edge activity to reinforce pictorial reference in sculpture that no longer seems weightless. The activity is now internal, isolated within a frame. As a result, Nevelson begins to make consummate works within the studio that are then transferred to the gallery for exhibition, with no evolutionary alteration occurring in the process of installation. In these isolated sculptures, the reflection of light is so brilliant that it obliterates the divisions of the boxes, and the regularity of the grid (the result of stacking similar units)

111

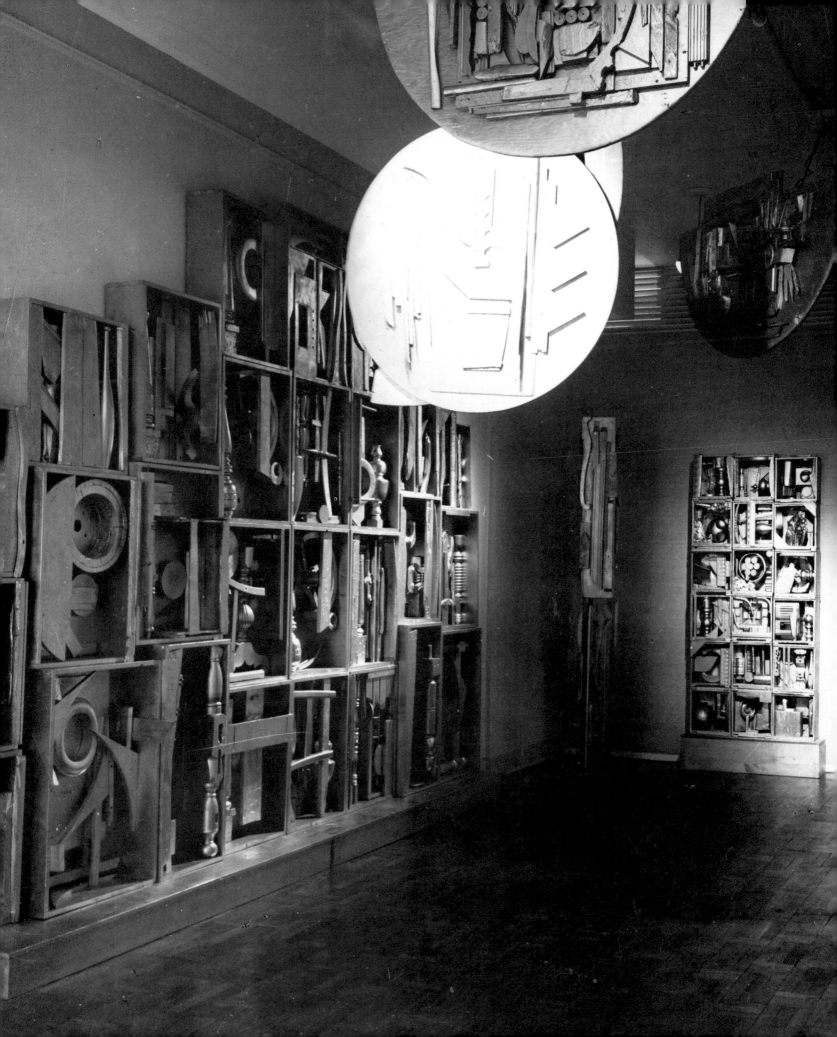

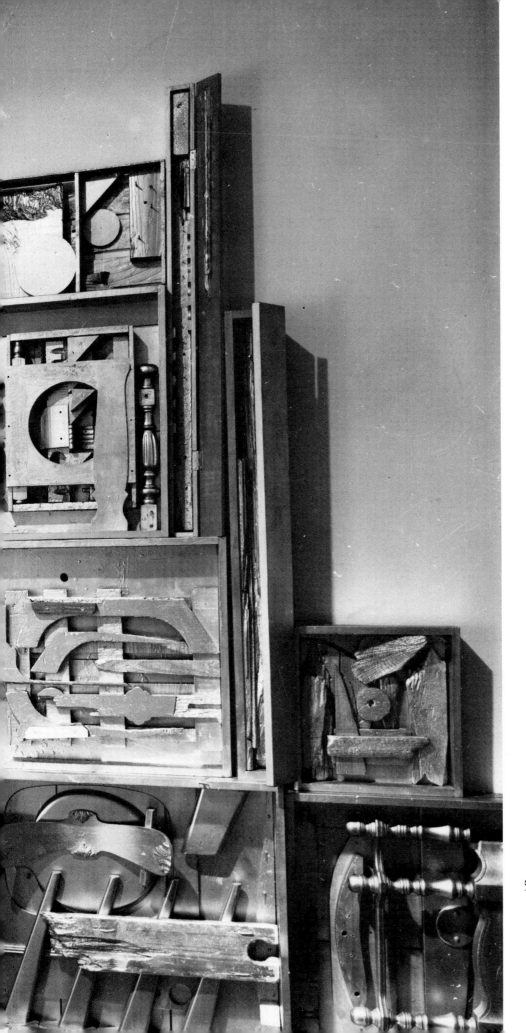

57. Exhibition at Martha Jackson Gallery.
Royal Tides, 1961.

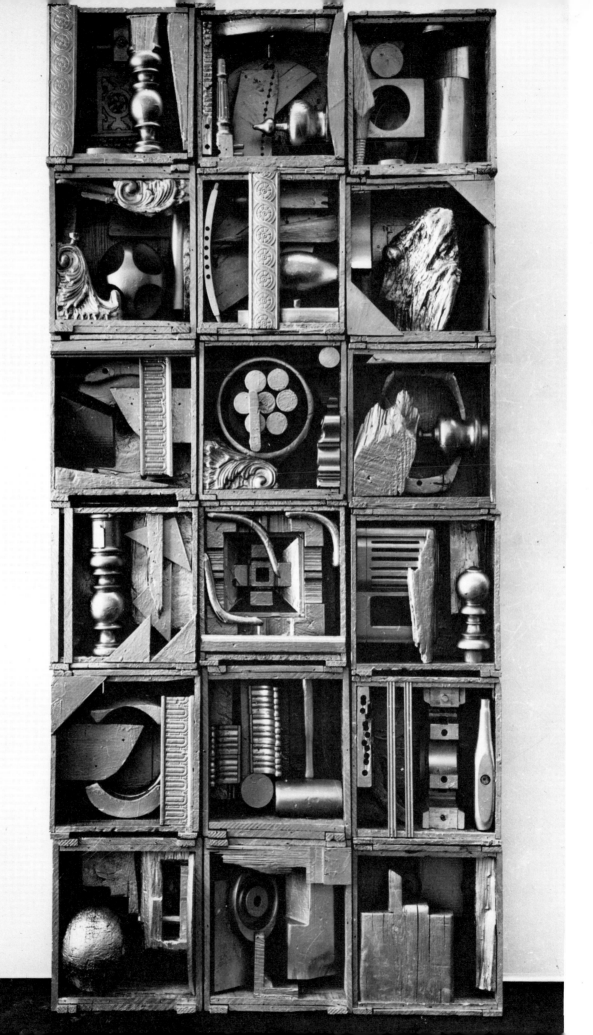

is integrated into the total composition. The grid subliminally becomes the stabilizing mechanism of the superactive reflections, and this subtle interaction of the cells allows the total image rather than the composite images to assert itself.

Nevelson directed the installation of *Royal Tides* (Fig. 57). Sculptural walls were installed with generous spaces between them, as if to allow the reflected spilloff of the gold itself to bridge the spaces. William Seitz writes of the gold sculpture *Royal Tide I* (Fig. 58):

> Each gilt-sprayed component of *Royal Tide I* is complete, an absolute in its clarity, yet each functions as a unit in a poem of eighteen stanzas. Those qualities that Schwitters loved—traces of human use, and forgotten craftsmanship—still exert their magic here, but their color and dispersiveness is formalized by the gilding. Depth is flattened, but the reflecting surface delineates each block, sphere on volute, dowel hole, slate on recess, with scholastic thoughtfulness and precision.
>
> This authoritative work resembles a reredos, an altar; but its dedication is not to a spiritualized divinity. The immediacy, clarity, and tangibility of its form and surface muffle and control, though they do not obliterate, atmosphere of mysticism and romanticism. The gold is as much that of Versailles as of Burgos.*

The Venice Biennale of 1965 was, and to some extent still is, the most prestigious of the big international art exhibitions. Traditionally, countries send (in the opinion of their own appointed judges) their major talents to compete for the prize of excellence. Major artists allow themselves to be demeaned by participation in this carnival; nevertheless, selection is very much sought after. In 1963, Nevelson was invited to represent the United States in Venice. The Museum of Modern Art each year undertook the fund-raising and selection for participation. By the time the approximately $60,000 necessary for financing was raised, it was too late for Nevelson to construct a show for Venice, but Dorothy Miller and Nevelson found a unique solution. Daniel Cordier, who exhibited her work in his galleries in Paris and Frankfurt, had organized a major Nevelson exhibition that was circulating to European museums and galleries. A catalogue of the exhibition was published containing photographs of the sculptures and a list of the exhibitions. Just before the exhibition was to leave Frankfurt for another engagement, it was commandeered to Venice for installation in the American Pavilion.

The American Pavilion, modest in size, is one of the least attractive permanent structures in the exhibition gardens. It was built by the U.S. Government to resemble Monticello and is not flexible enough to meet the demands of contemporary art. There are five glass-ceilinged rooms: a small, domed circular entrance room, and two large rectangular galleries, each leading to a small cul-de-sac. The works of Jan Müller and Loren MacIver were in the small rooms, and

* William Seitz, in catalogue of an exhibition, *The Art of Assemblage* (New York: The Museum of Modern Art, 1961).

8. *Royal Tide I*, 1961. Wood painted gold, 96″ x 40″ x 8″. Collection Howard and Jean Lipman, New York.

Nevelson was given the three large galleries. She painted the circular entrance room gold, one of the large galleries white, and the other black. The glass ceilings of the two large galleries were covered with cotton scrims the color of the room to soften the intensity of the Venetian light; in this altered environment, Nevelson and Dorothy Miller, with the help of two Italian craftsmen, installed the show. After each wall was unpacked from its meticulously fitted crate and the units were placed within the corresponding color rooms, Nevelson began the installation. She disregarded the catalogued order of the individual works because they were not large enough to fill the spaces separately. The once consummate walls, mostly the property of Daniel Cordier, again became the raw materials for the construction of three new environments. In the entrance room, gold columns were suspended from the dome, circumscribing the space above stacked boxes and columns, in a near symmetrical arrangement. The most densely filled of the three rooms was the black gallery, where Nevelson constructed an enormous wall of narrow vertical elements sparsely filled with small, spiraling arcs. Islands of free-standing boxes were assembled to great height next to large shallow trays placed on decorated and plain pedestals close to the floor. The dim, filtered light made partially visible a phantom universe of *Sky Gardens* suspended in a starless sky. In the white gallery, only one wall was filled with a reconstruction from elements of *Dawn's Wedding Feast* (Fig. 59), and an icy white moon was suspended above the doorway.

Nevelson did not win the prize: It was awarded to Giacometti. At the end of the exhibition, the walls reverted to their original arrangements and continued the exhibition tour. The most interesting behavioral aspect of the entire Biennale episode was that Nevelson was content to create three enormous environments with a temporary existence of two months. Although the potential for sales during the Biennale was enormous, none of these works could be sold. Nevelson's concern was for the immediate impact of her exhibition.

Participation in the Venice Biennale was another symptom of success, and, as a result, Nevelson was invited to join the company of the most prestigious American artists in the Sidney Janis Gallery. It would appear from enormously conflicting stories told by the artist, some of her friends, and Daniel Cordier (Martha Jackson has since died), that it was psychologically stifling for Nevelson to be managed by, or meet the demands of, two dealers simultaneously. "They wanted more work than I could produce and Cordier and Jackson couldn't get along with each other. My contract was up and I seemed to be on auction between the two of them. Can you imagine anyone trying to boss me—that way of life was over in the 1930's."

It was impossible to resolve the difficulties, and Nevelson broke her relationships with Jackson and Cordier. At this perfect moment appeared Sidney Janis, who at that time represented de Kooning, Kline, Rothko, Albers, Pollock, Motherwell, and Gottlieb. She was the first woman that Janis represented and the first American sculptor. Nevelson joined the Janis Gal-

59. *Voyage*, 1962. White room at Venice Biennale.

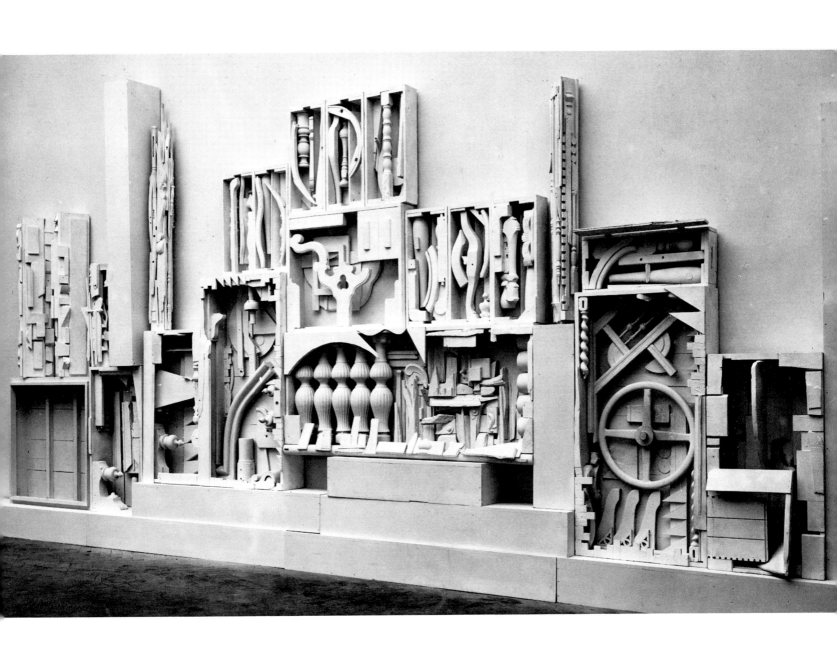

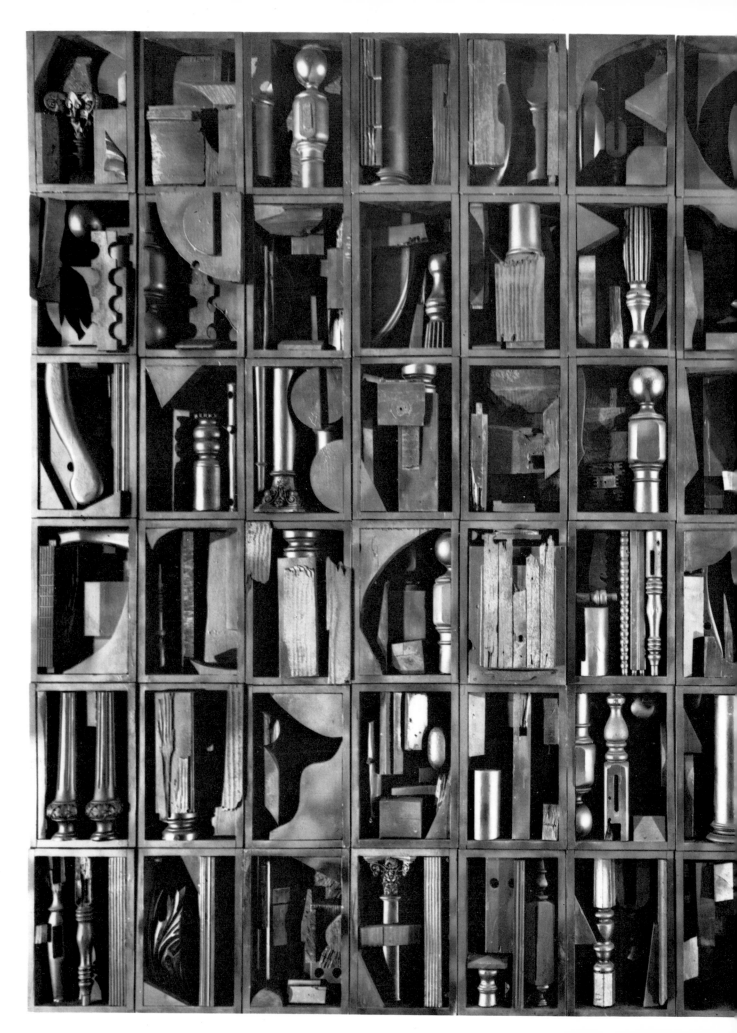

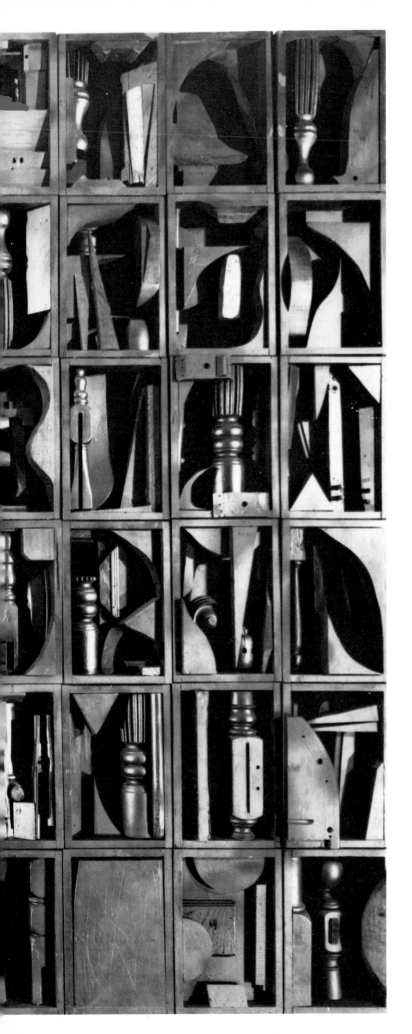

60. *Totality Dark*, 1962. Wood painted black,
98″ x 127″ x 7½″. Collection Pace Editions
Inc., The Pace Gallery, New York.

lery with no specific financial guarantee, which was the policy of the gallery, and on New Year's Eve, 1963, her black, white, and gold nonenvironmental exhibition of separate sculptures opened.

Three massive and beautiful walls were included in the show. The white wall, *New Continent* (Color Plate IV), has already been discussed. The gold wall, *Dawn* (Color Plate V), and the black wall, *Totality Dark* (Fig. 60), are filled with the most compressed imagery to appear in all of her work. *Dawn* is so tightly packed with dumbbells, baseball bats, hat forms, and rifle butts that the images within the boxes are hidden by the front row of objects.

Totality Dark shares the same compression of images; however, the absorbent black surface softens the edges that in turn suggest a greater depth, revealing even less than *Dawn* but implying more. All three works were produced during the fall of 1962, the first time that works of different colors evolved at the same time. It was only possible for Nevelson to achieve this versatility in a situation where the works were separate sculptures, one of the residuals of the gold period. Nevelson was packaging three periods of her works into these pieces. Although the three works are remarkable, the totality of the exhibition was burdened by a sense of summation and finality. The greater financial success that she expected because of her association with a different and legendarily successful gallery was unfulfilled. One small work was sold out of the exhibition, and Nevelson was in debt to Janis for money that she had borrowed to prepare the show. Her relationship with him quickly deteriorated, and it became necessary to sell her house (she rerented it from the new owners and rebought it in 1967) to survive while paying court expenses and attorney fees to extricate herself from an intolerable relationship. Nevelson's greatness was not dependent on the proximity of the other artists in the Janis Gallery or on the endorsement of, at the time, the most important dealer, but her isolated self-image needed the reinforcement of her peers. Janis held the three great walls as collateral until a year later, when, with the help of friends, Nevelson repaid him the $20,000 that she owed him. Jackson and Cordier owned most of her work, she had lost the security of her house, and she was bitterly disappointed and depressed. One of the most difficult periods of her life followed. *Moon Garden Plus One*, the Venice Biennale, and public recognition of her as one of the great American artists had all been consumed. The great environmental works appeared to be over, and she even made a summary statement in the Janis show. Financially broke, she appeared to have outlived the moment, and close friends feared she might end her life.

IX. *Tide I Tide*, 1963. Wood painted black, 9' x 12'.
The Albert A. List Family Collection, Byram, Conn.

X. Installation at Whitney Museum of American Art, 1967.
Left: *An American Tribute to the British People*, 1960–65.
Wood painted gold, 12' x 14¾'.
Collection The Trustees of The Tate Gallery, London.
Right: *Sun Garden I*, 1964. Wood painted gold, 72" x 41" x 2
Collection Mr. and Mrs. Charles Diker, New York.

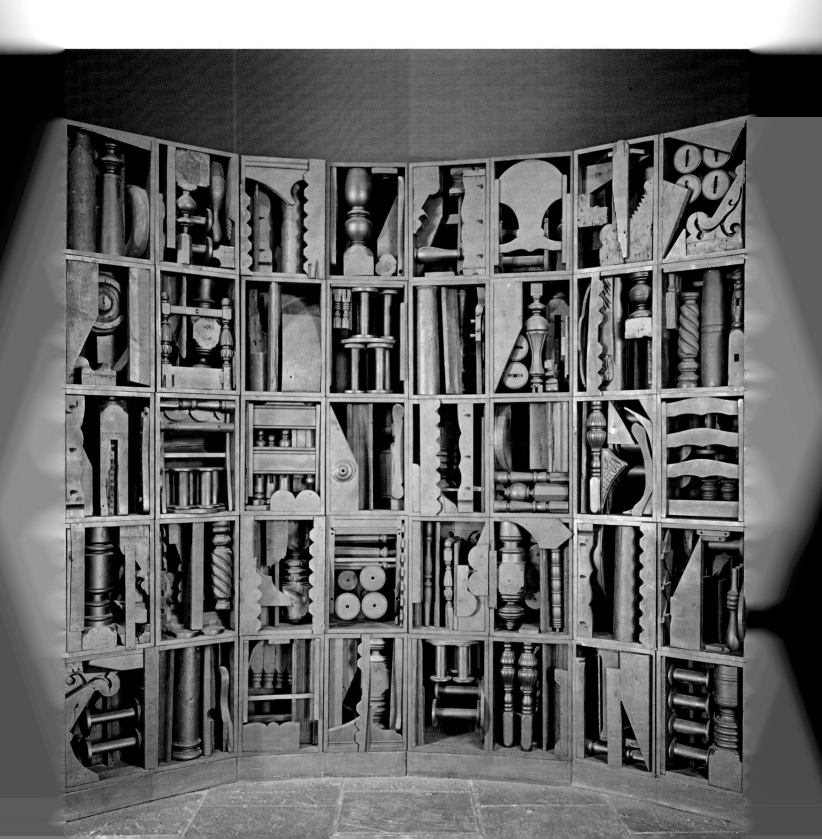

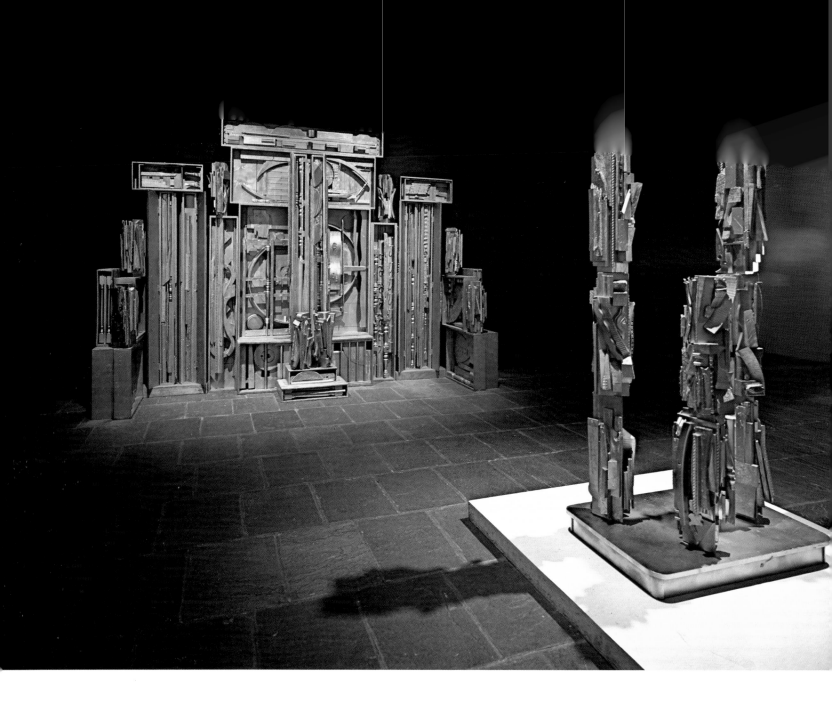

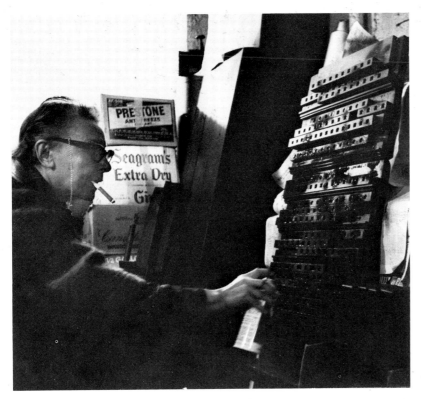

VIII Time, luck, and fate were on Nevelson's side when she was invited by June Wayne in the spring of 1963 to go to Los Angeles on a Ford Foundation grant and produce a series of prints at the Tamarind Lithography Workshop. Nevelson recalled, "I wouldn't ordinarily have gone. I didn't care so much about the idea of prints at that time but I desperately needed to get out of town and all of my expenses were paid." This opportunity saved Nevelson's life. Los Angeles was a fresh, warm place, and the Tamarind staff became supportive to her. She immersed herself in the production of lithographs by printing lace and rags (Fig. 61) into the stone and drawing into black fields with a sharp tool. The images are melancholy, brooding, and elusive; forms almost accidentally appear in black fields, unrelated and lost. Occasionally color is used but then only deep blue and Indian red (one of Nevelson's favorite colors).

When all else seemed lost, Nevelson still had one of her most important possessions. "All my life people have told me not to waste my energies on anger," she says, "but I kept anger, I tapped it and I tapped it. Most people die without screaming out."

That summer, I visited Nevelson in Los Angeles, as we were involved in negotiations for her to join the Pace Gallery that was to open six months later in New York. We went to a party together at the home of a film writer, and the enormous anger and impatience that consumed her was aggressively vented on our host. To begin with, she disliked on sight the enormous collection of late Lipchitz sculptures that surrounded her. There were also several Léger paint-

123

61. Untitled lithograph from Tam-
arind Series, 1963. 31½″ x 23″.
Collection Pace Editions Inc.,
The Pace Gallery, New York.

ings, but no Nevelson sculptures. Everyone had had too much to drink and Louise, while lean-
ing over to get her purse, fell off the gild stool she was seated on, nearly losing the wig she wore
cocked like a hat. She lay on the floor for a minute clutching her wig. In a voice considerably
less than intimate, Nevelson said, "They would give me a goddamn three-legged stool." All
conversation ceased, and in an attempt to reestablish the current of pleasantries and artifice,
the host nervously raised a new subject. "You're an unconventional person," he began, only to
be interrupted. "What makes you think that I'm unconventional?" Nevelson asked. He con-

tinued, "You haven't noticed the most unconventional thing about this house. This is probably the only house in Bel Air that doesn't have draperies on the windows." He flicked a switch that illuminated the impressive gardens outside the windows. This was too much for Nevelson, who lashed out at him, "What do you need with windows when you don't have eyes. Tell me, wouldn't you give all of this up if you could write one decent thing?" Needless to say, the party was over, and it was clear that Nevelson was still convinced of her value as an artist.

Nevelson returned from Los Angeles optimistic, and began work on new sculptures. She said that the turning point of her intense depression came when June Wayne, the director of the workshop, told her that never in the history of Tamarind had an artist produced so many works in a six-week period, and that by her calculations the value of the prints was $150,000. "When I heard that," Nevelson recalls, "I was cured. It wasn't that I had the money or was going to

62. *Homage 6,000,000*, 1964. Wood painted black, approx. 9′ x 18′.
Albert A. List Family Collection, Byram, Conn.

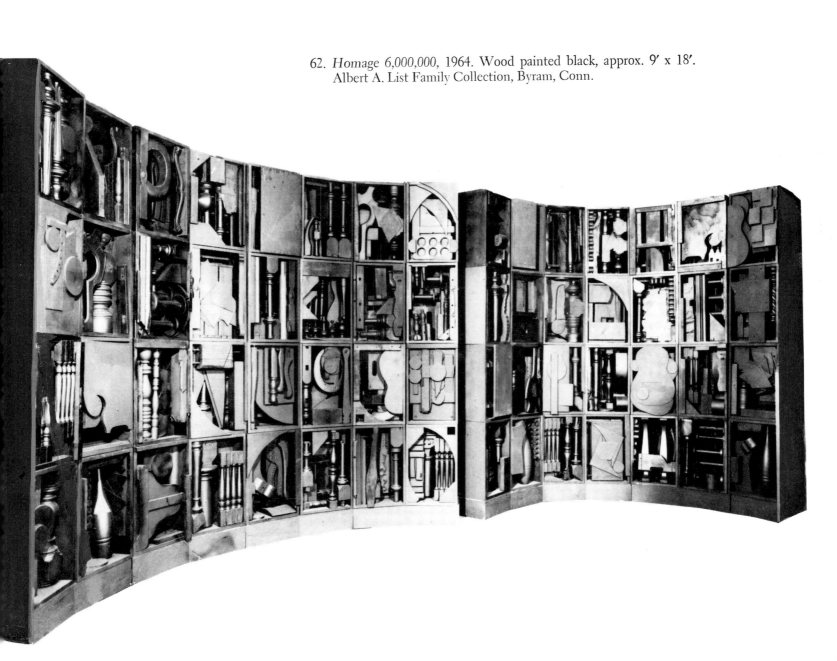

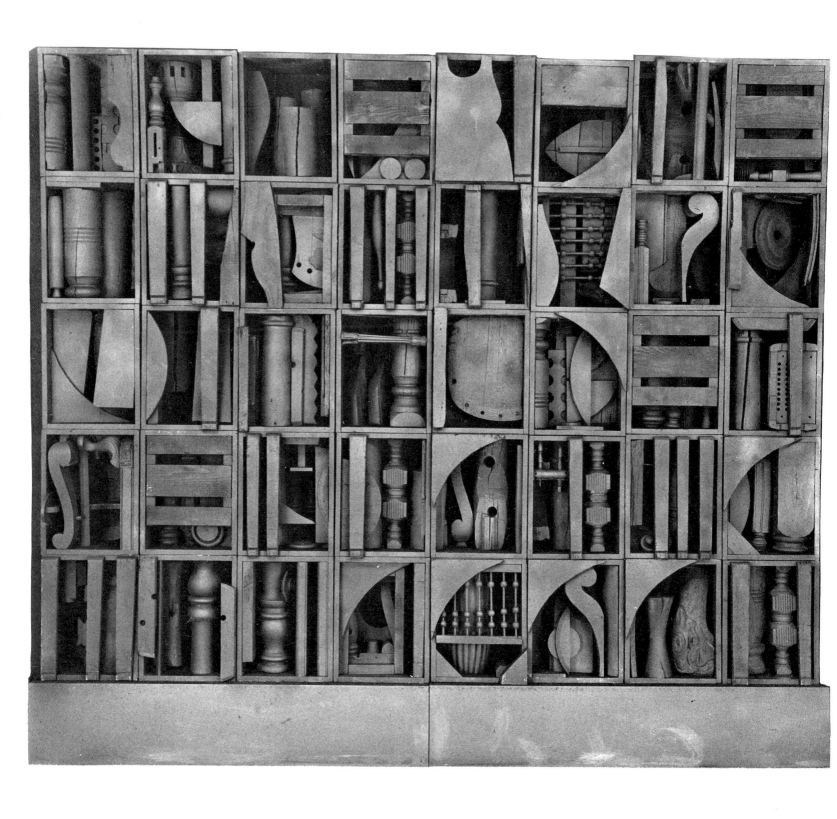

63. *1964 Black Cord*, 1964. Wood painted black, 8½' x 12' x 11½''.
Collection Mr. and Mrs. Joel Ehrenkranz, New York.

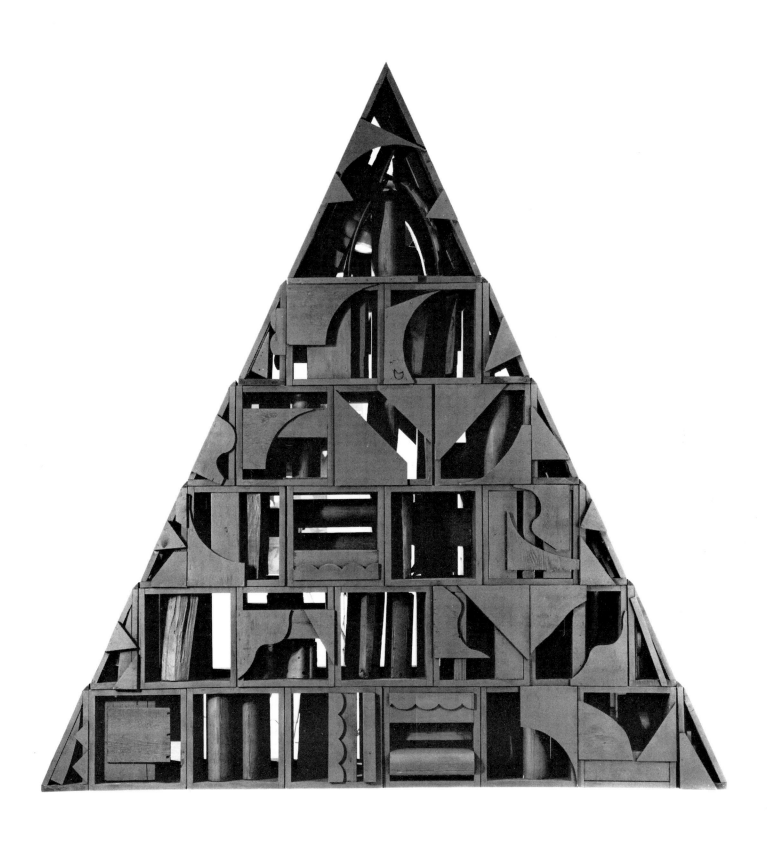

64. *Silent Music I*, 1964. Wood painted black (triangular), 83¼″ x 72¾″ x 10″.
Collection Pace Editions Inc., The Pace Gallery, New York.

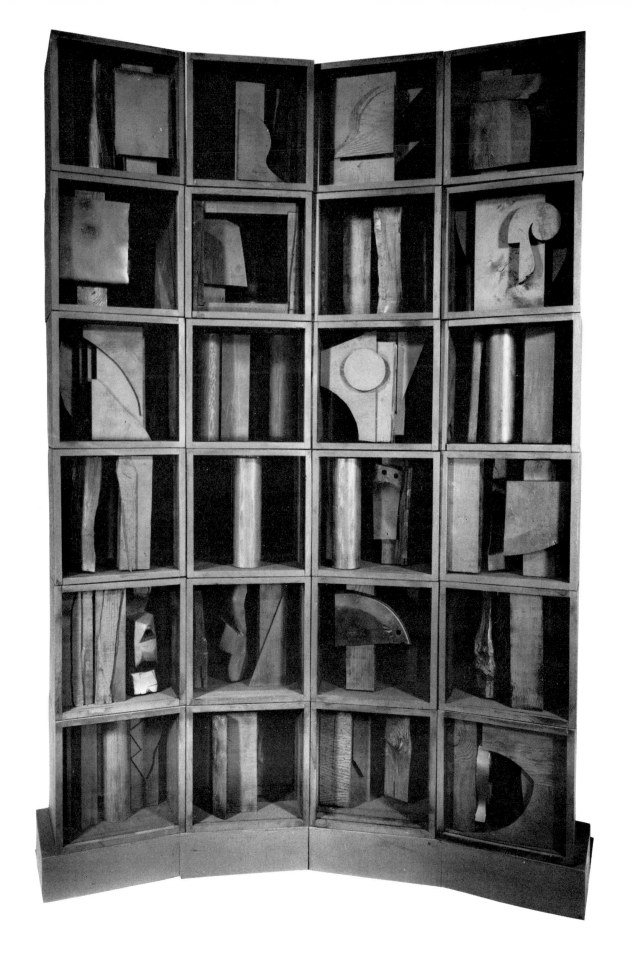

65. *Self-Portrait*, 1964. Wood painted black, 90″ x 60″ x 11½″.
Collection Mr. and Mrs. Ben Dunkelman, Toronto, Canada.

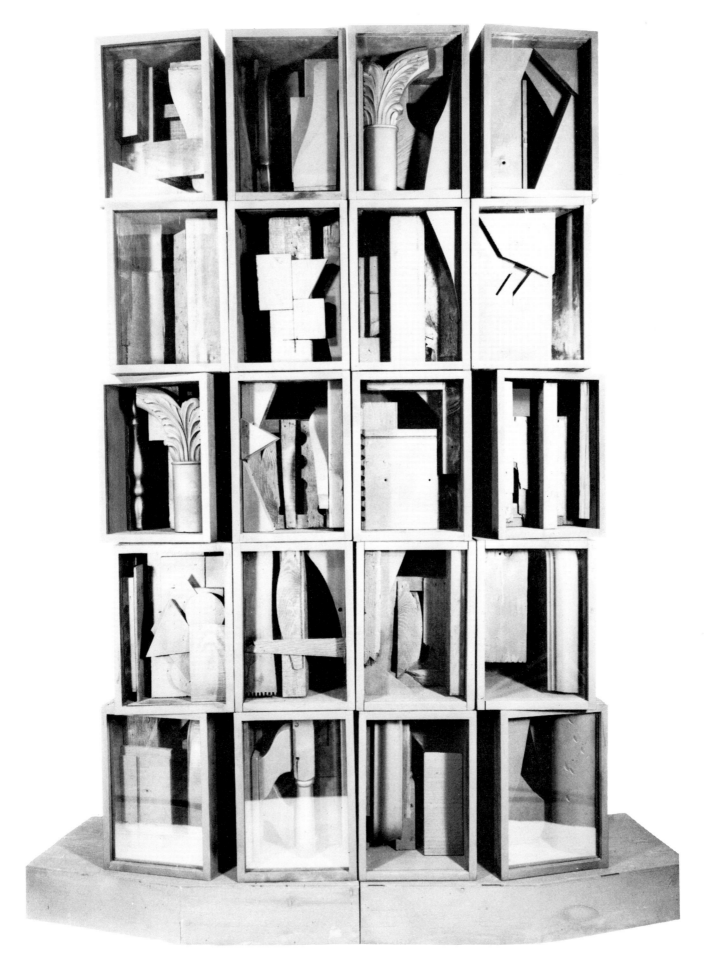

66. *Silent Music II*, 1964. Wood painted black, 80″ x 50″ x 11½″.
Collection Makler Gallery, Philadelphia.

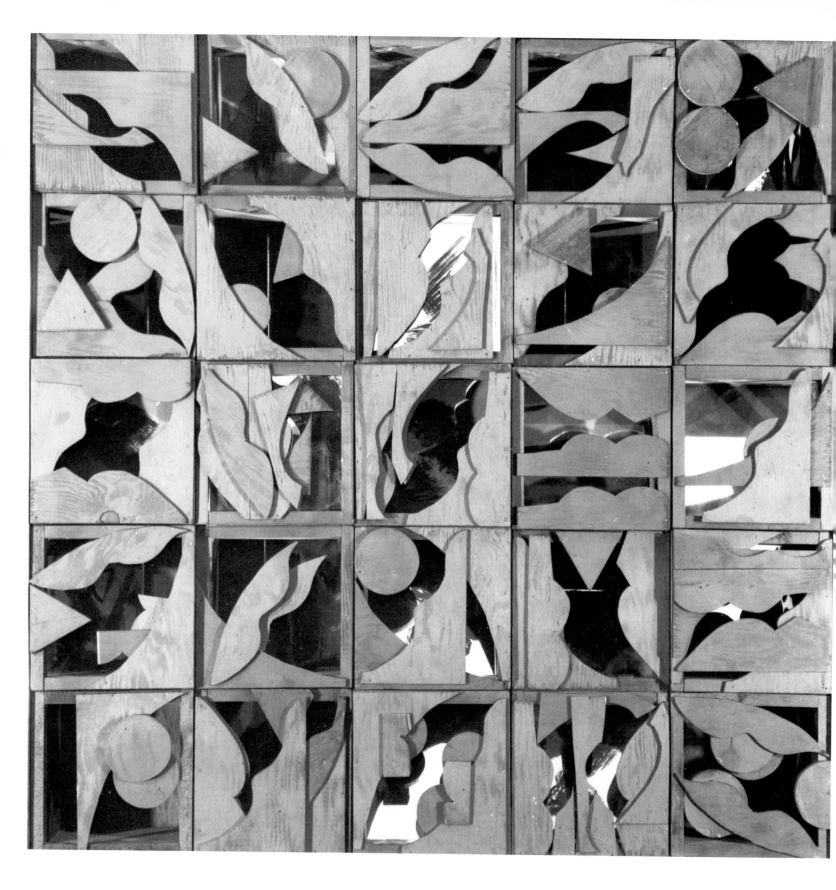

67. *Square Reflection*, 1964. Wood painted black, 45″ x 45″ x 10¼″.
Wasserman Family Collection, Chestnut Hill, Mass.

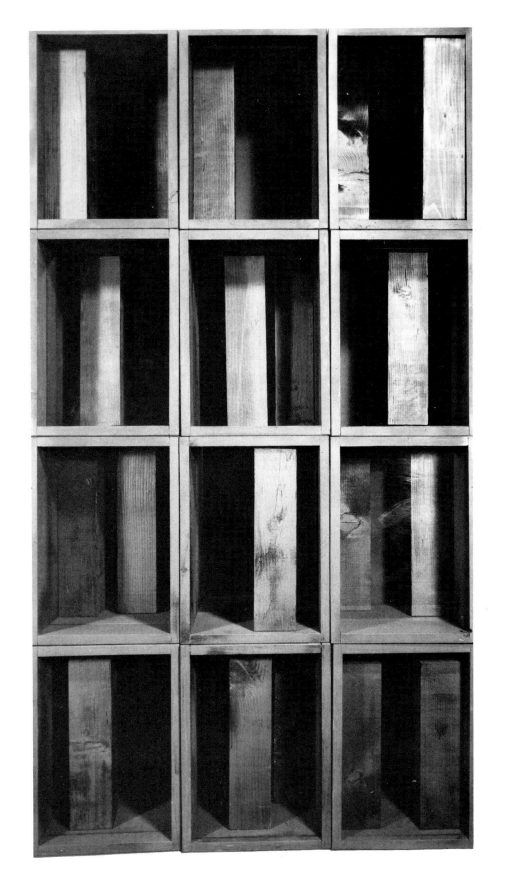

68. *Silent Music V*, 1964. Wood painted black, plexiglass,
64″ x 36″ x 11½″. Collection the artist.

have it, it was just that it made everything bothering me seem just as ludicrous. You might call it a leveling situation."

From a base of what appeared to be defeat, Nevelson reclaimed her future. She created an enormous wall and titled it *Homage, 6,000,000* (Fig. 62). In this work, Nevelson dealt with large interior elements: fans of flat triangles, circles, rectangles, furniture parts, and giant yarn spools, occasionally overspilling their boundaries or nailed across the surface like doors frozen in the act of closing in the large, chaotic passages. It is more than the creation of another edifice of her private universe, it is the successful attempt to reclaim her universe by reconstruction. The title, like all of Nevelson's titles, is a designation for purposes of identification.

Homage, 6,000,000 was followed by *1964 Black Cord* (Fig. 63), which reaffirmed that Nevelson was again entering a black period, the first since her gold works. The return of black also marks her most radical change in format. In November, 1964, at the Pace Gallery, Nevelson showed a group of sculptures that, although no longer dependent upon the gallery space and clearly delineated by format, remained environmental.

In *Silent Music I* (Fig. 64), the artist composed the square and wedge units into an isosceles triangle. In *Self-Portrait* (Fig. 65), a vertical, arc-shaped wall of four stacks, each containing six boxes, is filled with a series of black signpost-like images. Plexiglass panels cover the face of each box to "distance" the images. *Silent Music II* (Fig. 66) curves back toward the wall, cracking open into irregular wedge-shaped spaces between the units like the leaves of a book opening from the spine.

The change in format and the inventory of silhouettes would have represented a significant step in the evaluation of the artist's work, but this evolutionary step was to be of greater complexity. With *Silent Music I*, Nevelson exposes the total work and continues to extend her space by means of mirrors inserted in the back of each box. The reflected forms are the back and sides of the real forms and the boxes also contain the moving and static fragmented images of people and other objects in the room. They consume the actual environment and act upon it by visually punching a hole in the space and filling it with illusive activity. This and several other works, including *Square Reflection* (Fig. 67), invite the viewer to participate within the sculpture, and the threat of her earlier works—to absorb the viewer—is realized.

The most unexpected piece of the series is *Silent Music V* (Fig. 68), where the artist employs one form, a rectangular column, and repeats it throughout the small wall. This image is anti-illusionary and specific in nature, varying greatly from her other walls. Each unit presents a reorganization of relationships between the space and placement of the similar forms. The concreteness of the objects within the space is asserted as the repertory of limited relationships totally reveals the objectness of the forms. Simultaneously, the almost chance placement of the rectangles helps to explore and reveal the negative area of the box until its space becomes com-

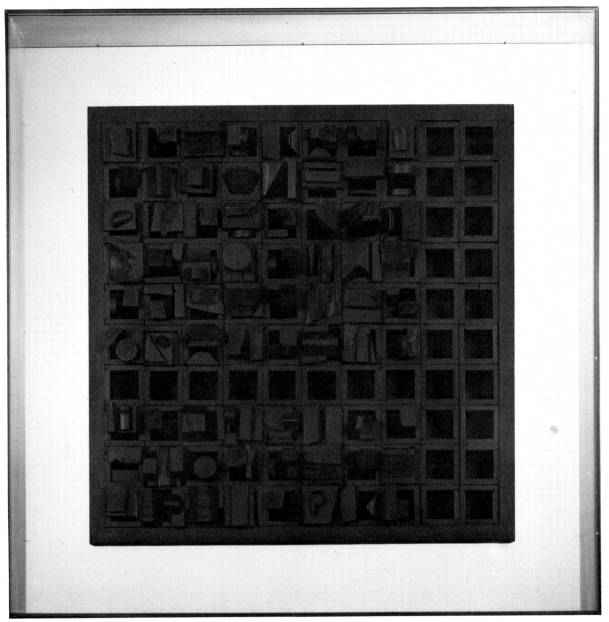

69. *Diminishing Reflection XIII*, 1965. Wood and plexiglass, 23″ x 23″.
Collection Howard and Jean Lipman, New York.

pletely known. This cross-reference vocabulary of ideas relating to a specific form is like the microscopic examination of an image stored in memory. Finally, the retained image of this work is the single rectangular column.

Concurrently, Nevelson produced her most intimate pieces, entitled *Diminishing Reflections* (Fig. 69). She had fabricated multiple miniature boxes approximately 2 inches square, which she filled with chess pawns, checkers, and scraps of wood. In some of the works, the back panels were mirrored, reflecting the static spores as well as the room beyond. She placed these next to or among boxes that were not backed by mirrors. The dramatic result was that the mir-

ror boxes read as shallow spaces and come forward, while the black boxes project infinite density. In some *Diminishing Reflections*, she combined two walls and composed diptychs. In these, one wall panel may be completely empty and the other totally packed, or boxes backed by angled mirrors are played against a mirror-backed panel filled with elements.

To protect these tiny walls from being swallowed by human-scale reference and to prevent them from looking like toy Nevelsons, the artist has enclosed the walls in cases of smoky gray plexiglass. These create the impression of a chamber filled with an enormous distant wall secreted behind the light reflections on the clear plexiglass surface. The highly reflective plexiglass, in some cases compounded by the insertion of mirrors, made fixing on the total image difficult, in the same way that one is unable to grasp the independent structures within a large Nevelson wall. Several small walls were made by vertically stacking boxes slightly in front of the one below until the maximum protrusion was reached and the stacks reversed their direction. This was the general form that the clear plexiglass, black metal, and cor-ten steel walls were to follow.

IX Nevelson resents the multitudes of people that attempted to renew their vague old acquaintances with her. She feels they are the same people who were absent when she needed friends. Once she said that she wears glasses as much not to see people as to see them. Several years ago, during an opening at the Martha Jackson Gallery, Nevelson was interrupted in conversation with friends by a man who suddenly hugged and kissed her. One of the men already talking to Nevelson turned to the interloper and said, "I didn't know that you knew Louise Nevelson." He replied, "I've known Louise for more years than I can remember. I know her *very* well." Nevelson raised her glasses suspended on a silver chain around her neck, looked directly into the intruder's eyes, and asked, "Have I ever slept with you?" Embarrassed, the quickly shrinking man nervously said, "Why no, no, of course not." "Then you don't know me *very* well," Nevelson replied and, turning back to the man she was originally speaking with, continued the conversation.

The absence of other people in her daily life is intended to create a sense of freedom from dependence on them; also, she refuses to complicate her life. She works with one assistant. In the early 1960's, it was rumored that Nevelson commanded an atelier like a modern Rubens, but this, of course, would have been psychologically impossible for her. From 1952 to 1964, she was assisted by Teddy Hazeltine. Early in 1964, Teddy brought a friend to the studio to meet Nevelson: Diana McGowan, who became her assistant and personal photographer after Teddy's death. Nevelson's compulsive, almost automatic work habits are incompatible with

70. Entrance to 29 Spring Street, 1971.

the patience and preconceived work-order necessary for planning a project and directing its completion by a number of assistants, at least a project that she is physically capable of completing herself.

Until 1960, Nevelson virtually made all of her works. In 1960, she began to have boxes made especially for her rather than relying only on found ones. Contrasted with milk cases and lettuce crates, the boxes that she ordered from the carpenter were sleek and perfect. This marks the beginning of a new direction compatible with the then formative minimal aesthetic of the late 1960's.

In the early 1960's, a visit to Nevelson's studio was like a trip to a natural phenomenon, like seeing the Grand Canyon. One entered her twenty-room pseudo-Venetian palazzo, which once served as a private sanitorium, through glass double-doors covered by iron grills (Fig. 70) . The ornate iron grills are the color or noncolor in which the artist is currently working. The grills were gold for the duration of her excursion into the reflective surfaces of her gold sculptures. I have also seen the doors painted white and red. The latter does not relate to her art, and Nevelson says that she just felt like having red doors. Five stories of studios and living space bristled with works completed and in process. Some studios were completely packed with boxes stacked

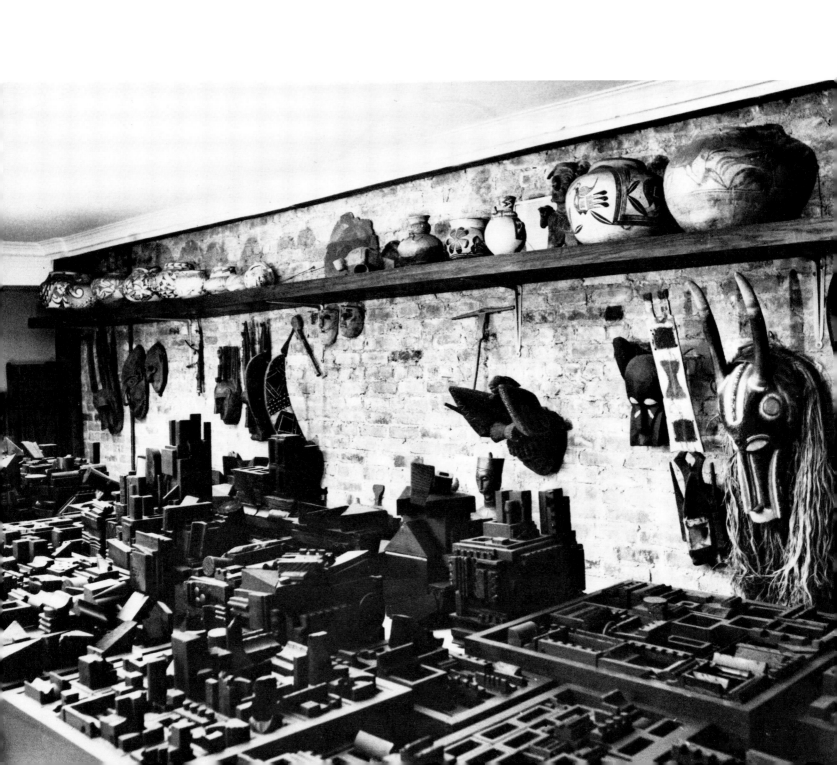

71. Living room, 29 Spring Street.

densely to the ceiling, leaving only a narrow passage to walk through. In the darkness, it was impossible to see very much, but she could always immediately locate the units and walls she needed. Sculpture spilled into the hallways, like the product of the legendary machine that made the oceans salty. All this was not space enough for an empire-builder. Down the street, in an empty store that was once a pizzeria, there was another studio filled with sculptures. Behind the store, in a courtyard surrounded by the backs of tenements decorated with fire escapes, was a small paved area approximately 40 by 50 feet, where Nevelson would work on hot summer days. She found this enclosure—the space at the bottom of a well, extremely compatible; she often worked late into the night, the only illumination provided by the lighted tenement windows.

Her living room (Fig. 71) was painted white, with the exception of one long wall that was left natural brick. African masks and early American tools, including curry combs and weaving tools of exquisite proportions and simplicity, were hung upon the brick walls. On a shelf, spanning the wall three feet from the ceiling, crammed closely together, her collection of American Indian pottery, pre-Columbian sculptures, African figures, and Puerto Rican *santos* was stored. Japanese lacquer chests, wooden tables, and folding chairs completed the collage of room. From time to time, one of her own reliefs hung on the opposite wall. The dining room (Fig. 72) was a showcase for a dramatically presented work. One entire wall was painted sometimes black and sometimes gold, according to the color of the sculpture it backed. A circular glass tabletop rested on four curved glass petals, each secured in a wooden cube. Simple wooden chairs surrounded the table, a Japanese soft-wood chest stood next to the door, and small sculptures were always on the floor (as they often were in the living room). A crate with wooden vertical and horizontal separations looking like one of her sculptures hung on the wall filled with mail that had been separated alphabetically. The tiny adjacent kitchen had a half-size refrigerator, a small stove, a sink, and an enormous Shaker dry sink. The hallways were hung ceiling to floor with Eilshemius paintings. On the bedroom floor, the hallways were filled with early Nevelson paintings.

By 1966, Nevelson's market was firmly established, and both museums and private collectors were eagerly buying her work. The economic security that she now felt was greater than at any time in her life and gave every indication of permanence. She was sixty-six years old. In an astounding gesture, Nevelson now almost completely divested herself of all material possessions. The Eilshemius paintings had already been sold as a result of the Janis situation, the primitive sculptures and pottery were sold, and all of the furniture, including the dining-room table and Japanese chests, was either sold or put out on the street for the rubbish collector. She had the black floors scraped down to their natural pale wood and then waxed. The living quarters and the studios, now nearly emptied of their inventory, were all painted white. In the liv-

138

XI. *Dawn's Wedding Chapel I*, 1959. Wood painted white, 90″ x 51″.
Collection Dr. John W. Horton, Houston, Texas.

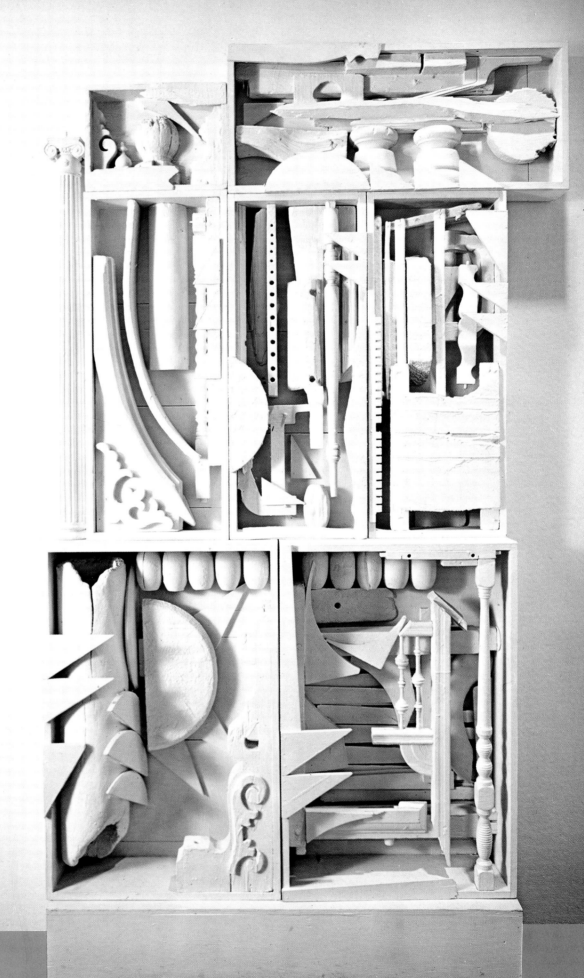

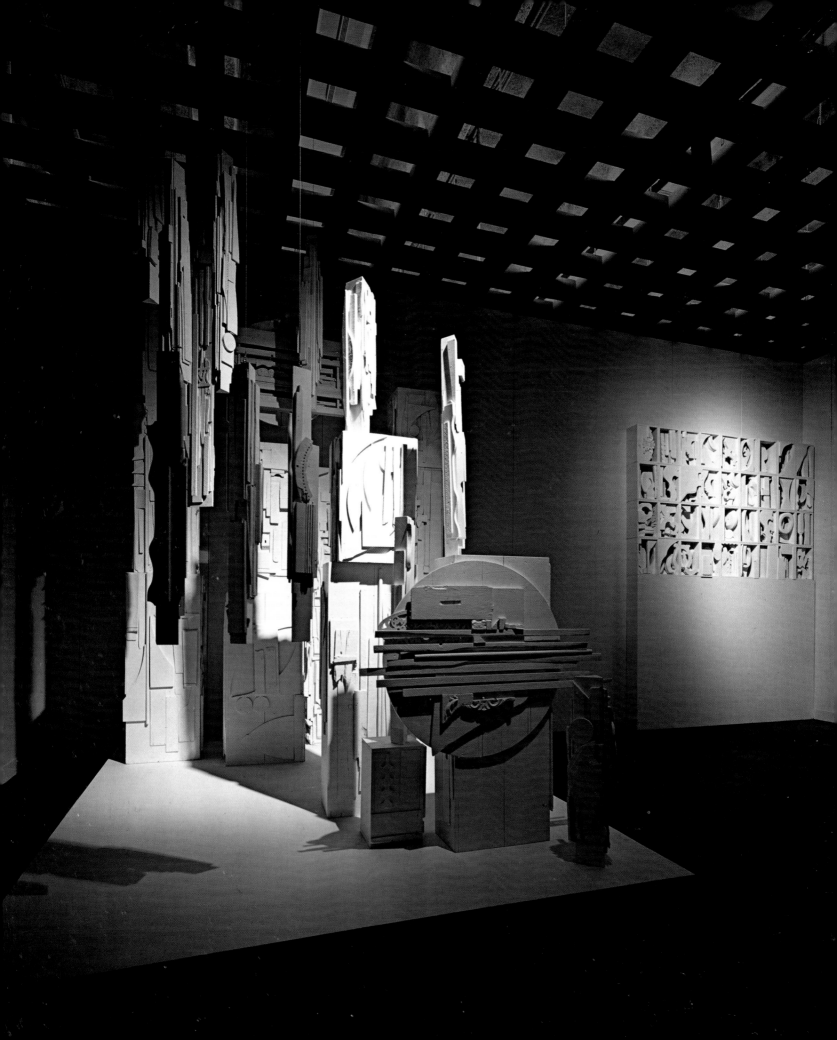

ing room, the shelf was removed, and the natural brick wall was also cleaned white. Just as the *Silent Music* series had opened up, by means of mirrors, to reveal the totality of the images within the enclosures, so had Nevelson removed all of the hiding places that surrounded her to expose a considerably less vulnerable person.

Nevelson replaced all of her discarded "burdens" with gray steel office utility and filing cabinets. They are anonymous and practical and do not impose an aesthetic presence. At this point in her life, she prefers an environment uncontaminated by physical history. All of the expected comforts and accouterments of living have been sublimated to allow no distraction from her purpose: her work. The comfort of friends does not interest Nevelson, and, in fact, she says that soft chairs produce boring, comfortable conversations. Besides, she rarely entertains guests. "You know, I don't care about food and my diet has very little variety," Nevelson said. "I read once that in her old age Isak Dinesen only ate oysters and drank champagne and I thought what an intelligent solution to ridding oneself of meaningless decision-making." Nevelson's solution to furniture was as efficient as Dinesen's to food.

"Being born is a terrible accident," Nevelson says. "And I believe that the inheritance of ancestry and religion is a crime. To further be hindered by possessions that I must take to the grave would be unthinkable."

Visiting the house after 1967 was a very different experience, more like visiting a monastery than a garden in moonlight. The grills on the doors are still painted black. The black iron railings of the stairway are secured into the gray marble stairs, shallow wells worn at the center from use. The right wall of the stairwell is painted black, as is the facing wall of each landing. On the first- and second-floor landings, one is confronted with a new work (Fig. 73) or small environmental groupings of works in a constant state of change and refinement. The reception room (Figs. 74 and 75) floor, gleaming with new varnish, is nearly empty. Small pale wood tables, pushed together, serve as a single conversation, utility, and dining table. Small sculptures may be stacked at random on the floor, and sometimes a large sculpture totally fills the walls between the windows, but most often it is nearly empty of art. The only nighttime illumination is the light from a bare flood-bulb at the top of a photographer's tripod, placed behind Nevelson's chair, illuminating her guest. The circular transparent glass table that once graced the dining room was replaced by a redwood picnic table and matching benches, all painted black. Recently this has been discarded, and the perfectly square room has become a shrine for a new sculpture that totally circumscribes the otherwise empty space. The fourth floor houses her clothing, all packed with obsessive neatness into steel lockers. The empty hallway leads to Nevelson's room, which has little more than a bed covered with an Indian blanket, a sculpture by Mike Nevelson, and storage cabinets (Fig. 76). The rest of the floor is made up of various studios and some sculpture storage.

141

II. Installation at Whitney Museum of American Art, 1967.
 Left: *America-Dawn*, 1962–67. Wood painted white, 18′ x 14′ x 10′.
 Right: *New Continent*, 1962. Wood painted white, 77¾″ x 121¾″ x 10⅛″.

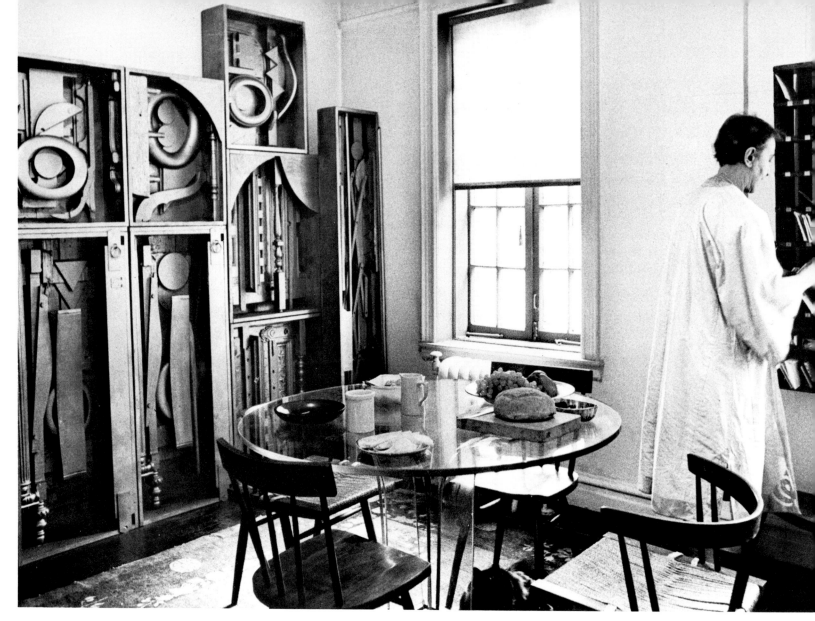

72. Dining room, 29 Spring Street.

During a trip to St. Louis in 1965, Nevelson, usually more interested in product and conception than process, toured the fabrication company and foundry that produces Ernest Trova's works. She was impressed by the commercial castings being made in the foundry and equally fascinated by the gates and risers that were a result of the casting procedure. Gates and risers are positive castings in bronze or aluminum of the openings through which the molten metal is poured to fill the mold, and the tubular passageways through which the air escapes the in-rushing metal. She ordered a series of boxes to be fabricated in aluminum, with partially enclosing triangular shapes to be fastened on the open front and back of the solid-sided boxes. After a wait of approximately a month to fabricate the intended component enclosures, as well as for the foundry to collect a reservoir of rejected waste-castings and gates and risers, Nevelson

returned to St. Louis. She expected to work within the familiar process of her wood assemblages, using objects in an immediate and intuitive interplay. The size and weight of the metal castings made the familiar spontaneous trial-and-rejection method unworkable. Furthermore, it was impossible to suspend forms immediately from the top surfaces without supporting them at the bottom. In short, she was unable to achieve the tension, flexibility, and immediacy that characterizes her style. Instead of creating a more resistant and immortal work, the metal castings appeared soft, blistered, and unvaried in texture. The first attempt was unsuccessful, and she rejected the results. It was clear to the artist that, short of casting existing wood walls, working in metal would necessitate the invention of a vocabulary and a surface finish as hard and deliberate as the material itself. In the past, Nevelson had cast existing low wood reliefs in bronze with unsatisfying results. Two wood columns were cast in bronze in 1967. Achieved by disassembling each group of forms and lost-wax-casting them separately, the metal totem was

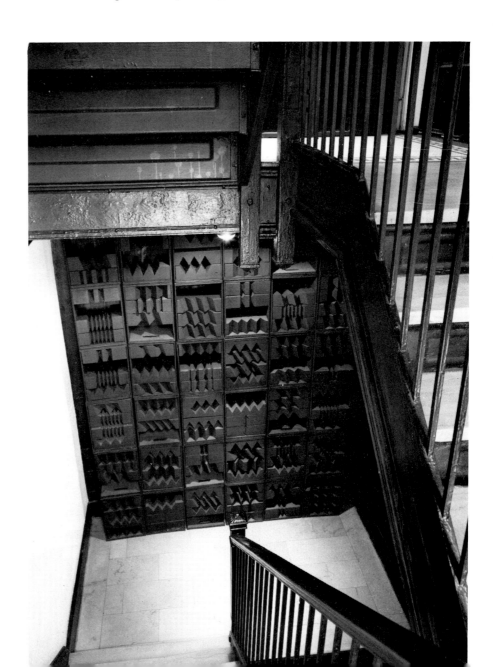

73. Stairwell, 29 Spring Street, 1971.

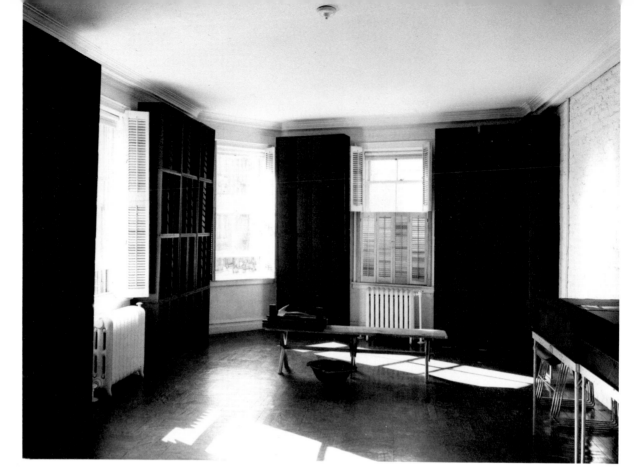

74. Reception room, 29 Spring Street, 1971.

75. Reception room, 29 Spring Street, 1971.

76. Nevelson's bedroom, 29 Spring Street, 1971.

reassembled into its columnar format. A black patina was applied to the wood-grained bronze, and the immediate effect was that of the original wood. At first she was pleased, but within a few days it was apparent that the spontaneous life of the columns was absent. She abandoned her plan to cast a large wall by disassembling each form within each box and casting it separately; the bronzed elements were to be reassembled exactly like the wood prototype. The simplification of her own environment, which was the freedom from bondage to insulating objects, was symptomatic of the evolution of her sculpture. Nevelson had survived the most difficult periods of her life, and she was about to lay totally visible the essential structure of her sculpture.

"By the mid-1960's I knew that I was functioning on a different level," Nevelson says. "I could now synthesize all of my work into one line. Only once before could I be so economical in form. I made a sculpture in 1955 called *The Bridge*. It was a single two-inch lath 10 feet long with a couple of wood blocks on either end. To change the texture of light I glued a one-half-inch-wide ribbon of black velvet to one edge of the 10-foot lath—I crossed that bridge."

The instinct for permanence exhibited in Nevelson's turning to metal sculpture so late in her life is striking at a time when the art community (especially the collectors) had accepted

her found-object wood sculptures as aesthetically and monetarily valuable. Perhaps that is in itself the reason that she can now work in metal. Materials of greater durability enabled her to place her works and herself out of doors, unenclosed and unprotected. Although wood is a material of longevity, metal is attended by concepts of immortality to which Nevelson was not averse. But the complexity and flexibility of her requirements were demonstrated when she simultaneously created works in plexiglass that are both physically and visually delicate and illusive. Nevelson found a new, or at least another, freedom in the method of construction of her metal and plexiglass works, a metaphorical disembodiment that now made it possible to allow participation of others, to realize her art. Unlike the welded metal sculptures that were dominant in the 1950's, she could, through earned aesthetic permissiveness and intellectual freedom, more than technological skill, create works out of enduring materials by directing their process into existence. The technicians became an extension of her own hands. There was, however, another great limitation that she sought to overcome with her metal sculptures, and that was her previous inability to compete with and assimilate nature itself. The metal works did not shut out the real world but rather dealt with it by inclusion. She was secure enough to come out of her shelter and incorporate her self, in its extension, into the world she tried so hard to reject. But this rebirth was on her own terms. She could rid herself of possessions both as external as her furnishings and as internal as her sculptures. She enjoyed the luxury of celebrity without the price that an actress or politician has to pay. Her celebrity germinated from her works and was very much confined to them. They were the disguise she wore to protect herself, and that had always been one of her purposes. It was a reflected celebrity, like seeing oneself on film and being part of the audience. She once said that she considered all art works to be sexual objects for the artist and for the viewer.

She remembers a confrontation in which she saw a person, totally unaware of her actions, culling sexual experience from one of her sculptures. In the late 1950's, Nevelson made one of her rare museum visits to see an exhibition at the Whitney. After viewing the show with a friend, they went to the gallery where Nevelson's sculpture *Black Majesty* was installed. From a flat, rectangular base, four tower-assemblages rise with near equal spacing between them. The elements are unusually smooth and elegant of surface; dissimilar to most of her works, *Black Majesty* invites tactile participation. In the gallery, two women were discussing the piece with such concentration and disdain that they did not notice Nevelson and her friend entering the room. "They call this sculpture?" one angrily demanded, rhythmically rubbing a form. "I wouldn't take this home to burn it." She continued massaging the form. Nevelson and her friend were astonished and fascinated and continued to listen and watch. At the playful urging of her friend, Nevelson walked forward and told the women that she was the artist. "I don't care if you are the artist—I wouldn't take this home to burn," she repeated. Nevelson and her

friend left the gallery. Nevelson's awareness of the sexuality of her work contributed to her waiting so long before she considered publicly showing her work, selling it and thereby divesting herself of self-images.

The very basis of Nevelson's environments is enveloping rather than object-delineated, and when she turned to metal sculpture, she was cognizant of the challenge of incorporating landscape into sculpture. Her metal sculptures had to be flexible enough to incorporate unknown landscapes. There were no options for the continuation of the consistency of environmental concern in Nevelson's work, other than adopting a new arena within which to work.

Nevelson's first metal works were made of aluminum, because it is, in comparison to bronze and steel, light in weight and gave her greater flexibility in stacking the units within the box format that she was to continue. For one of her sculptures, she experimented with magnesium, which weighs a little more than wood and gave her an even greater freedom for recomposition and structural changes after the piece was factory finished. Nevelson was at first put off by the fork-lift equipment and cranes necessary for fabricating the metal sculptures. Soon she got used to them and employed them as hammer and nails—changing and moving the arrangement of boxes and forms as intuition directed. Benefiting from experience, she learned from the exercise of error in St. Louis that a radically different approach to process was necessary to produce the works that she envisioned. Because of scale, weight, and cost, most decisions needed to be made before fabrication began. As an architect plans his buildings, so did Nevelson plan her sculptures. She began by working in small-scale models that she made of gray sheet cardboard, making and taping together small open frames that had four closed sides and were open at the front and back. She cut a vocabulary of forms as precise and rigid as the material of their ultimate fabrication. Radiating arcs, progressive squares, familiar **S** curves, and tubes were some of the forms prepared in miniature and stacked for use.

Several separate total box compositions were completed, and Nevelson ordered their construction, each in multiple quantities. Contrasting with the transparent, sooty blackness of the *Diminishing Reflection* enclosures, these were fabricated in polished opaque black plexiglass. The selection of black plexiglass as the material for the *Atmosphere and Environment* models was based on her decision to construct the large pieces out of aluminum, surfaced with a shining vinyl epoxy that resembles plexiglass in its anonymous reflective surface. When the separate plexiglass units were finished, Nevelson began to arrange them into her familiar stacked assemblages, tearing out, changing, and adding forms almost endlessly until the interaction of the separate units reinforced their boundaries. Nevelson placed the completed model on the windowsill for several days to observe the variations of its light-conducting and -reflecting qualities. When she was satisfied, the first major metal work was put into production. In the early models, the geometry of the forms and regularity and rhythm of their composition is reminiscent of the

77. Model for *Atmosphere and Environment I*, 1966.
 Black plexiglass, 12¾″ x 20⅜″ x 8¾″.
 Collection Mr. and Mrs. Douglas Auchincloss, New York.

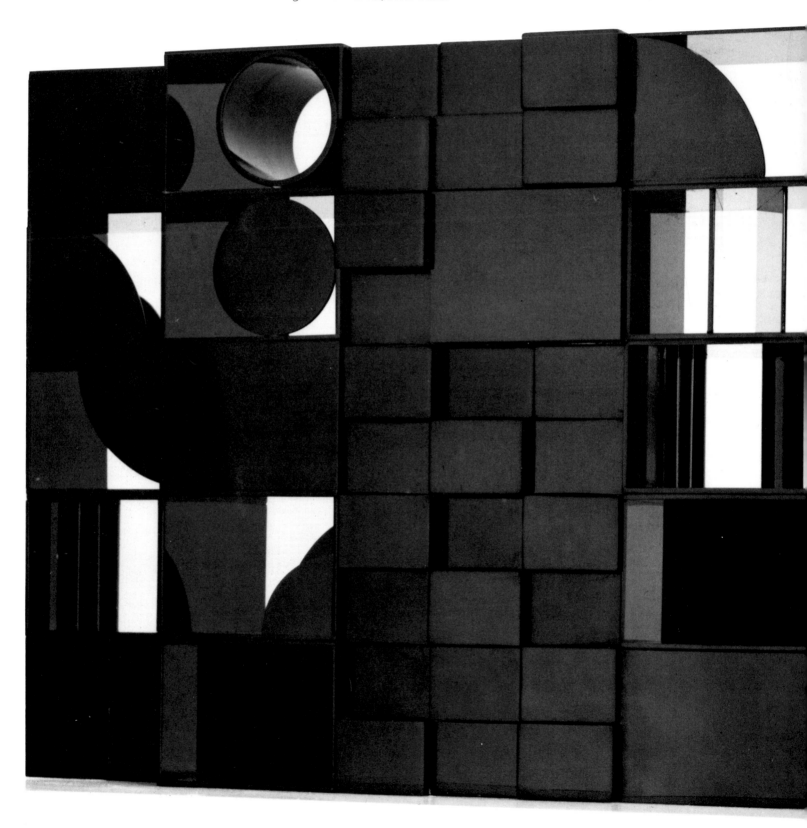

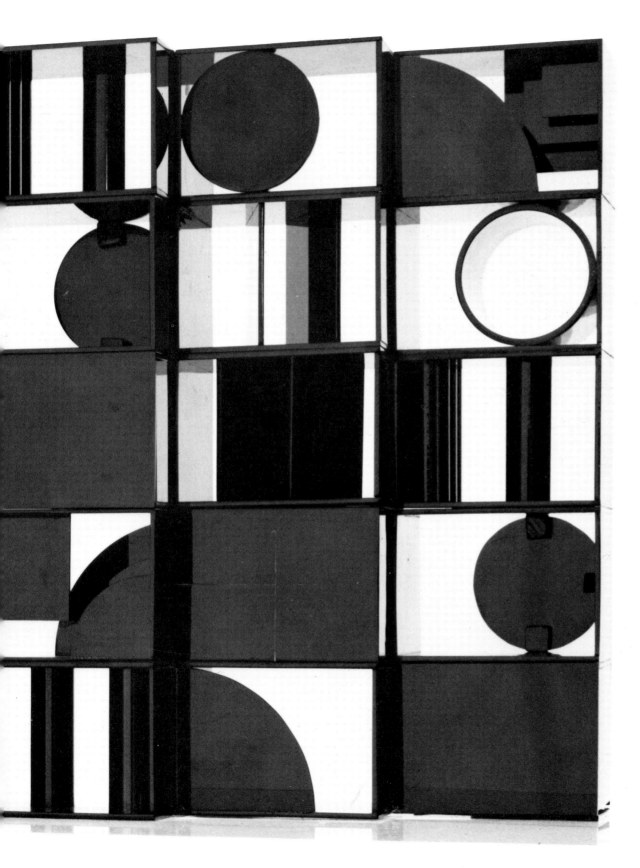

stylistic totality of the Art Deco movement of the 1930's (Fig. 77). The first of these units was designed in 1964, predating the aesthetic resurrection of the 1930's and the predilection for Art Deco repetition and redescription of form that has infiltrated fashion and the arts, and is particularly apparent in the protractor paintings of Frank Stella and the sculpture of Roy Lichtenstein. In Nevelson's *Atmosphere and Environment I* (Color Plate VI), there is a staccato composition of open boxes containing few repeated simple forms played against a center section of undulating black aluminum bricks jutting in and out of a solid composite rectangle, breaking and reflecting the light and the surrounding images with the movement of the viewer. It is a theatrical scrim, like a Cubist canvas that interrupts activity by framing images and reflecting their fragments on the forms within the units as well as the sides, top, and bottom of the boxes. It is a collage of distortions and comparisons that ultimately prismatically contains the multireflected facets of the immediate surroundings. In *Art and Visual Perception*, Rudolf Arnheim describes this phenomenon.

> Now everything in this world is a unique individual; no two things can be equal. But anything can be understood only because it is made up of ingredients not reserved to itself but common to many or all other things. In science, greatest knowledge is achieved where all existing phenomena are reduced to a common law. This is true for art also. The mature work of art is subjecting everything to a dominant law of structure. In doing so it does not distort the variety of existing things into uniformity. On the contrary it clarifies their differences by making them all comparable.*

Atmosphere and Environment I succeeded in packaging and enclosing the changeable qualities of landscape itself, as it becomes integral to the sculpture. Nevelson's vocabulary of forms was expanded by this to incorporate the forms in nature that the artist still insists have never impressed her. But although they had never impressed her in their natural state, by reflection she has ritualized them into new images. Changing light and shadow continue to expand the forms within the separate enclosures. Like her wood walls, these works are frontal in intention. They differ greatly from her early works in that they invite the spectator to view them from another vantage point. Each wall is concave and convex, aggressive and recessive, depending on the viewer's position. Their format is derived from the *Diminishing Reflections* series, in which she sometimes staggered the vertical rows of boxes forward to the maximum protrusion and then reversed the order like two pages angled away from each other for support.

The sculptures that followed became more involved with the interlocking of concentric arcs and squares, repeated and visually interconnected throughout the entire work (Fig. 78). The

* Rudolf Arnheim, *Art and Visual Perception* (Berkeley and Los Angeles: University of California Press, 1969).

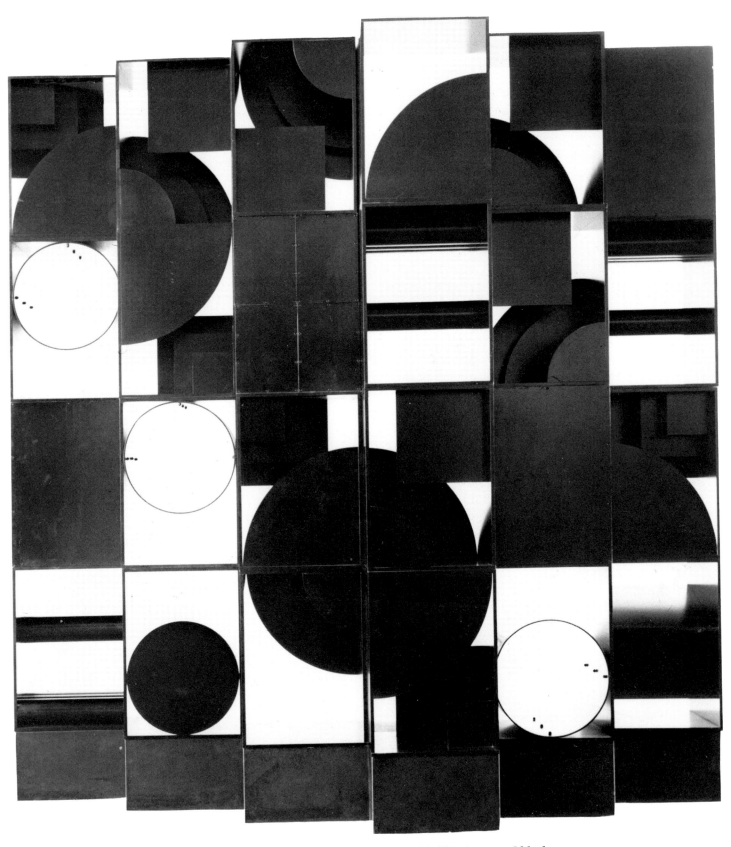

78. Atmosphere and Environment V, 1966. Aluminum and black
 epoxy enamel, 102″ x 96″ x 48″. Private collection.

arcs, radiating in value intensification due to atmospheric perspective, relate one frame to the next. As the rhythmic formal flow intensified with the progression of the series, the normally secondary or negative space areas became more eccentrically shaped (because each unit was filled by more and more complex forms) and took on a greater importance; they functioned as illusion. Susanne Langer, in a discussion of rhythmic design, describes the intuitive processes in the creation of art and their dependence upon particular circumstances. She says that a few practices, the essential ones, are found everywhere:

> The most essential one is the interaction of the primary illusion with the highly variable secondary illusions that arise and dissolve again, while it remains steady, complete and all but imperceptible because of its ubiquity. The fact that secondary illusions never present completely developed realms of virtual time, space, etc., makes their manifestation appear against the plenum of the entirely developed primary illusion which consequently seems like a negative background, supplying their complementary forms; and since secondary illusion may be of many kinds, that background has to have a protean character which gives it an air of indefinite potentiality.*

Louise Nevelson is obsessed with the creation of illusive imagery. The private blackness of the great walls, shrouded in shadow, contrasts sharply with the accessibility of the metal sculpture or landscape-framing devices. The reflected images on the enameled aluminum surfaces suggested transparency and direcetd Nevelson to the production of a series of sculptures as elusive as light.

* Susanne Langer, *Mind: An Essay on Human Feeling* (Baltimore and London: Johns Hopkins Press, 1967).

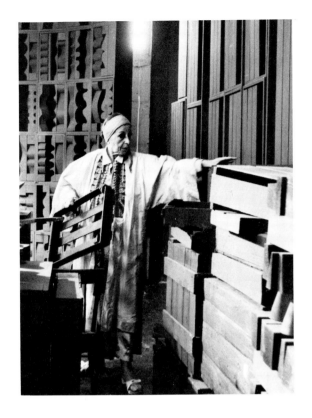

X The Whitney Museum of American Art presented the first major retrospective of Louise Nevelson's sculpture in 1967. Nevelson designed the installation, selected the works, and constructed a dark passage connecting two periods of her work. She entitled this passage *Rain Forest* (Fig. 79), and it existed only for the duration of the exhibition, unfortunately the fate of all her environments. Open boxes or frames filled with piercing tropical forms cascaded from the ceiling, frozen in space over flat, rectangular mirror-surfaced bases, each of which supported a cluster of columns that appeared to rise from a pool. Several sheets of clear plexiglass were interspersed between the black wood elements to catch and reflect the dim white light. Sculpture lined the walls, reliefs and black moons covered the ceilings, and obstacles of sculptures ascended from the floor. The installation was nearly completed, and on the Sunday prior to the Tuesday opening, Fred Mueller and I went with Nevelson on what we naively considered a last-minute check of the exhibition. A guard let us onto the floor that had been closed to the public during installation, and we toured the exhibition. Nevelson was generally pleased, noting lighting and slight mounting changes, until we came to the room containing her early figurative terra cottas and plasters. She would have preferred that they had not been included in the exhibition, but pressure from the museum to make the exhibition comprehensive convinced her to lend the works, most of which had never been exhibited. The largest and least successful sculpture, entitled *Earth Figure*, was in a corner on the floor awaiting the last-minute construction of its base.

153

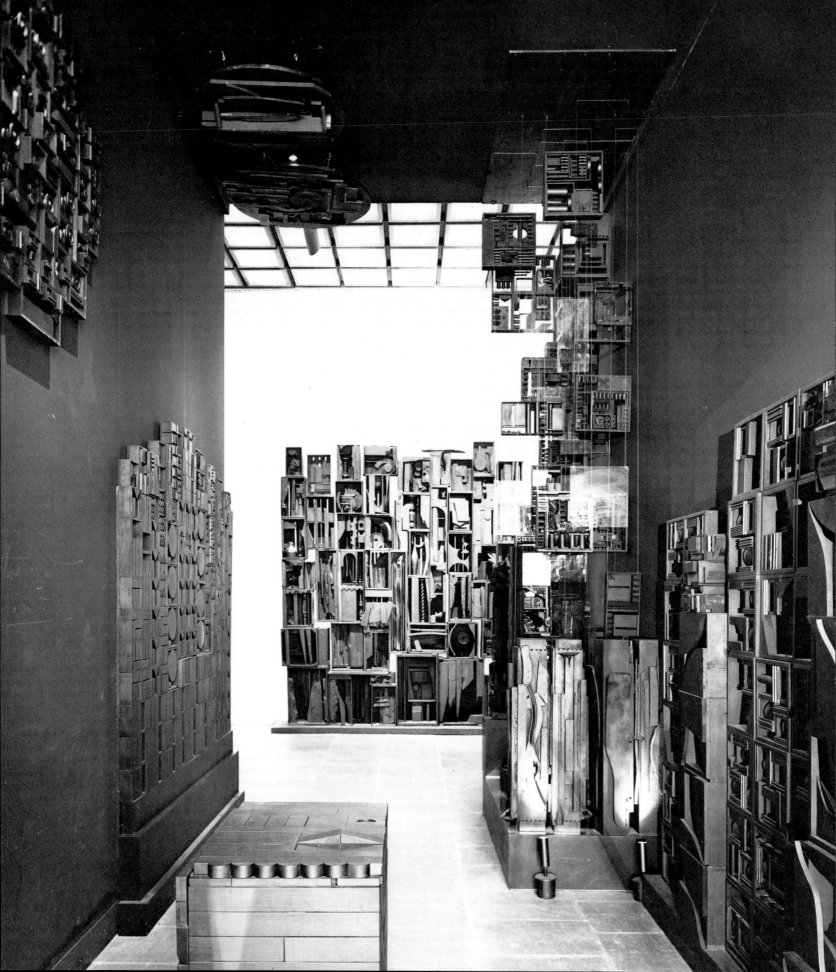

She had never been satisfied with this sculpture. In the studio, it was mercifully protected from Nevelson by the clustering of other pieces around it. Out of her studio, she disliked it even more. There was no way to graciously remove it from the exhibition, as the work was already included in the catalogue. She asked us to pick up the sculpture and move it to the other side of the room. As we carried it she suddenly said, "Drop it." We followed her instructions, and the massive black-plaster figure of a stylized running woman smashed to pieces on the floor. Having edited the exhibition, we all left. The next morning Louise called John Gordon at the Whitney, told him of the accident and assured him that the fault was hers alone. She was now satisfied with the exhibition; she had edited out the weakest piece.

The term retrospective implies looking back from the end toward the beginning, and with every major accomplishment in her life, she is quick to add, "We haven't even started yet." To negate the end connotation of a retrospective, Nevelson showed the first of a new series of works: a transparent plexiglass sculpture entitled *Ice Palace* (Fig. 80).

In *Transparent Sculptures I–VII* and, later, in the *Canada Series* of five pieces, Nevelson confronts us with the transparent skeletal impression of a sculpture, and in this impression is the revelation of the most intimate distillation of structure that underlies all of her work. This is the quintessential extension of her enchantment with the properties of reflected light and the notion of dealing only in positive space. By prismatically conducting, reflecting, and redirecting the light, Nevelson successfully created works that have no real spatial displacement, no weight or constant mass. They identify their approximate position in space like constellations in the sky. Although the series, with the exception of two works, is of tabletop proportions, the impression of scale is volatile; they are transparent sponges that expand with abundant light and contract to near invisibility with insufficient illumination. The need for sufficient light conduction presented the greatest challenge in the realization of the first piece and prototype for the series, *Ice Palace*. The solution for this and other problems within the construction of the plexiglass series was possible because of Nevelson's knowledge of the media accumulated in the process of producing the aluminum sculptures and one other important work. The transparent sculptures are structural variants of the *Atmosphere and Environment* series. They were also somewhat influenced by the construction of a unique piece in the body of Nevelson's art, *Expanding Reflection I* (Figs. 81 and 82), which is a composite of sculpture and printmaking. The 230 cells are made of transparent plexiglass, most of which have been silk-screened with photographs of *Diminishing Reflections* and fragments from her other wood sculptures created between 1964 and 1966. Within this incestuous collage, compound rectangles project forward to differentiate levels. An occasional solid plexiglass hemisphere prism magnifies the Benday grain of the silk-screened images. Flat, black wooden rectangles, circles, and triangles float in chambers devoid of gravity. By contrast, they appear to be painted forms,

155

79. Installation of *Rain Forest* at the
 Whitney Museum of American Art, 1967.

and the silk-screened images, with their strong photographic contrast of light and shadow, give the third dimension to the work. Four small works completed the series, which seemed isolated until the construction of the transparent sculpture.

Nevelson began the transparent sculptures by the fabrication of a clear plexiglass miniature of one of the *Atmosphere and Environment* sculptures. The small transparent model had discernible glue-bubbled joints that destroyed any image continuity. She then devised a new method of construction, whereby the panels and forms of each unit were fastened together by chrome-plated screws and bolts and then each unit was similarly fastened to the next. The light-conduction challenge was solved, and the resultant image was a crystallization of light directed nervously around and through the entire sculpture by as many as 1,500 metal conductors. In *Canada Series V* (Color Plate VII), photographed for maximum effect against a black field, one immediately discerns the glistening supportive grid or dotted line of sculptural fasteners that form the primary image of the work. Stabilization of this grid is achieved by the forms

80. *Ice Palace*, 1967. Clear plexiglass, 24″ x 26″ x 12″.
Collection Robert W. Sarnoff, New York.

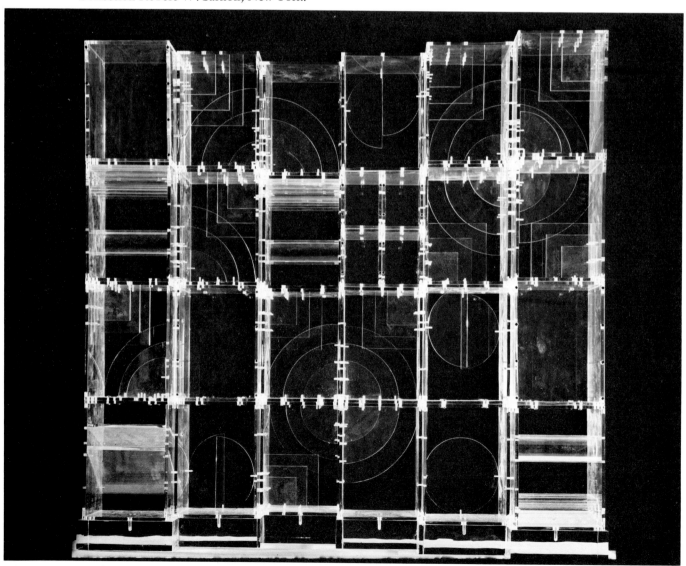

156

within the secondary supporting images of the sculpture. A tracery of light, directed into arcs and rectangles, sweeps across the entire sculpture, intensifying their rhythmic interaction by reversing their images as reflected in the walls of the separate units. Cylinders of heavier-gauge material act as anchor structures, reacting to the same light intensity with greater luminosity and stability. The entire piece is based on a heavy sheet of plexiglass usually scribed to the outline of the piece. As the light intensity diminishes, the more fragile activity is lost. However, in any state of constant light, the work is also subject to enormous variation. The work being viewed is three-dimensional, and its transparency should allow a total revelation of the work without changing viewing position; however, the viewer must change his position to absorb different facets of the sculpture in the creation of new forms by the overlapping of transparent shapes.

The viewer's movement is the activator of light, and it is the fragile quality of light that divests the sculpture of any real sense of physicality and, consequently, the viewer of any substantially remembered image. To achieve these results, the works demanded a perfection of craft that simultaneously denies their construction and exposes it. The evolution of Nevelson's use of the box format from container to object is achieved in this series. Writing of the exhibition, Hilton Kramer articulates the stylistic transition of Nevelson's work from the first walls to the transparent sculpture:

> The new sculptures are constructions in plexiglass. They are transparent, geometric, rather Miesian in their combination of a strict unembellished syntax and a cool detached glamour. They have distinct affinities with the current mode of Minimal sculpture, yet they stand apart from it, if only because Mrs. Nevelson's work offers so much more in the way of visual incident. A maximum of visual incident—accretions of form that state and restate, that amplify and dramatize the basic structure of the work—was the principle on which Mrs. Nevelson designed her first sculptural "Walls" some ten years ago. In the interim, though her work has passed through some notable changes, she has remained loyal to this principle, and it serves her well in these new constructions.

He goes on to describe the early exhibitions as "spectacular sculptural environments" and with great clarity sums up that accomplishment of the transparent works:

> For Mrs. Nevelson is a romantic by temperament, and in following what is, essentially, an antiromantic course she has submitted her work to something stronger and more persuasive than the subjective taste to which it first gave expression—she has submitted it to the logical imperatives of its own form. In her work of the fifties, the Constructivist element was means; in her work of the sixties, it has become both means and end, but more end than means. Structure is no longer designed to "contain" the image; increasingly, it *is* the

81. *Expanding Reflection I*, 1966. Wood, silk-screened plexiglass, 76″ x 36″ x 3″. Collection The Chase Manhattan Bank, New York.

82. Detail from *Expanding Reflection I*, 1966. Black wood, silk-screened plexiglass, 76″ x 46″ x 3″. Collection The Chase Manhattan Bank, New York.

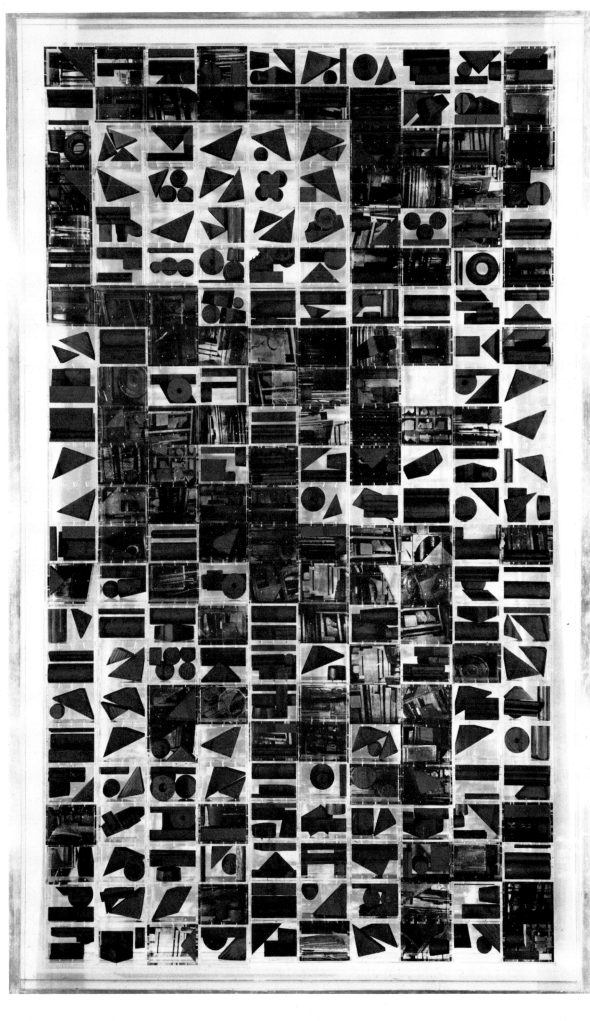

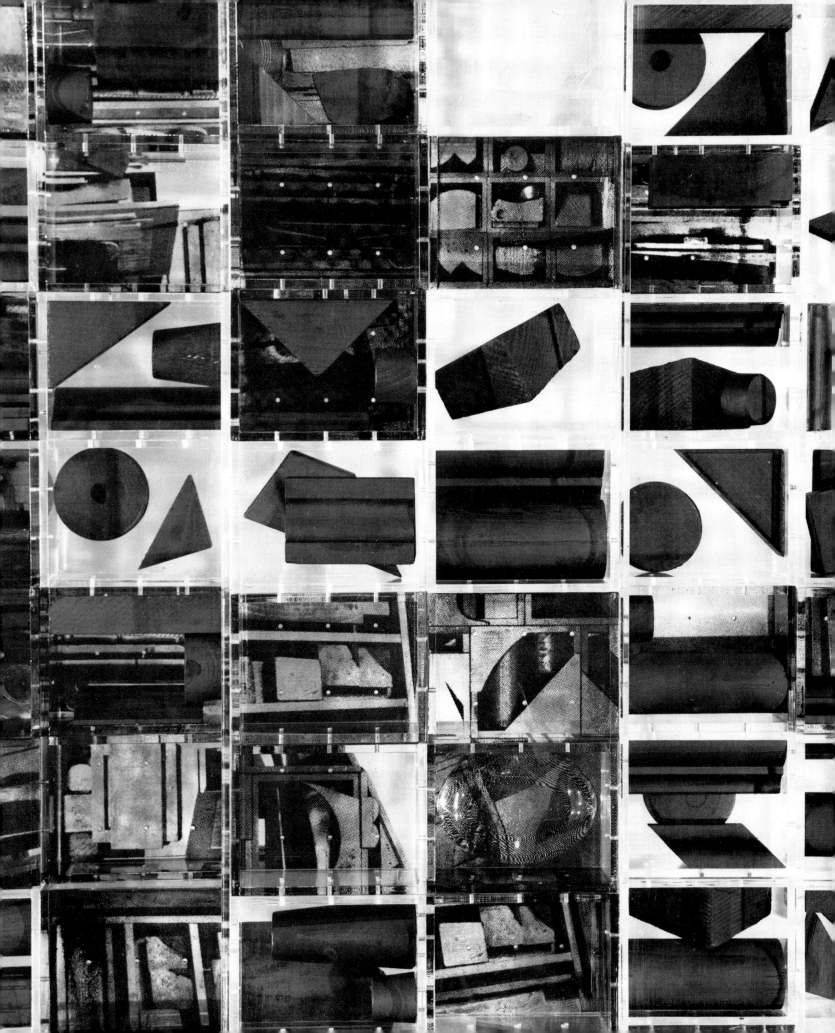

image, and the materials and technique invested in the structure are thus employed to articulate that image.

The ideal of a transparent structure, in which space, mass, and light are identical and indistinguishable, in which the very syntax of the structure gives voice to the unity and inseparability of these elements—this ideal has haunted the Constructivist esthetic from its beginnings. Indeed, from before its beginnings; we find it stated as an aspiration in those crystal palaces of the nineteenth century that anticipated so much of the Constructivist idea. I doubt if any sculptor has carried this old ideal to a more vivid realization than Mrs. Nevelson has in her new work.*

Nevelson continued to produce plexiglass sculptures for two years, until, in 1968, she abruptly stopped. She claims that she has not left the medium forever, but I doubt that she will work in it again. To Nevelson, small works are pages in a sketchbook, and if they are not direct studies, they have enormous influence upon her major works, which are almost always enormous. The magic evanescence of the plexiglass works is dependent upon their miniaturization. As the scale expands and the forms become large planes, the natural detritus in the air is electromagnetically attracted to the surface and spoils the perfection of the piece upon which the activity and illusion depend.

In the metal works, Nevelson could make multiple-process changes and alterations, even after the work was completed. It only required that alterations be made to the existing modules. However, plexiglass is a material that reveals every alteration and requires remaking the altered unit and sometimes the entire piece. The process changes were many, and the time needed to remake these miniature pieces, which had to be constructed with jewelers' tools, was as long as three months for each major refinement. These most visually immediate of Nevelson's works are the least immediate and most arduous to produce. Consequently, the entire series consists of only thirteen separate works. Two pieces are unique, and the others exist in editions of three or six.

In each new series, there is a sense of excitement and discovery and this is especially true of the plexiglass pieces. Nevelson places a premium on surprise, and perhaps she is more surprised by the results of her labor than we could ever be. It is, to some extent, as though she had not made them but rather had been presented with them like a tropical flower that defies categorization by suggesting animal rather than vegetable. She once said that when it comes to the so-called real world, artists are made of surprise, innocence, and blindness. For Nevelson, time is arrested by her works, the work process being frozen in the product. The necessity for the control of time and environment is not confined to her waking hours but penetrates multilevels of consciousness. The dream images she remembers most clearly that recurred most often were

160 * Hilton Kramer, *New York Times*, January 28, 1968.

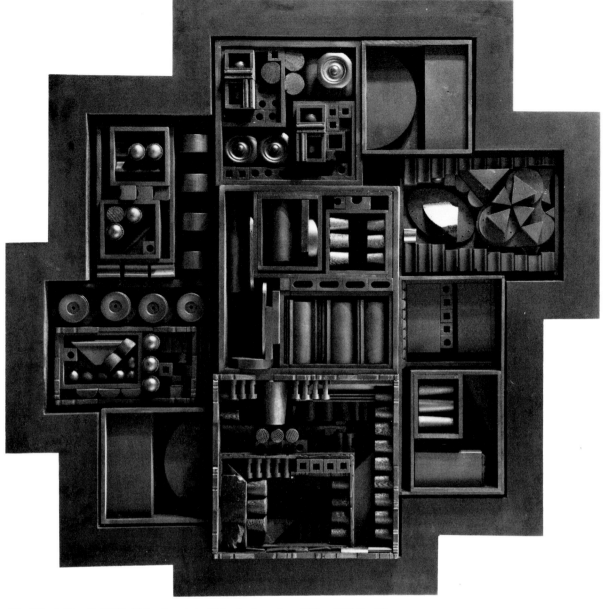

83. *Black Zag J*, 1968. Wood painted black, formica, 41″ x 48½″ x 6″.
Collection Mr. and Mrs. Sidney L. Solomon, New York.

of her sculptures dancing, floating, and soaring in open space. These dreams were most recurrent before she devised the wall format that anchors her work to the floor. She keeps returning in memory to what she insists is the greatest surprise of her life, seeing the ship's depot in Liverpool on her childhood voyage to America. "I can still see it filled with light, it was a fantasy. There were many shops that I thought were houses under one roof that could have been the heavens. There was a store that sold dolls. I had never seen a doll and I was fascinated by the eyes. When you laid her down her eyes closed every time—I marveled at how unhuman it was because my eyes could remain open."

Perhaps the brevity of Nevelson's plexiglass period was based not totally on temperamental incompatibility but on so great a crystallization of personal style and image that further experimentation could only have resulted in repetition. Contemporaneously with the fabrication of

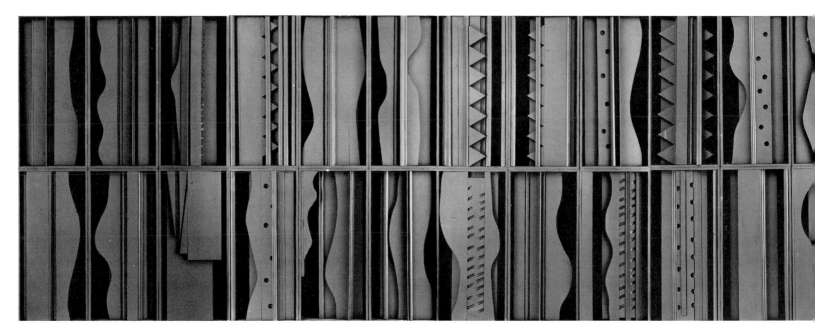

84. *Nightsphere-Light*, 1969. Wood painted black, 8¼' x 47' x 11¼".
Collection Lincoln Center for the Performing Arts, Inc.,
Juilliard Theater Lobby. Gift of Howard and Jean Lipman.

the plexiglass and metal works, she produced a series of wood wall reliefs that she called *Zags* (Fig. 83). Composed of several box units (some, boxes within boxes) aggregated in an irregularly outlined whole, they were framed in black Formica. The forms within often found their origin as Lincoln logs and playschool blocks. She was particularly responsive to the regularity and geometry of these forms. Their anonymity of manufacture and perfection of surface, which eradicated the wood grain, correspond with her conception of perfection in the plexiglass and metal works. The anonymity of her forms and materials is also compatible to, and revelatory of, the period of their creation. In the context of her work pattern, the selection of children's blocks, although they were bought by the hundreds at Macy's, was equivalent to finding lettuce crates and broken chairs on the sidewalk. The most interesting transition was that after the metal sculptures, her forms were no longer exclusively found (or bought) objects. She began to design and order her own inventory of random forms, not for specific pieces but to store and later integrate into new sculptures. As the plexiglass pieces ended, the scale of the *Zags* that started out approximately 30 by 30 inches increased to a maximum of 40 by 70 inches.

Eventually, Nevelson made two black wood walls, opened at the back as well as the front, echoing in format the black metal walls. They were still considerably smaller than the earlier walls but they indicated her return to larger-than-human-scale wood sculpture. Her return to heroic proportion was conspicuous with the construction of the wall *Nightsphere-Light* (Fig. 84). The elements are flat, curvilinear, and completely devoid of texture and appear more to be made of metal than of wood. Different intensities and qualities of light are not reflected; the artist deliberately chooses to stress the grating repetition of similar compositions within the

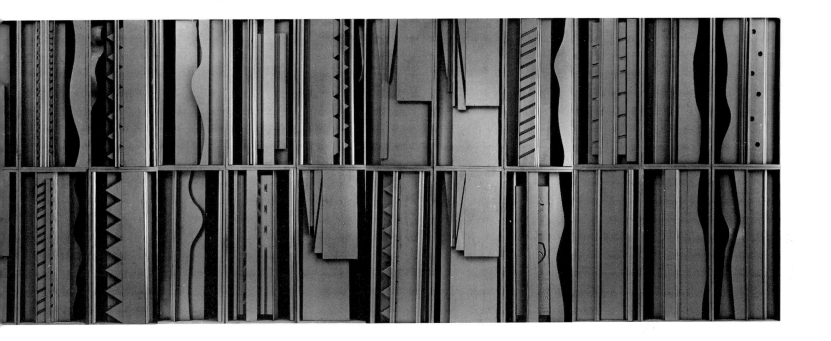

large units. Little more than the surfaces of the boxes are utilized and the shallow pictorial quality is intensified by the selection of Arplike elements cut from boards of similar thickness. In *Nightsphere-Light*, Nevelson has leveled all activity to a common role. The Constructivist sensibility is apparent without the glamour and illusion of the plexiglass and without the contrast and reflected image metamorphosis of the enameled aluminum sculptures. Subsequently she produced another wall entitled *Night-Focus-Dawn* (Fig. 85), which extends repetition to greater extremes and which, for me, is the zenith of her wood sculpture. In format, it is similar to the large black rectangular walls of 1966, but there the similarity ends. Each unit is almost indistinguishable from the next. The basic composition is a box within a box: an irregular, linear, expressive, fragile fruit crate played in a contrapuntal composition of enormous subtlety against a manufactured box. Double spears are attached to the closed fruit crates like decorative armor, delineating the middle ground of the space. Two discs nailed to one side of each box reaffirm the total depth of the cell. Occasionally a box is upside down, but the rhythm of identical or near identical images gradually builds to a single complex form.

Nightsphere-Light and *Night-Focus-Dawn* decided the continuation of the metal sculpture and, more specifically, directed Nevelson to cor-ten steel. Cor-ten steel begins as a dull silver color. It is then sandblasted to give it an irregular orange-peel surface that will hold the natural rust-colored patina that progresses with oxidation to matte black-brown.

In her largest metal works, Nevelson uses cor-ten steel in geometric forms and an over-all ziggurat-like format to arrive full circle at a synthesis of the sensibility of her early textural sculptures of the 1950's and the sleekness of the plexiglass and metal sculptures of the 1960's.

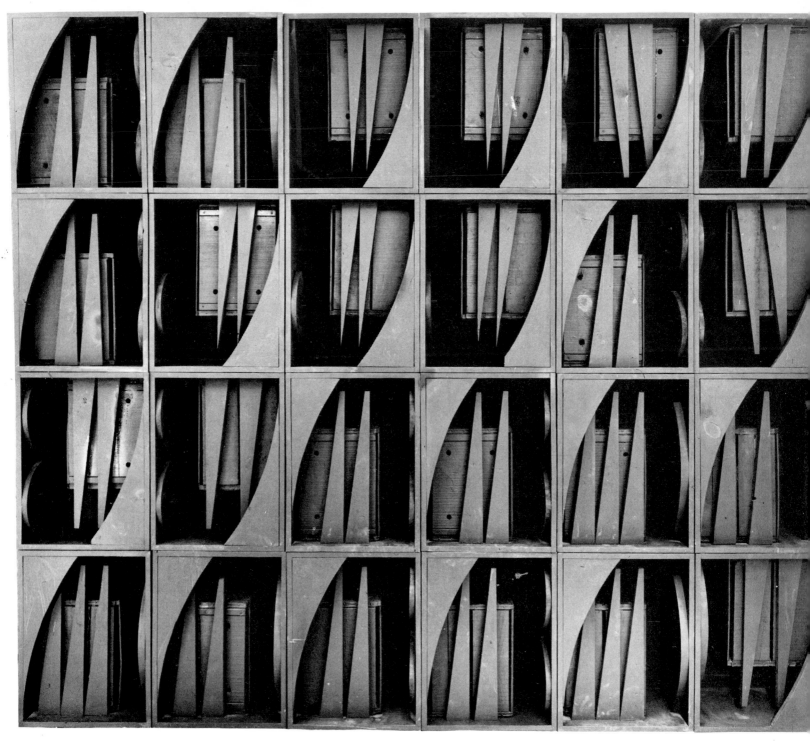

85. *Night-Focus-Dawn*, 1960. Wood painted black, 8½' x 9¾' x 14".
Collection Whitney Museum of American Art, New York.
Gift of Howard and Jean Lipman.

86. *Atmosphere and Environment X*, 1969. Corten steel, 16¾′ x 11′ x 6′. Collection Princeton University, The John B. Putnam, Jr., Memorial Collection, Princeton, N.J.

87. *Atmosphere and Environment XII*, 1970. Corten steel, 16¼′ x 10′ x 5′. Collection Fairmont Park Art Association, Philadelphia.

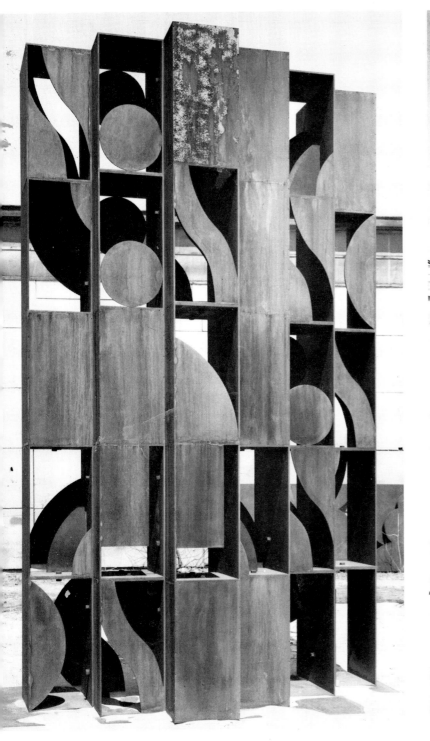

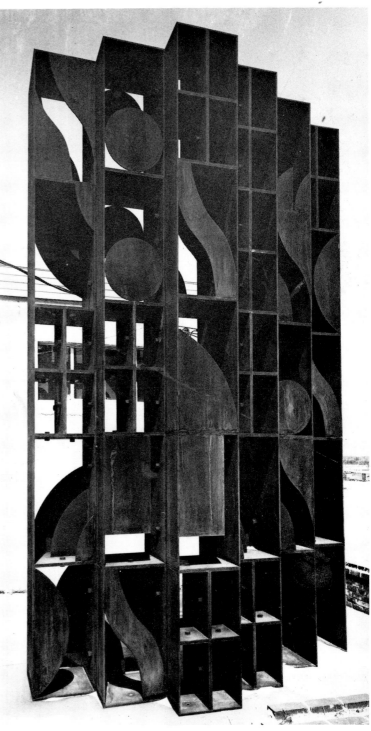

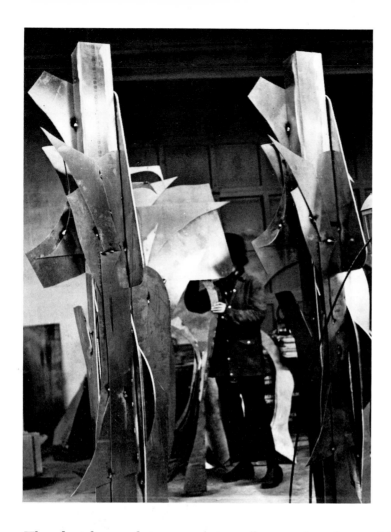

88. *Seventh Decade Garden*, 1971, sculptures in process at Lippincott. Direct-welded painted aluminum, 109″ x 57″ x 40″.

The plexiglass sculptures unexpectedly served as the models for the enormous cor-ten pieces, as did certain aspects of the enameled aluminum sculptures, notably the vocabulary of concentric arcs and **S** curves. However, the interior forms of Nevelson's cor-ten sculptures are fewer; in *Atmosphere and Environment X* (Fig. 86) and *Atmosphere and Environment XII* (Fig. 87) many of the boxes are empty, sometimes open and sometimes closed. Structure is image, the frozen promise of a building in its skeletal stage of construction. As in the transparent series, all of the bolts and joints are exposed and incorporated as interior forms and format-intensifying devices. The vitality is dependent upon the selection of the material with its inherent surface imperfections, which transform the geometry of the structure into a consistently changing experience. The stylistic perfection of the forms supporting the structure and the unpredictable *found* color of the surface make the work appear to have been designated a sculpture rather than created as one.

This nonreflective found color is illusive in its natural process of change and variation. Though the work is a unifying color, its corners weather and anodize at different rates and bleed from one unit into the next. Pools of deeper rust accumulate around the screws and bolts. Instead of framing and reflecting the landscape, these sculptures weather into it and become part of it. Aside from their patina, their only illusive quality is externally stimulated by the

166

89. Installation of *Seventh Decade Garden* at The Pace Gallery, New York, 1971.

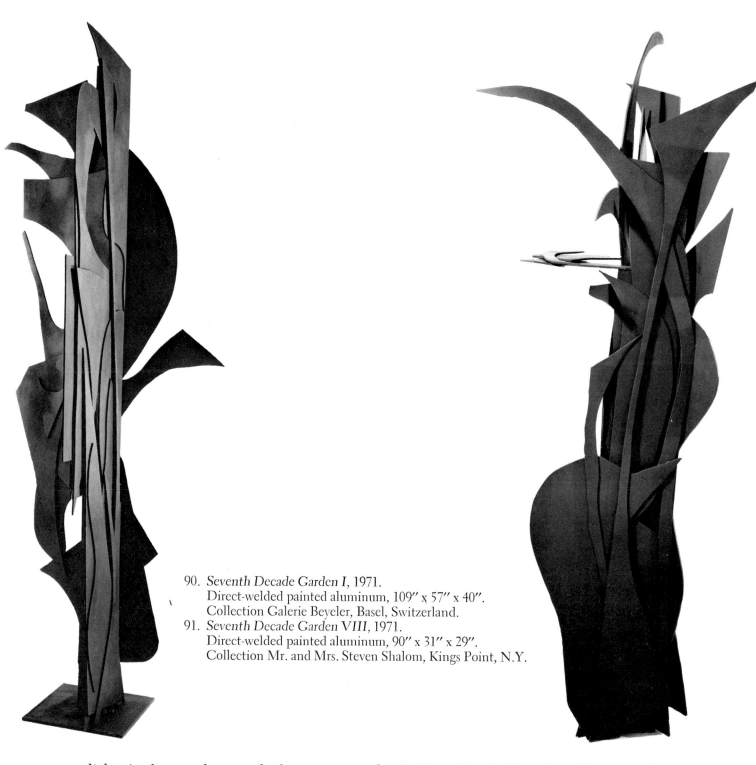

90. *Seventh Decade Garden I*, 1971.
 Direct-welded painted aluminum, 109" x 57" x 40".
 Collection Galerie Beyeler, Basel, Switzerland.
91. *Seventh Decade Garden VIII*, 1971.
 Direct-welded painted aluminum, 90" x 31" x 29".
 Collection Mr. and Mrs. Steven Shalom, Kings Point, N.Y.

light. As the sun changes, the boxes cast angular shadows that divide and proliferate. When they are placed upon pavement, the afternoon sun causes a honeycomb of light and dark that assumes an activity and importance equal to the sculpture. The shadow steals mass from its body, thereby diminishing the visual weight of the piece.

Ironically, these essences of Nevelson's sculpture, the ones most nearly "wished" into existence, are the very ones that not only reveal their process but are specifically about it.

In her early seventies, Nevelson produced an unexpected series. On a periodic, in-process

168

visit to the manufacturers of her steel sculptures, she was taken past a room filled with scraps of aluminum: waste products from the production of another artist's work that were awaiting removal. After claiming the scrap she ordered the fabrication of ten rectangular and triangular cores and temporary bases. The works produced were entitled *Seventh Decade Garden* (Figs. 88 and 89).

The garden pieces exist on many levels and are of particular interest within the context of Nevelson's career. They are the consummate stylistic unpackaging of her art. Undulating, tendril-like linear forms emphasize the verticality of the sculptures and large, flat, asymmetrical sheet-metal forms project off the core and into free space. In some instances, such as *Seventh Decade Garden I* (Fig. 90), the central core is completely obliterated by the forms, and the sculpture becomes a series of eccentric angles, each cupping different space. These angles, fanning out into space, are blinders that direct the viewer to three separate views; all flat and all frontal and only able to be viewed one at a time. Despite the aggressive use of space (like *Homage, 6,000,000* but much less complex), illusory space is shallow, and the play of the thin sheet-metal in layer upon layer becomes a black-on-black shadow drawing in space. The natural shadow caused by the edge of the appliqué-shapes operates in a descriptive linear manner. Although this piece is the most three-dimensional of the series, it is the least radical departure from her earlier works: It is a turnstyle of the pre-wall shallow reliefs of the early to mid-1950's, a description applicable to some extent to all of *Seventh Decade Garden* pieces; however, the scale and spatial extension of piece I makes it apparent.

Especially interesting is the shelf device in *Seventh Decade Garden VIII* (Fig. 91). Wrapped in curvilinear forms, the column flares from the floor and rises and narrows toward the top before opening into a bouquet. Just before this point, Nevelson has created a horizontal arc-shaped shelf (made of several arcs welded together in flat layers) cantilevered off the sculpture that arrests the activity by means of visual constriction, thus intensifying the free burst of blossom at the top. This horizontal device occurs in another work, *Sky Cathedral*, predating the *Seventh Decade Garden* by twelve years.

At no other time in her life has Nevelson produced works of such aggressive spatial participation. The flowers of her *Seventh Decade* are the garden of her private universe. In themselves, they embellish her world, but they are more interesting than mere signals of security within her life style. Aesthetically, they have no weight, and the application of black for the purpose of claiming the works does not give them the weight of the cor-ten steel or even of the wood sculpture. They could easily be cardboard or cut-paper mock-ups for pieces to be eventually made in metal, because of their immediacy. The entire series was made in two days. As she examined her forms, Nevelson realized that there were two nearly identical pieces of each scrap shape. She welded a piece first to one column and then to a twin, in almost exact placement,

and by this process she created five sets of twin sculptures, each painstakingly made in synchrony with its counterpart. This impulsive work process is unique to this metal series; it was not possible in any of the other fabricated metal sculptures.

Interrupting the carefully studied, factory-fabricated sequence of the *Atmosphere and Environment* series with as radical a departure as welded metal appears to be a regression. In technique, welded metal is much closer to the early found, hand-assembled sculptures than to the late wood or metal works. At one time, this technique offended her femininity. However, Nevelson is at an especially flexible and powerful time in her career, in contrast with the art world in general. At a time of uncertainty in the continuing stream of art, Nevelson has come full circle, totally delineated her realm, and is now free to make excursions back into time itself and take directions that she previously rejected or with which she only flirted. Therefore, there can

92. *Black Garden Wall I: Flight*, 1971.
Black painted wood, formica, 9½′ x 14′ x 5½″.
Collection Pace Editions Inc., The Pace Gallery, New York.

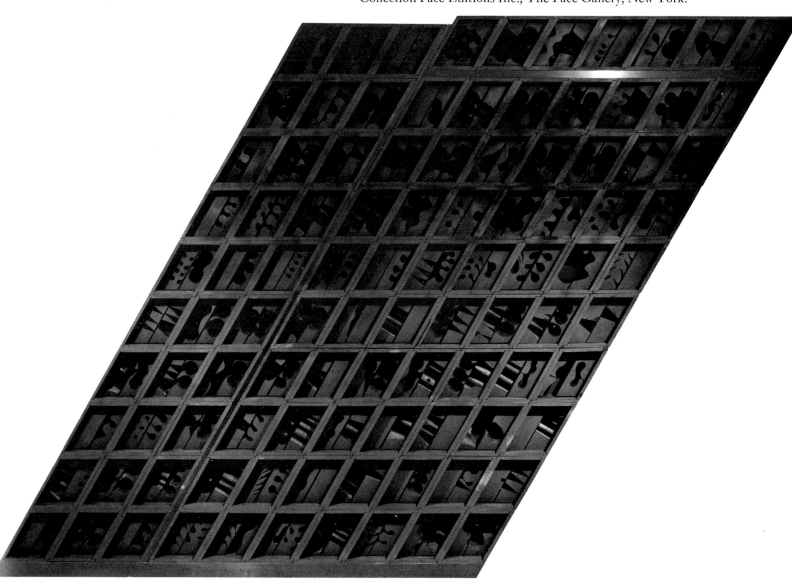

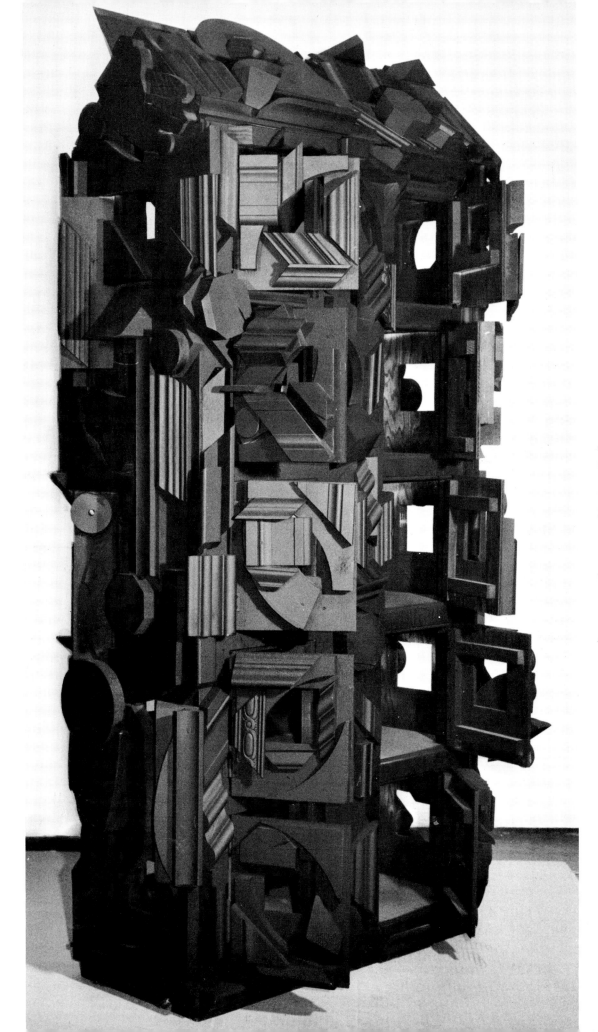

3. *Sculpture House II*, 1972.
Black painted wood, 54″ x 28″ x 12″.
Collection: The Artist.

be no continuing logical chronology to her work. Following the production of the *Seventh Decade Garden* sculptures, Nevelson made *Black Garden Wall I: Flight* (Fig. 92) in the accumulated form of a parallelogram and composed of small parallelogram boxes. It is the shallowest of her large works and repeats a floral motif reminiscent of the last work of Matisse. Half the top right row of boxes have been extended upward by means of a two-inch formica-covered wood insertion that breaks the geometric perfection and agitates the movement. Enormous tension results in damaging the perfection of the parallelogram.

The positive forms cut from the pieces that make up *Flight* provided Nevelson's scavenger aesthetic with raw materials for the creation of thirty-six columnar sculptures averaging twenty-eight inches in height and entitled *Young Trees*. In almost endless variation, she applied the forms to vertical cores that are sometimes scalloped, serrated, or cut in free form, on one side. The *Young Trees* and the parallelogram wall contain positive and negative elements of the same forms, and the totality of image created by the two works together exerts an almost surrealistic balance.

With the *Young Trees* and *Seventh Decade Garden*, Nevelson has returned to the sensibilities that she utilized in the mid-1940's in her early landscape pieces and re-explored in 1959 in the *Sky Column* series.

Nevelson immediately followed the Seventh Decade Garden sculptures with a second group of welded aluminum *Tropical Trees* and simultaneously returned to black wood with the construction of houses to complement her garden and make her landscape more complex (Fig. 93). The houses, or "sculpture houses," as the artist calls them, are variations on her boxes. The shapes of the new boxes—some vertical and some horizontal—are varied by the addition of pitched roofs, windows, and doors. Their black exteriors bristle with aggressive spines and sensuous curves. The miniature doors open to reveal clustered or hanging forms in tiny secret pockets of blackness that unexpectedly expand the interior spaces to far greater dimensions than their clearly delineated monolithic exteriors would indicate. Similar in size to doll houses, they differ from conventional miniatures by suggesting habitable structures viewed from a great distance.

An artist whose body of work is consistently powerful, and who is capable of regeneration, Nevelson is firmly part of the history of twentieth-century art. She has extended the properties of illusion into the vocabulary of sculpture and introduced the ephemeral, nonspecific, and nondelineable into the repertory of art. In these achievements, she claimed the territory within which art as diverse as the illusory glass walls of Larry Bell and the isolated environments of George Segal could be created. It is Nevelson, along with David Smith and Alexander Calder, who is responsible for the renaissance of sculpture in American art; it is Nevelson who most destroys the boundaries between painting and sculpture.

SELECTED WORKS 1930-1972

Untitled, 1930. Pencil, 11½" x 10¾". Collection Whitney Museum of American Art, New York. Gift of the artist.

Untitled, 1932. Pencil 10" x 12". Collection Whitney Museum of American Art, New York. Gift of the artist.

Untitled, 1932. Pencil, 13¼" x 14". Collection Whitney Museum of American Art, New York. Gift of the artist.

Figure, 1932. Bronze etched and painted. Collection unknown.

 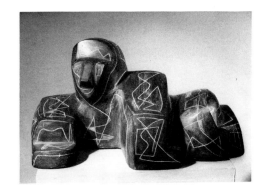

Duck, c. 1934. Bronze, 10" h. Collection the artist.

Figure, 1940. Terra cotta, painted black, approx. 10" x 24" x 18". Collection unknown.

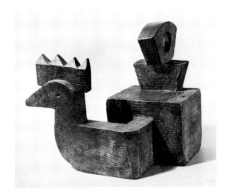 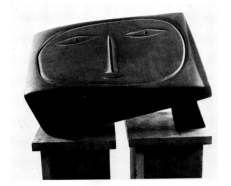

Dancer, 1944. Bronze, 16″ x 14″ x 8″. Collection Mr. and Mrs. Ben Mildwoff, New York.

Self-Portrait, c. 1944. Tattistone, 17¼″ x 12″ x 7″.
Collection Feibes & Schmitt, Architects. Schenectady, New York.

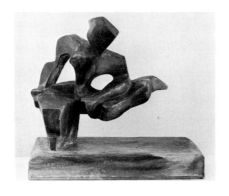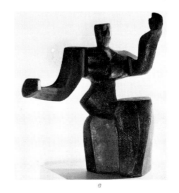

Owl Figure, 1947. Terra cotta, 18″ h. Collection the artist.

Tattistone to Anita Berliawsky, c. 1947. 24″ h.
Collection the artist.

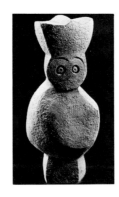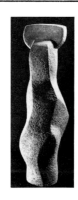

Archaic Head, 1947. Terra cotta, 8″ x 9″ x 11″.
Collection the artist.

Mountain Woman, 1947. Aluminum, 12″ x 22″ x 9″.
Collection the artist.

Abstract Bird Form, 1946. Marble, 12″ x 15″ x 5½″.
Collection Diana McKowan, New York.

Bird Form, c. 1945. Marble, 13⅝″ x 21⅛″ x 4″.
Collection Museum of Fine Arts, Houston, Texas. Gift of the Federation of Modern Painters and Sculptors.

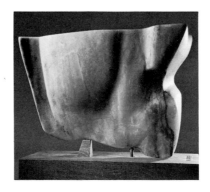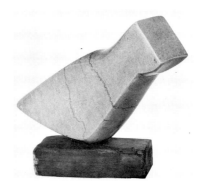

Exotic Landscape, 1942–45. Wood painted black, 12″ x 27″ x 11¼″.
Collection Pace Editions Inc., The Pace Gallery, New York.

Voyage, c. 1953. Wood painted black, 53″ x 15″ x 10″.
Collection Pace Editions Inc., The Pace Gallery, New York.

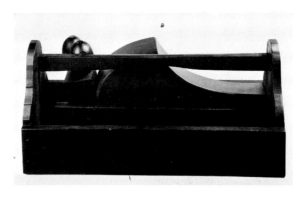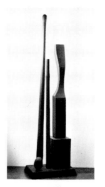

Night Presence IV, 1955. Wood painted black, 28" x 20½" x 10½". Collection Pace Editions Inc., The Pace Gallery, New York.

Black Wedding Cake, c. 1957. Wood painted black, 38½" x 24". Collection Dorothy H. Rautbord.

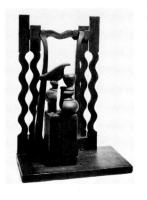 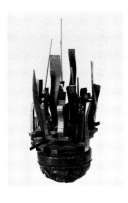

Night Presence VI, 1955. Wood painted black, 11" x 32¾" x 8¾". Collection Vivian Merrin, New York.

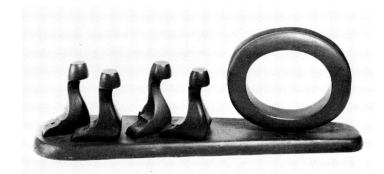

Moon Spikes IV, 1955. Wood painted black, 36½" x 42" x 10". Collection Pace Editions Inc., The Pace Gallery, New York.

Black Majesty, 1955. Painted wood, 32" x 65". Collection Whitney Museum of American Art. Gift of Mr. and Mrs. Ben Mildwoff through the Federation of Modern American Painters and Sculptors.

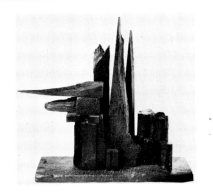 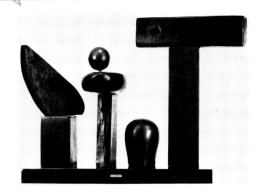

Studio at Nevelson's house on East Thirtieth Street, 1955.

Undermarine Scape, 1956. Wood painted black and stained glass, 28½" x 17½" x 17". Collection Mr. and Mrs. Ben Mildwoff, New York.

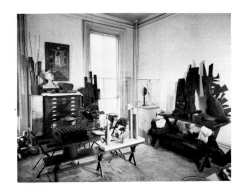 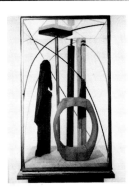

Night Flower, 1957. Wood painted black, 24¼" x 17½" x 4¾". Collection Mr. and Mrs. Irving W. Rabb, Cambridge, Mass.

The Little City of Dawn, c. 1957. Wood painted black. Destroyed.

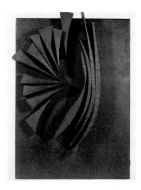 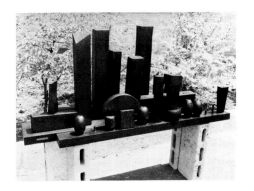

World Garden VII, 1959. Wood painted black, 29½" x 20¾" x 6¼". Collection Galerie Daniel Gervis, Paris.

Sky Cathedral Presence, 1951–64. Wood painted black, 9¾' x 14½' x 29".
Collection Walker Art Center, Minneapolis, Minn.

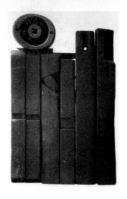 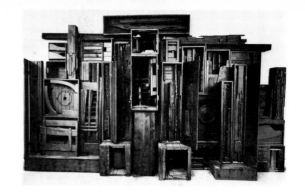

Sky Cathedral, 1958. Wood painted black, 8½' x 11⅛'.
Collection Albright-Knox Art Gallery, Buffalo, N.Y.

Tropical Garden II, 1959. Wood painted black, 71½" x 131¾".
Collection Le Centre National d'Art Contemporain, Paris.

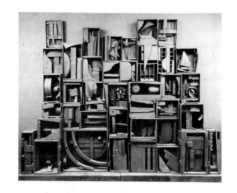 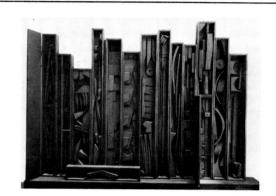

Black Wall, 1959. Wood painted black, 112" x 85¼" x 25½".
Courtesy The Trustees of The Tate Gallery, London.

Ode to Antiquity, 1959. Wood painted black, 87" x 38".
Collection Mr. and Mrs. Avram Goldberg, Brookline, Mass.

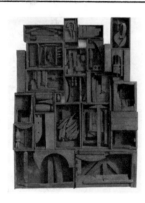 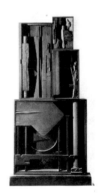

Young Shadows, 1959–60. Wood painted black, 9½' x 10½' x 7¾". Collection Whitney Museum of American Art, New York.

Cathedral Garden #4, 1960–63. Wood painted black. Wall: 90" x 44" x 17". Left column 66¼" h., right column 84" h.
Collection Mr. and Mrs. Alvin Lane, New York.

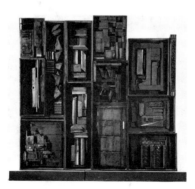 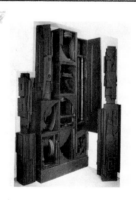

Royal Nightfire, 1963. Wood painted black, 97" x 41".
Collection Mr. and Mrs. Arthur A. Goldberg, New York.

Night Totality, 1959–64. Wood painted black, 9 1/3' x 9 2/3' x 10½". Collection Pace Editions Inc., The Pace Gallery, New York.

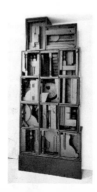 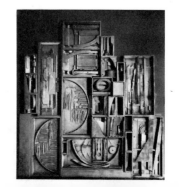